Photographs from the Real World

Photographs
from the Real World

Edited by Dag Alveng

DE NORSKE BOKKLUBBENE

This book is published in connection with the
exhibition "Photographs from the Real World".
The exhibition is part of the Pre-olympic Cultural
Program of the XVII Olympic Winter Games at
Lillehammer in 1994. The exhibition is produced
by Lillehammer Art Museum.
Project Manager: Per Bj. Boym
Guest Curator: Dag Alveng

Lillehammer Art Museum, Norway
November 13 1993 – January 23 1994

©1993 De norske Bokklubbene A/S
Editor: Carole Kismaric
Design: Per Maning
Translation: Elisabet W. Middelthon, Frank Schramm,
Margaret K. Wold and Elinor Ruth Waaler
Halftone photography: Robert J. Hennessey
Color separations: Tangen Grafiske Senter A/S
Typesetting: Cliché Grafisk/Tangen Grafiske Senter A/S
Printing: Tangen Grafiske Senter A/S, 1993

ISBN 82-525-2664-0

This book is one of the series of quality books
included in the Cultural Program of the
XVII Olympic Winter Games at Lillehammer
in 1994. It has been published in collaboration
with De norske Bokklubbene A/S.

Contents

Foreword

The Crisis of the Real by Andy Grundberg, art critic of "New York Times," was published in 1990. This book contains a collection of articles on photography from 1974 to 1989. The title refers to how art in general, and photography in particular, rejected concepts such as the essential and the real.

When the Lillehammer Art Museum approached Dag Alveng asking him to take on the responsibility of being the guest curator of an exhibition of photographs from the last fifteen years, it immediately became evident that this would be a very focused exhibition. It may seem as if the exhibition is put together in order to undermine certain trends in the art of photography during this period. The traditional, which may easily be read as the essential role of the photographer is the focus of this exhibition. The exhibition is entitled "Photographs from the Real World" – not only "the World" but "the Real World" – underlining this theme as well.

The status of photography has undoubtedly changed as a result of the development of art during the last twenty years. Many of the photographers who have contributed greatly to this development, are represented here. When viewing their pictures, with all their inherent dissimilities, it is difficult to understand the concept underlying this exhibition as a limiting philosophical concept. However, it is possible to grasp a nerve that connects these pictures. What the pictures as a whole communicate, is best described by the American Nobel Prize Winner of physics, Steven Weinberg, in his book *Dreams of a Final Theory,* of 1993:

When we say that a thing is real, we are simply expressing a sort of respect. We mean that the thing must be taken seriously because it can affect us in ways that are not entirely in our control and because we cannot learn about it without making an effort that goes beyond our own imagination.

The exhibition is a result of an inspired international cooperation. Susan Kismaric, curator at the photography department of the Museum of Modern Art, New York, has been very helpful during this project, sharing with us her great knowledge of, and her broad contacts in, the international world of photography. The participating artists have been very cooperative, and in cases where galleries have been asked to contribute, our questions have without exception been positively answered. The cooperation with Fotomuseum Winterthur, Switzerland, proved to be a successful relationship that enables us to present Lewis Baltz important work "Ronde de Nuit."

When we approached authors and critics to write essays, we were met with enthusiasm. The book, just like the exhibition, comes into existence as a result of international cooperation among experts within the field of photography. Especially, we should like to express our gratitude to Carole Kismaric, previously editor of *Aperture*, who willingly undertook the responsibility of editing the texts. Likewise, we are very grateful to the Norwegian Book Clubs, producers of the book, and their project leader, Gro Stangeland, who have shown great enthusiasm for this international collaboration and a willingness and ability to create a book of exceptional quality. The production of this book has been supported by Eastman Kodak.

The exhibition is part of the pre-olympic cultural program of the XVIIth Winter Olympic Games at Lillehammer in February 1994. One of the aims of this program is to present Norwegian art in an international context. Without the wholehearted financial and practical support of Lillehammer Olympic Organization Committee, it would not have been possible to organize this important presentation of contemporary photography.

Per Bj. Boym
Director Lillehammer Art Museum

Photographs
from the Real World

Dag Alveng

Photographs from the Real World examines what has happened to the fundamental role of the photographer–to go out into the world to record what is there and transform it into a photograph. Rather than surveying art in the 1980s and 1990s, which would include photography in some form, this exhibition focuses on the idea of the photograph as a document made in the world. The exhibition aims to demonstrate how traditional, straight photography, what has been called by John Szarkowski "the art of pointing," has been affected by recent artistic developments, which have provoked a subtle renewal and refinement of contemporary photographic seeing. While most of the photographers in this exhibition strictly adhere to the traditional approach of making straight pictures and do not manipulate their images to describe and interpret the world, they all use a variety of contemporary artistic strategies that have evolved in the last two decades.

Since the invention of the medium, photographers, for different reasons and with varying impulses, have performed the seemingly simple act of recording the world. In the nineteenth century, they were commissioned by governments to record architectural projects, to document newly explored regions of the world, to preserve an event or the identity of an individual for posterity. While the motivation for documenting such events has changed radically over the last one hundred years –from making ostensible objective records of man's achievements to an increasingly subjective enterprise–we've come to understand that the photographers who make such pictures have always been concerned with making pictures that describe *their* experience and their perception of what was before *their* camera.

Fig. 1

Obviously, all photographs are from the real world, because the camera can only record what exists. At the same time, all photographs are about something that does not exist, because they abstract the world in a picture. Nevertheless, a photograph of people by Walker Evans, made for the Farm Security Administration in the 1930s Depression in America, has more in common with the staged self-portraits from the 1970s by the postmodernist artist Cindy Sherman than one immediately assumes. Each photographer presents to the viewer an idea about his chosen subject. An Evans photograph, because it appears to have been made without manipulation and because it is so resolute in its attention to what is before the camera, convinces us that it is a picture of the "truth." That is, it describes accurately what is in front of the camera. Consequently, our ideas about the Depression in America have largely been formed by Evans's documents. We believe that during the Depression, America and its people looked the same as they look in Walker Evans's pictures of them. Yet these photographs are products of Evans's imagination. He *chose* his subjects, he photographed them in a *certain* place, at a *specific* distance, in a *particular* light, from a *specific* angle to realize his conception of them. His choices, while infinite, were limited by his own parameters and by his belief that a photograph was an act of imagination, only as good as the intelligence, talent, and sensitivity of the person behind the camera.

Cindy Sherman's photographs are "constructed" because she does not find her subject matter out in the world but gathers her materials and brings them together to photograph in a studio. Her

7

self-portraits, made in the 1970s, in which she acts out a variety of roles and emotional moments played by women in films and magazines, replicate the film stills handed out by motion picture studios. They are 8x10 black-and-white prints of the poor quality of film stills. Sherman chose her costumes, built or carefully selected her environments, lit each scene accordingly, and acted a moment in the life of a vulnerable waif, neurotic or dutiful housewife, sex-bomb screen star, or prim secretary. In the final analysis, when one begins to try to distinguish between the work of Evans and Sherman, one sees that it is the process of making their photographs that most distinguishes the work of each artist from the other. There is the same amount of fiction in each photographer's work; one photographer's work is no more conceptual than the other. Each body of work can be called conceptual, because each artist went about their work with a specific idea they were trying to communicate.

In the photographs of the German artists Bernd and Hilla Becher of architectural details in factories and facades of homes, the understanding of how documentary photography is conceptual can be easily perceived. The Bechers take straight-forward individual photographs of related subjects, all from the same distance and vantage point. By massing groups of virtually similar subjects together into grids, they imply the countless number of factories or homes there actually are, focusing our attention on the design and construction of such objects that normally go unnoticed. The use of the grid structure as a conceptual device makes their work a bridge between the traditional documentary work of a photographer like Evans and the conceptual art of an artist like Sherman.

During the 1960s the goal of many artists was to make their work available to as many people as possible. They achieved this by producing inexpensive, multiple editions of artists books and prints that could be purchased by a larger audience. Whereas a painting by Robert Rauschenberg cost tens of thousands of dollars, Ed Ruschas's photographic book, *Twenty-Six Gasoline*

Fig. 2

Stations, produced first in 1963 in an edition of 400 copies sold for $4.

During the 1970s, photography was integrated into the world of traditional fine arts through an international, commercial art market. A proliferation of galleries, exclusively devoted to photography, opened around the world, and art galleries, which had previously only exhibited painting and sculpture, began to exhibit photographs. It was during this evolution of the commercial gallery system that artists became acutely aware of the discrepancy between the high prices much art began to command, art's privileged audience, and the ideals of their sixties generation.

In reaction, artists began making site-specific works, performance pieces, and works meant to make the sale and collection of their work difficult if not impossible. As members of a generation that was rebelling against *all* tradition, including the sometimes crass commercialism of the art world, they stressed the importance of the ideas and the process of making art, rather than the value of an art work as an object that could be bought and sold. Consequently, traditional art galleries and collectors began to buy and sell photographs because they were an inexpensive, collectible commodity.

In the United States, this infiltration of photography into the fine art market occurred simultaneously with a growing interest on the part of scholars, curators, and art historians in the history of photography. Members of the post-war baby boom generation, who were raised on the images of movies and television, were fascinated with the meanings, interpretations, and creative possibilities of photography. Susan Sontag's book, *On Photography,* first published as a series of articles in the *New York Review of Books* from 1973-77, was an intelligent, provocative meditation on the medium. It was read by anyone with more than a passing interest in photography and by those people who previously had considered photography to be a craft with little intellectual panache. Sontag's book, and the writing of John Szarkowski, then director of the Department of Photography at the Museum of Modern Art

in New York, in books such as *The Photographer's Eye* (1966) and *Looking at Photographs* (1972), helped bring a broader, more intellectual, and sometimes more sophisticated audience about art in general, to an understanding of contemporary photography in America.

Also at the end of the seventies, museums began to expand their exhibition and collecting programs to include photography, and colleges and universities began to teach photography as part of their curriculum. Photography classes were most often part of a school's fine art program, so photography students and professors were able to begin a dialogue with painters, printmakers, and sculptors. This generation of photography students, who came to understand their medium to be an art on a parallel with painting or sculpture, graduated from these programs to continue to work, teach, and exert their influence internationally.

With traditional art galleries exhibiting photography, a further exchange of ideas and methods between artists and photographers took place. While painters, such as Robert Rauschenberg and Andy Warhol, had taken up photography a generation before, their use of the medium was primarily limited to the photo silk-screen. The artists of the late 1960s and early 1970s used photographs more directly. The Americans Bruce Nauman, William Wegman, and John Baldessari, and the Germans Joseph Beuys, Dieter Appelt, and Sigmar Polke, among others, used photography to document performances and to explore the idea of how the world was represented in a photograph. Their use of photography precipitated the final integration of the medium into mainstream fine art. It was not difficult for artists of the sixties generation, who had purposefully rejected the high cost and elitist atmosphere of the art world, to embrace the unpretentious medium of photography–after all, anyone could make a photograph–and to find tremendous intellectual reward in the medium.

The continuing effect of this interaction between photographers and fine artists has been felt most strongly in the art produced during the last fifteen years. On the one hand, photographers who printed their photographs in small formats meant to be held in the hand and who had been satisfied with pictures reproduced in books or mounted in albums, were confronted with the walls of museums and galleries, large exhibition spaces that provoked them to experiment with the issue of just how big a photograph could be and still maintain its inherent character. At the same time, fine artists began to use photography in their art production, often combining photographs with text, painting, video, or other techniques–creating a new art form that was to come to be called mixed media. This exchange inspired photographers to make large-scale installations of their work and to make serial work that was complex in its arrangements and often consisted of multiple elements. They were freed from previous practices of exhibiting photographs according to rigid ideas that had more to do with books and exhibitions that respected the logical, predictable sequence of photographic images.

Improved technology of color film and papers also provided more accurate and believable photographic colors and encouraged more photographers to work in color. In this arena of open experimentation, more photographers began to refine and revise older, large-format camera and nineteenth-century printing techniques, which they applied to contemporary subject matter.

Perhaps most importantly, the postmodern art movement that emerged during this period and was given a great deal of critical attention, affected the traditional ways of thinking about photography. In an attempt to create an art that was new, artists evaluated the past and deconstructed accepted notions of what art is. They integrated old ideas and forms with contemporary ones to comment on the art process and the history of art. Appropriation, reappropriation, politics, psychoanalytic theory, fabrication, refabrication, and feminist ideology became the content of contemporary art. Postmodern artists took up photography with an intellectual zeal meant to question the very ideas embedded for more than a century in traditional photography.

What had once been a unified notion of acceptable content and form for artists was fractured by the 1980s. Everyone had his or her own agenda, intent on getting across the social, political, or intellectual ideas that best expressed their contemporary experience. Audiences could not depend on seeing predictable subject matter. Gays were making art about being gay; African-Americans about being black; women about rape and other feminist issues. It

was almost as if the social and political aspirations of the 1960s, which were meant to change society in practical terms, were being translated into subjective statements that, instead, changed what art looked like and was about.

While often confusing to the general public and dismaying to many in the art world, this era was an exciting and heady time because of the artistic possibilities it provoked. The critical discussion about postmodern art, its production, and its exhibition, overshadowed more traditional photography, especially what had come to be understood as documentary photography.

Photography, that most persuasive purveyor of accepted ideas, was the most suspect medium to the postmodernists. And it was documentary photography, after all, that was responsible for describing history, imposing values, transmitting culture. If art were to push any real boundaries, documentary photography had to be relegated to the dustbin in favor of a photography that was more self-aware. A photograph could not be presented, nor should it be understood, as a representation of reality, but must include within its form either a text to flesh out the "facts" or a reference to another photograph or the history of photography, in essence a disclaimer to indicate that the artist did not believe in the photograph either.

Photographs from the Real World concentrates on how sixteen artists from Europe, Japan, Latin America, and the United States developed traditional documentary photography within this social and artist context. It contains no staged work, although some of the work involves subjects who have posed for the camera. It contains no constructed sets, although some of the pictures were made inside. It contains no advertising or fashion photography, although some of the work has been made on assignment or commissioned. And it contains little work that can be considered truly postmodern, although some photographs are appropriated and are therefore documentary by their nature. With few exceptions, all of the work has been made since 1980.

The subject matter of the photographs ranges from surveillance of public spaces to traditional portraits, landscapes, and still lifes. The work is often larger than the photographs we are accustomed to seeing, and some are intended to be seen as part of an installation. In one case, the installation is accompanied by sound. *Photographs from the Real World* demonstrates the advances and revisions of photographic history that have occurred around the world. While the photographs from Great Britain reflect that country's continuing interest in the social documentary form, the photographs by Mexican photographer Flor Garduño of the people and rituals of Latin America reflect the pervasive surrealism of Mexican photography and art. The work of Shomei Tomatsu demonstrates the continuing interest on the part of Japanese photographers in a boldly graphic aesthetic. The Norwegian preoccupation with landscape photography is represented in the photographs by Jim Bengston. Indeed, the photographs from each country demonstrate that country's photographic community's relationship to the medium. Yet there is one contiguous factor in all the photographs in the exhibition, and that is the undeniable fiction of photography. Photographs from the Real World demonstrates that photographs are merely descriptions of aspects of reality and not surrogates for reality. The relationship between photography and the real world need not be complex and confounding, but the relationship between photography and traditional arts has finally realized its true and meaningful potential.

Fig 1: Walker Evans. Alabama Cotton Tenant Farmer Wife. 1936
Fig 2: Cindy Sherman. Sonia Henie, 1980, Courtesy of Henie-Onstad Art Centre

Photographs from the Real World

MARTIN PARR

"Boredom: the desire for desires"
Leo Tolstoy, Anna Karenina

There you are with someone, wishing you were doing something else. Or wishing they were someone else, or that you were doing something different with someone else, anywhere else.Or, wishing you were alone. It's happened to each of us. Your mind wanders. You look at your watch. You drum your fingers on the table. You jiggle your legs. You pick the lint off your clothes. You look around to see if *anybody* is having a good time. You look at your watch. You look deep into your glass and realize that it's empty; you've already chewed up the ice cubes. And then you give up, zone out, and stare vacantly at some far-away psychological space. You are bored. Bored. Bored. Bored.

Boredom is an extreme state of detachment. It occurs when you have no ideas or options, when you're too tired for fantasies, when anything said to you, every suggestion presented to you, seems dull or patronizing. If boredom feels like a low-grade fever you fear you'll never shake, it is no help *knowing* it's a temporary disappointment you have with life or with yourself. Boredom feels like a permanent disability. To combat it, some people try to follow the advice of the therapists, magazine writers, and new age gurus who challenge us to "live in the present." The concept is basic. Allow yourself to savor *every* aspect of the experience you are having. Every sight, every sound, every smell, every thought, every memory. But it's not so simple. You *can* find yourself living in the present one too many times.

Look at the distracted people in Martin Parr's nervously cheerful color photographs, from his series "Bored Couples." People at parties, at cafes and restaurants. Tourists visiting historic sites and beachside cafes. Shoppers cruising the malls. People who should be talking, drinking, dining, dancing, sightseeing, spending, or simply relaxing, are presented, at a loss. All the world's diversions can't stop their eyes from wandering right out of the picture's borders. Well, just what *are* they looking at? What are they looking *for?*

Parr earned his reputation documenting middle class people who, if they are not looking for the good life, are at least trying to have a good time. He has photographed bargain-hunting party animals, who cross the English Channel on ferries in search of cheap liquor. He has made touching still lifes of the carefully selected objects people display in their homes—to remind themselves and others who they are and what they stand for—which poignantly reveal the constraints of taste and class. An ongoing project, his photographs of tourists, shows the manic world of theme parks we've developed to artificially nourish our increasingly dulled sense of direct experience. In these series, Parr presented us with images of desperate engagement. With wit and an intellectual's distance, he smartly crafted a contemporary comedy of manners.

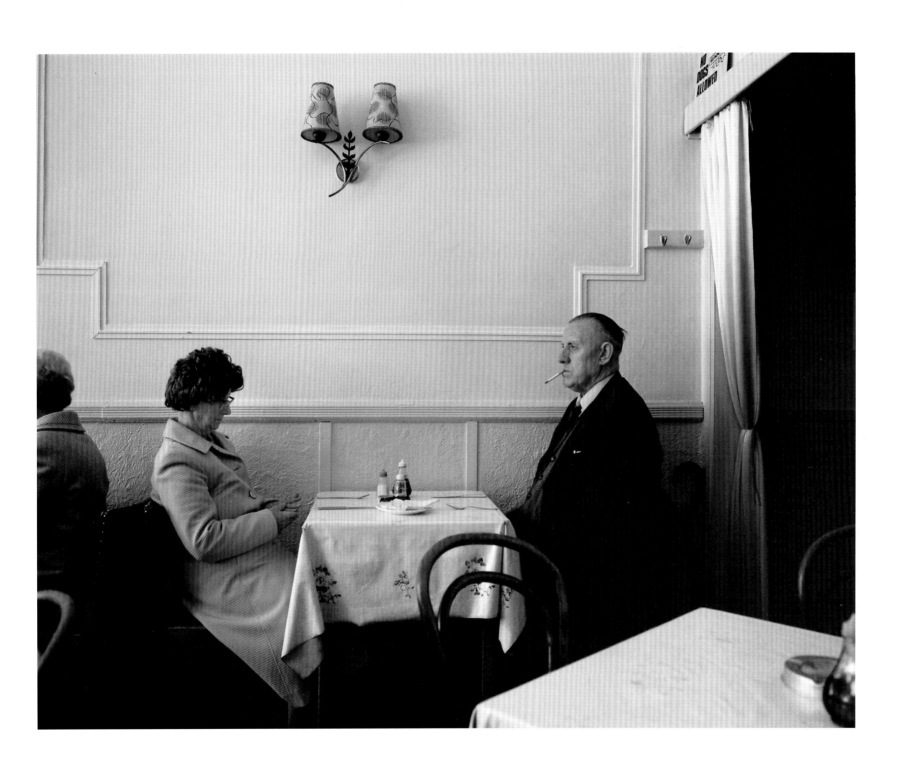

Untitled. From the Series "Bored Couples." 1992

But not now. In "Bored Couples," we don't see people acting out, consciously or unconsciously, or even trying to fool themselves. In these photographs, Parr presents pictures of people who, for one moment, for one reason or another, are just not *there*. The photographs are a little sad. The narrative energy we have come to expect from his work is gone. And in its place, he gives us images that are not about misplaced hyperactivity, but about absence. The photographs are a little sad. And they are compelling, not because they explain what boredom is or how it works, but because they highlight tensions, the dis-ease that erupts when a person refuses to look you in the eye, in life or in a picture.

On a very human level, you might empathize with, or feel sorry for, the people in these pictures. Maybe they've made a mistake, or are stuck in the situations we see them in. But how can we know? Parr has not dropped any clues that might illuminate the source of their malaise. And even if he did, the photographs wouldn't hold your attention for long. And yet they do. Parr has done something interesting, figured out a way to make pictures about boredom that aren't boring. How? A semiotician might analyze the pictures by describing a world of leisure, a Disneyland of signs, signifiers, and spectacles, which people choose to live in and then get tired of. A leftist might look at these photographs and blame the anesthetized look on every face on the economic systems that lull us into a stupor, so that the powers that control us can roll right over us.

Theorizing about what makes people bored may be intellectually challenging, but that is not what's on Parr's mind. In "Bored Couples," Parr is being more mischievously self-referential than observant. It *is* possible that the people in these photographs, like the couple sipping make-believe tropical drinks through straws the length of blow guns, are not bored at all. It's possible they've been entrapped by the camera, photographed at exactly the *wrong* moment, which becomes the perfectly *right* moment for Parr. These photographs look like, and some of them are, fabricated tableaux that Parr passes off as fact. How else can you explain the inclusion in this group of pictures of the photograph of bored Martin Parr and his bored wife? Seated in what appears to be a fast-food restaurant, Parr looks away from his wife and a wall sized photo-mural, as if both bore him. Yet his wife stares toward the big picture as if, in its monstrous scale, she might discover an exit from the photograph of boredom she's agreed to be in.

Parr used to let us to look and laugh at ourselves, when he was operating more like a photojournalist. But in "Bored Couples," he's gotten serious, turned modernist, and seems to be not only questioning why we've given up on action, but how we've gotten bored when we look for action *in* pictures. Perhaps we've just experienced too many decisive moments. When Henri Cartier-Bresson coined the phrase, "the decisive moment," he was describing the split second in which a photographer senses that the form and the meaning of a photograph coalesces and then snaps the shutter. Here, Parr seems to be saying that we've seen

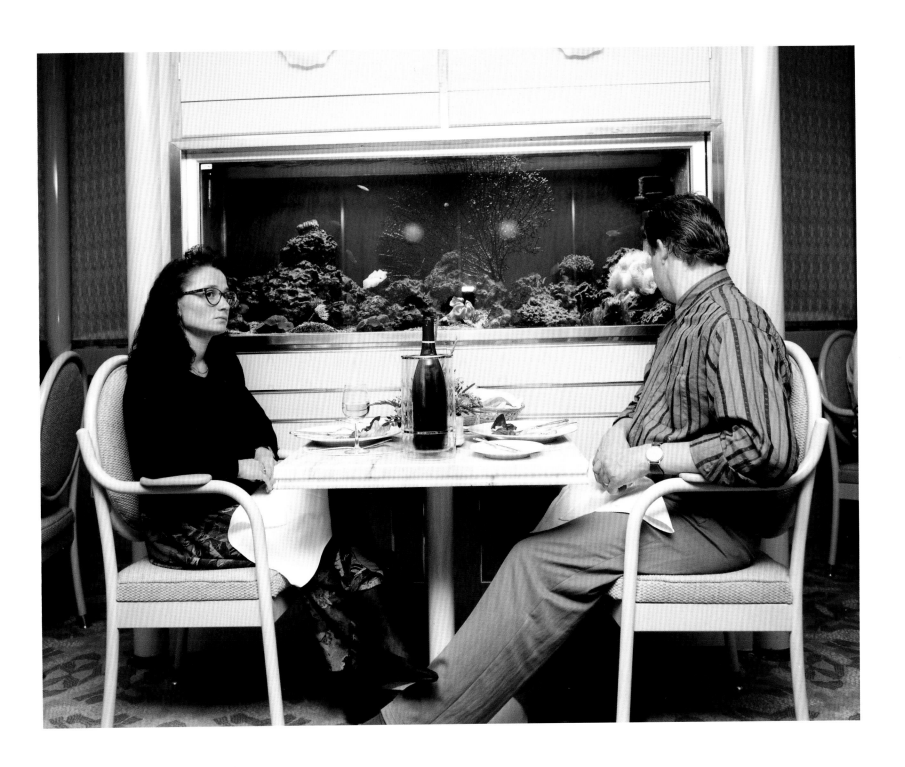

Untitled. From the Series "Bored Couples." 1992

too many decisive moments. And by pointing his camera at bored couples, Parr gets to point his finger at us, the people who will buy one more magazine, who will fast-forward the videotape, who will never let the television's remote control go, who will go to one more photography exhibition to satisfy our inexhaustible desire to escape into one more photographic illusion.

In a sense, Parr tricks us in these pictures. By making them funny and seductive, he gets us to focus on photographic situations that don't even hold the interest of the people who populate them. So, perhaps, what Parr is suggesting is that if real life feels flat, if our fantasies and passions have become two-dimensional, if we've become bored, well, don't expect photographs to save us. What these images of deadly duets—and all the photographs of happy couples that sell us everything from bath towels to vacations to condoms—are, when all is said and done, only photographs.

There has always been evidence of a perversely detached humanism in Parr's work. As he has chronicles the foibles of human behavior, he watches us look for something more, strive towards something better, try to be something else. But in these photographs, he's taken a step back, and he sees our exhaustion with our own desires, with our need to keep looking at pictures, and, perhaps, with his own reasons for taking them. In "Bored Couples," what we're faced with is Parr's depiction of people who are not only bored and adrift in life, but in a sea of images. Maybe what he is communicating in these cruelly compelling pictures is that there are fewer decisive moments left, but many, many more pictures to come.

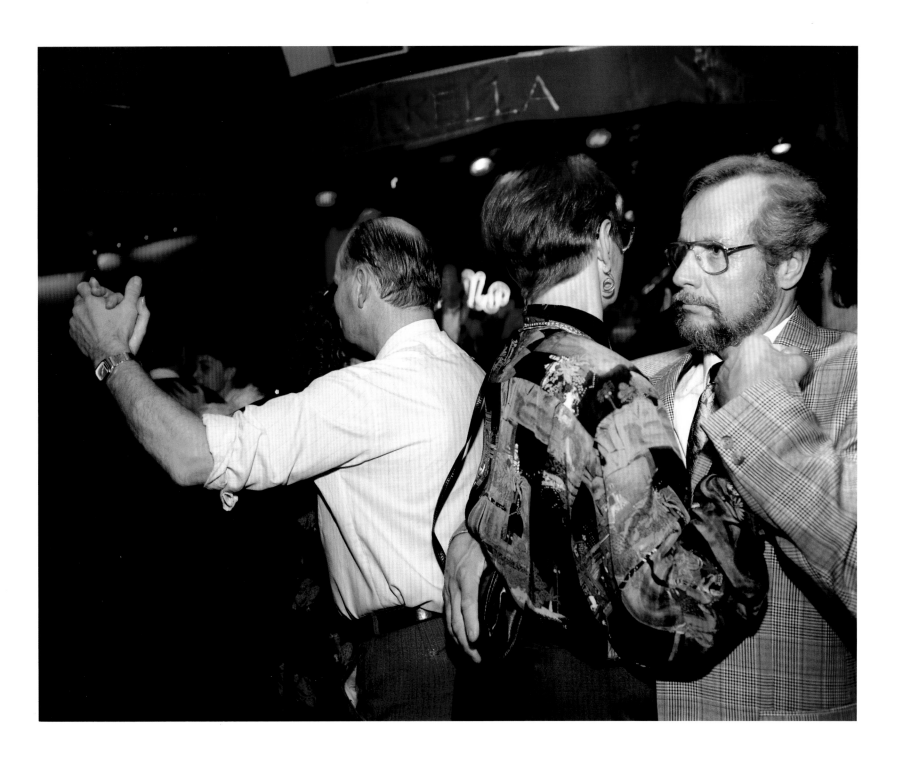

Untitled. From the Series "Bored Couples." 1992

Untitled. From the Series "Bored Couples." 1992

Untitled. From the Series "Bored Couples." 1992

Untitled. From the Series "Bored Couples." 1992

Untitled. From the Series "Bored Couples." 1992

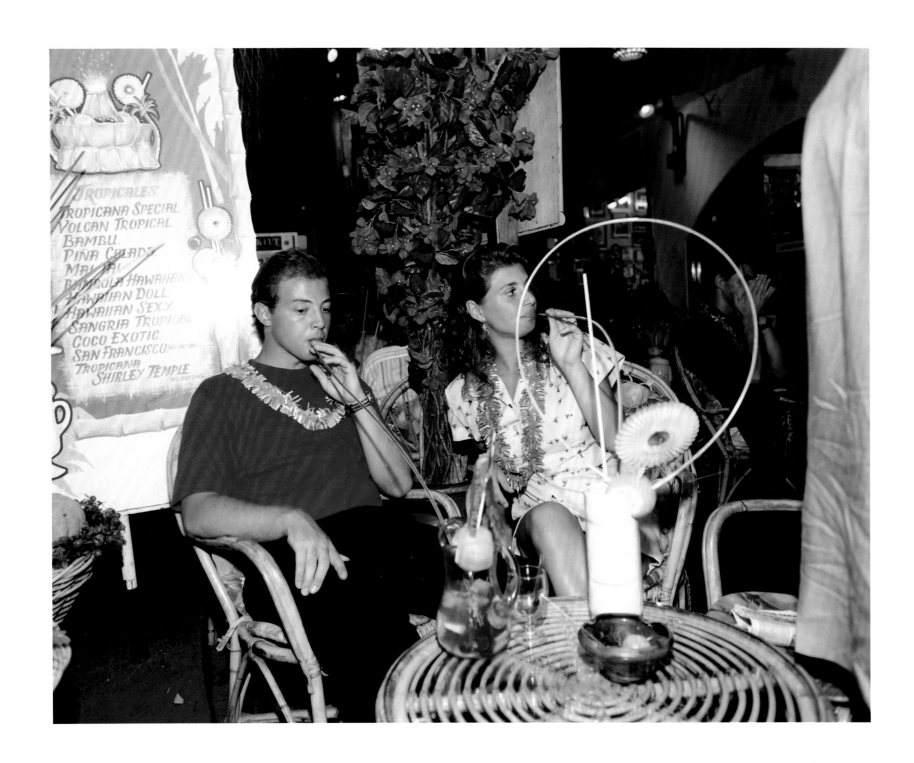

Untitled. From the Series "Bored Couples." 1992

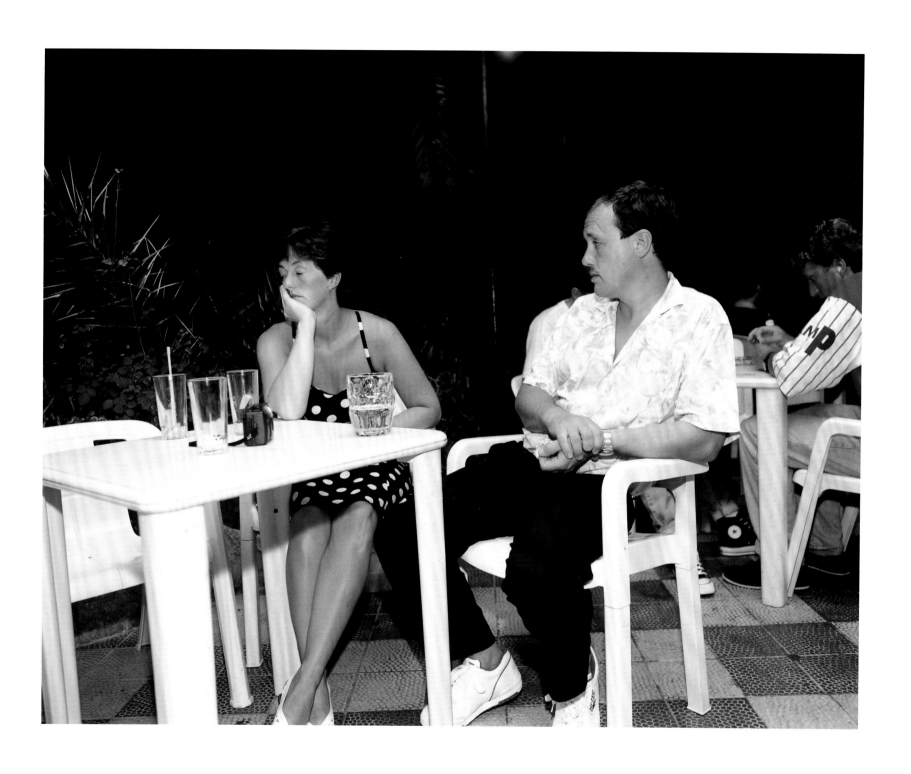

Untitled. From the Series "Bored Couples." 1992

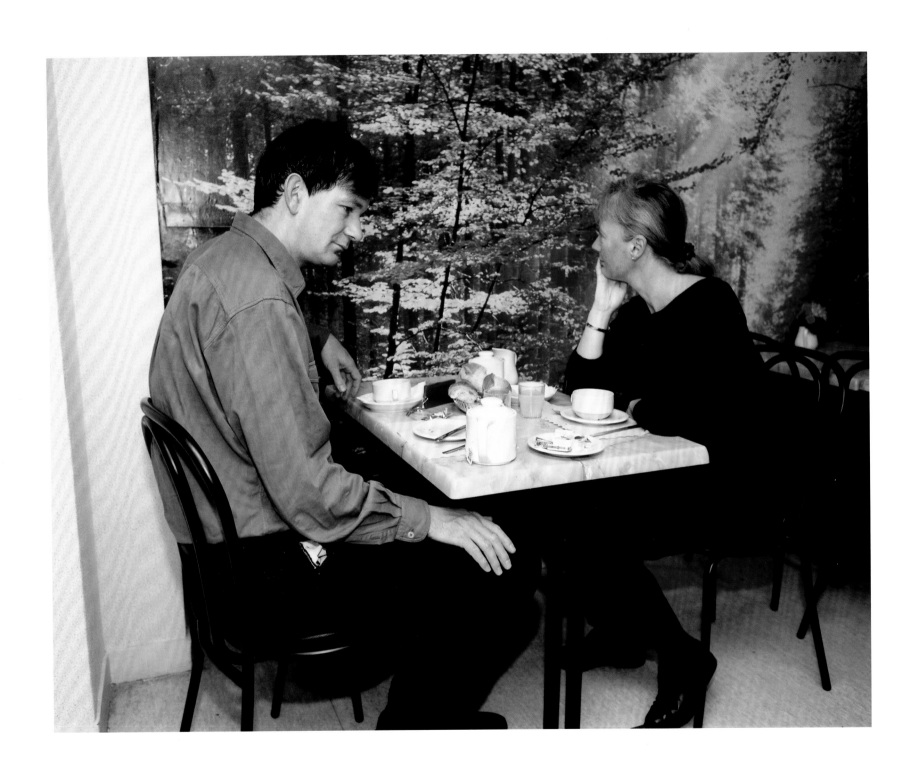

Untitled. From the Series "Bored Couples." 1992

FACE TO FACE WITH MUTENESS
Wieland Schmied

Michael Schmidt has developed a language of his own in his photography. It is a very concise, direct, precise language, where the extraneous is no longer necessary. Everything is concentrated on making a statement. Nothing is included in the picture that does not belong. Everything is omitted that can be omitted. Only that which *can* be said *is* said.

Michael Schmidt has developed a language of his own in his photography. However it is not like a separate language. It seems to be nothing other than the language of the objects themselves. Only the objects speak, so it seems, otherwise nothing else speaks. The photographer pulls back, so only the objects speak and say what there is to say.

Michael Schmidt has developed a language of his own in his photography, which is the language of objects that possess no language. It is the language of a people who have no language, who never have won or will soon have lost one. For reality cannot speak for itself, we must make it speak by looking at it. It is while we are regarding something that an object begins to speak and to say what there is to say.

Michael Schmidt has developed a language of his own in his photography. A language to say what? To say that something has to be said, that something important has to be said, that everything has to be said. To say that that must be said. But also to say, at the same time, that it cannot be said now, not now and not here and not by the photographer, because the circumstances in which we live and see and speak do not allow it. Neither the things themselves nor our way of looking at things allows it. And that this is so and not otherwise; that it is exactly reality about which we speak.

What remains to be said is that there could be a great deal to say, but it cannot be said. And what remains to be said is that nothing can be said except this not being able to say anything, or, perhaps, even why nothing can be said. Therefore a text on or about the language of Michael Schmidt cannot be called anything but "Michael Schmidt" or "Muteness," for his photographs have only one theme: muteness. He encounters this condition in every subject. Other themes do not open up for him. Other objects do not appear.

Michael Schmidt photographs walls and people, facades and faces, mesh grids, bars, walls and their coverings – asbestos, cement, concrete, mortar, plaster. The obstructed view. The closed-off person. Young people thrown back on their own resources, rebuffing, warding off, turning away, closing in on themselves. Their eyes closed, their eyelids lowered. No word is exchanged, no glance returned. Only this appeals to Michael Schmidt. He does not seek anything else. Only this captivates him. Only in this does he recognize himself.

As mentioned before, Michael Schmidt keeps himself entirely apart from his photographs. He does not intervene with his feelings; he only shows us what the objects show

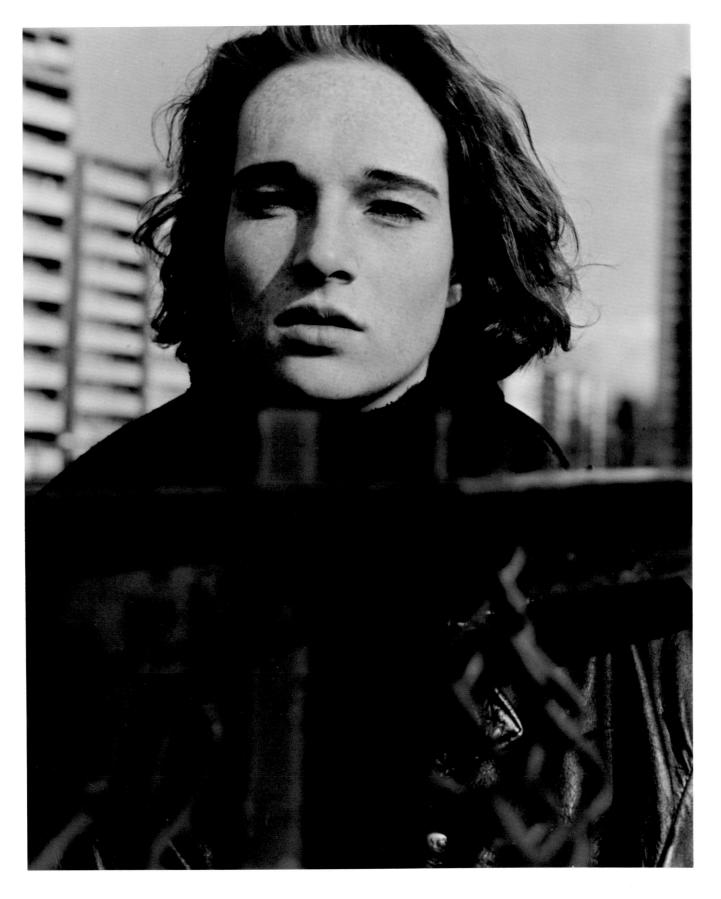

Untitled. 1989

him. This is obvious and cannot be denied. So it appears at a first glance, and it is no different on a second inspection. He strives for an objectivity that is as great as possible, not taking a position, no frivolity, no bravado, no playacting. So it is. But by being modest, Michael Schmidt is entirely true to himself. It sounds like a contradiction, but it is not. By pulling back, Michael Schmidt brings himself in closer. In each of his photographs something of himself is there. He looks at an object—at a wall, a barrier—and he recognizes himself. Nothing else. He finds that he belongs to the same world as everything that surrounds him and that his senses record. He is as much of this world as the objects that he sees. In this way, each of his photographs is a self-portrait.

A self-portrait with variations. A self-portrait, and yet, again and again, another face. Another face, and yet, the same world. Another subject in which he discovers the same thing. A new picture that is no different than what he has always seen. Michael Schmidt keeps striking the same note, and yet the tone is never monotonous.

Michael Schmidt always photographs the same thing, and it seems to be less and less. Michael Schmidt always photographs the same thing, yet he photographs it more and more honestly, more exactly, more succinctly than before. That is why it seems to disappear. The wall constructions that dominate with their rapport of gray and white, their uneven, granular surfaces, and the dancing light reflections. Are these wall structures not on the way to entropy? On the way to a final closure? On the way to complete obliteration? Surfaces of smooth cement, which cannot hold the concentration of the viewer, surfaces which have no focus. Roughly plastered walls with traces of mortar, of never-solidified clay. Everything is repeated endlessly. Everything becomes similar, resembles itself, and becomes silent, ceases to exist. These objects become indistinguishable, melt into each other, disappear. This path is irreversible unless it could begin again at the beginning in chaos. But who can get back to that?

It is worthwhile seeing what is yet to be seen. To see means to resist decay, disappearance, obliteration. Seeing begins as resistance. Seeing begins where there is nothing more to say. Seeing begins where there doesn't seem to be anything more to see. Seeing begins with the most inconspicuous objects. Seeing begins in photography. This is what Michael Schmidt's photographs, which speak of muteness, want to say.

While Michael Schmidt has his gaze fixed unwaveringly on reality, to wrest from that reality one more picture, he intends—even if it is only for a fraction of a second—to stop a process, to place himself for a moment against the decline of visibility, to press against it. Thus each photograph signifies a pause in history, an intake of breath, a ray of hope.

While Michael Schmidt directs his gaze toward reality, he acknowledges its disappearance. The longer he looks, the more reality fades, the more it must be imagined. Reality disappears, therefore the photographer must reinvent it. The autonomy of photography is based on the awareness that reality ceases to exist, that it will be less and less possible for us to grasp reality directly. Only indirectly, through the medium of photography, does reality come

back to life. However, even this life is only a reduced, limited one. Silence permeates everything, everywhere.

The autonomy of photography–that is a big phrase. Photographers tend to overemphasize it. The triumph of having their own reality–on the negative, in the print–this triumph causes them to overlook all too easily the umbilical cord that connects the reality of the photograph with its origin, the actual event.

I know no one who more decisively and more modestly deals with this concept of the autonomy of photography than Michael Schmidt. He does this so decisively because the reality of his pictures is the only reality that he recognizes and that gives him strength and stability. Or, more modestly, because he uses photography so moderately and justly. No fade-outs, no playing with focal distances or lighting, no technical tricks, no manipulation in the darkroom. Nothing but the view through the lens.

Let me say it again. Michael Schmidt directs his gaze toward reality, but in so doing, he comes up against the muteness of the world. This world, which presents itself to him, does not want to speak. A dialogue does not seem to be possible. This world turns away from any dialogue. It resists the gaze. This is where Michael Schmidt starts. This is where he is wide awake. This is where he gets all his abilities to work together. The experience of muteness tells him that which could have to be said cannot be said, not even in the language of photography. Each authentic photograph therefore speaks of this futility. This is Michael Schmidt's starting point.

By directing his gaze toward reality, he gains the certainty that the condition of muteness is initially a condition of the world, and it grips him and becomes his destiny. The world made Michael Schmidt the way he is. It determines and limits his possibilities of perception. Thus so, he must see it. The condition of muteness is beyond him, and therefore, it is an inevitable condition.

So, there is no way back. What remains for him to do is to record what exists, which is his experience of muteness. Language, whatever language, does not reach further. It only suffices to express one thing, muteness. So nothing else is left for him to do as his life's work but to document its inevitability. The seal of this inevitability is called photography.

Untitled. 1991

Untitled. 1991

Untitled. 1990

Untitled. 1990

Untitled. 1989

Untitled. 1990

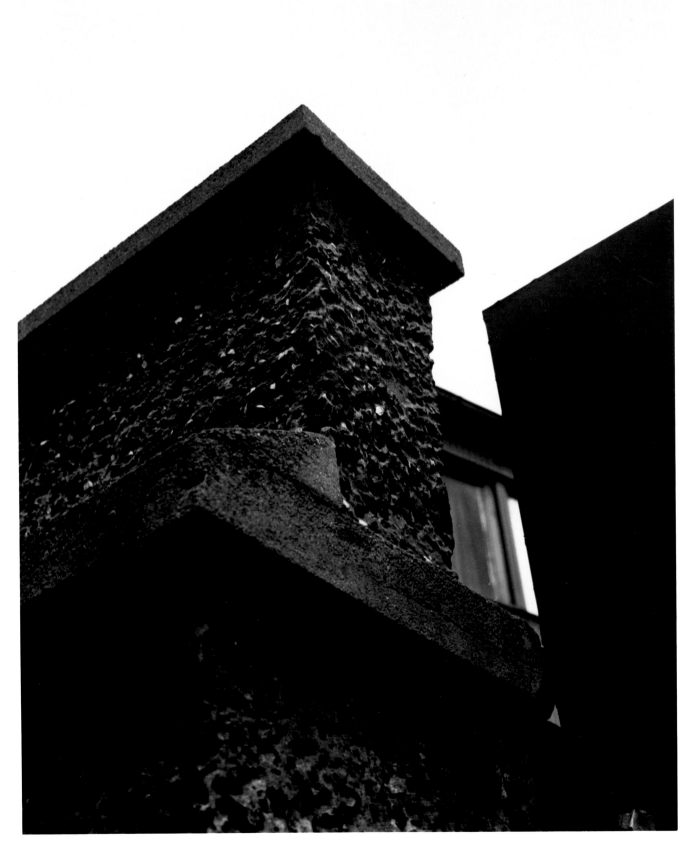

Untitled. 1991

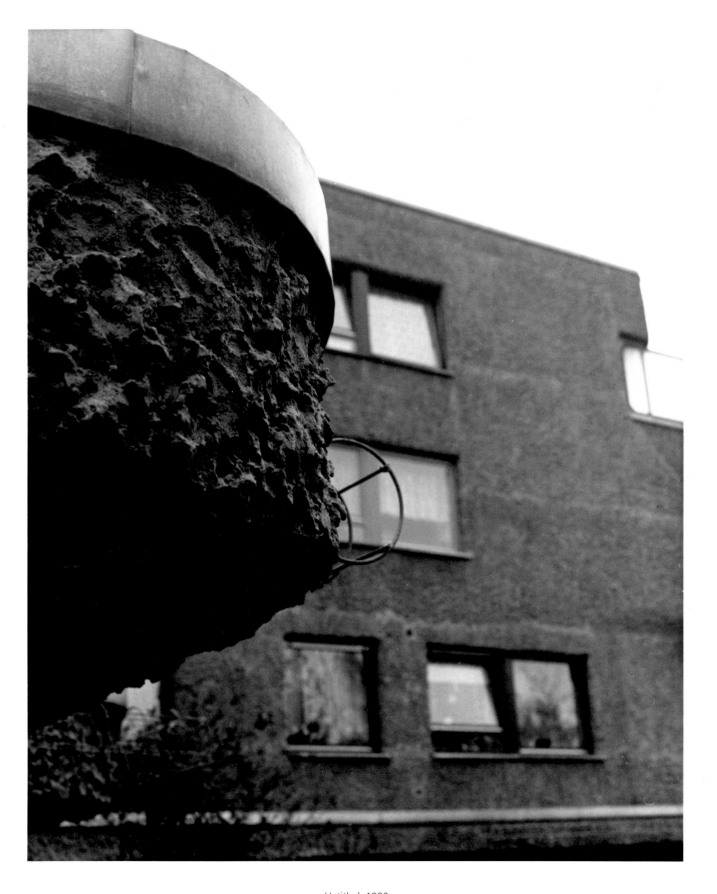

Untitled. 1990

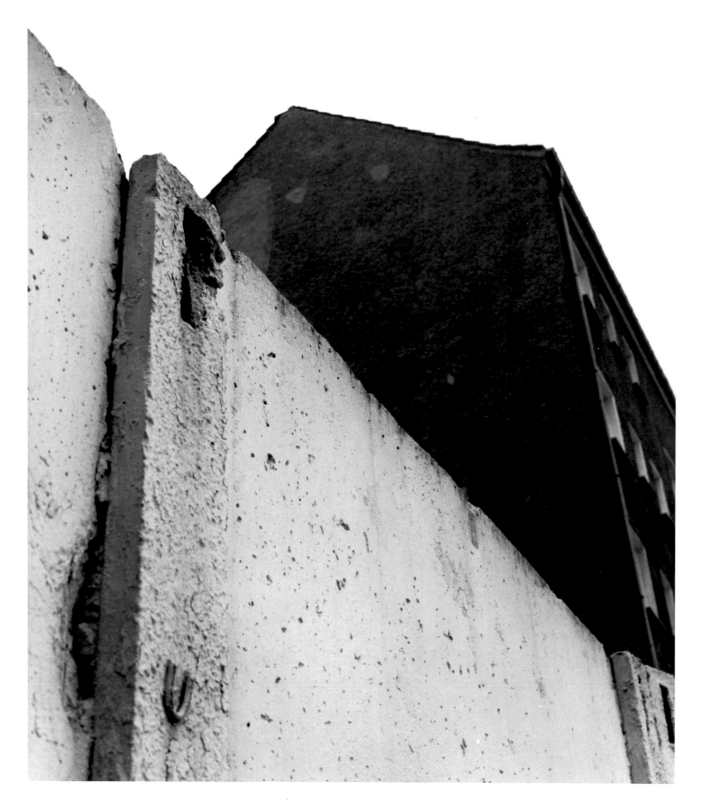

Untitled. 1990

EYE TO EYE WITH NOTHINGNESS

Boris von Brauchitsch

Thomas Ruff, born in 1958, started photography by taking stock of the interiors of his relatives' and acquaintances' homes in the Schwarzwald region of Germany, as a mirror of the personal life and living conditions of his parents' generation. Beginning in 1981, his oversized "Passport Pictures," which began to earn him an international reputation, depicted his own generation, soberly and devoid of any illusions. After the facades of faces came his photographs of the facades of houses, which, in their bleak banality, were a contrast to Bernd and Hilla Becher's topological work. Then came his almost intangible star pictures, which elude the viewer and can only be meaningful to experts. So Ruff's lens has zoomed from the individual out into the universe–"What a route! People–Houses–Stars" [1]–to find itself once again in the realm of the abstract.

A black field and many white points, marked with light. Ruff sees these points as countless, multifaceted pasts. "The light from one star takes four years to reach us; the light from another four million years. This way, we look back into different levels of the past.... The minute in which something was photographed becomes a part of the past." [2] The photograph, in a fraction of a second, freezes the present for the future and brings the past to the present in the future. The photograph is just as intended as the irritation that occurs at the boundary line between scientific recording and the poetic artifact.

Ruff bought negatives of star pictures from the European Southern Observatory and made monumental photographic prints (102"x74") only with the astronomical data for titles. Aside from the objective, investigative look of the research, however, the romantic gaze of man looking into the stars is always present as well.

His large-sized portraits and the photographs of houses and stars he uses to create an initially matter-of-fact, objective picture, an apparent copy of reality, of the surface of the exterior. The heads in his portraits look straight ahead, alert and serious, completely neutral. Ruff has always been suspicious of the profound character portrait. He is convinced that photography is only able to show one impression–though a subjective one–of the surface: matter-of-fact portraits of his generation, clear and detached. No more.

"We had read George Orwell's *1984* and were curious as to what would happen in 1984. In the seventies, the years of terrorist hysteria, professional bans, spying on prominent nuclear power opponents, being photographed by the police at demonstrations, we were really anxious about 1984." (Thomas Ruff)

Ruff's generation, the first generation of the computer age, has experienced a development that eclipses Orwell's utopia in its possibilities. At anyone's disposal is the potential for manipulation, supervision, and world-wide dispersion of information. The people portrayed

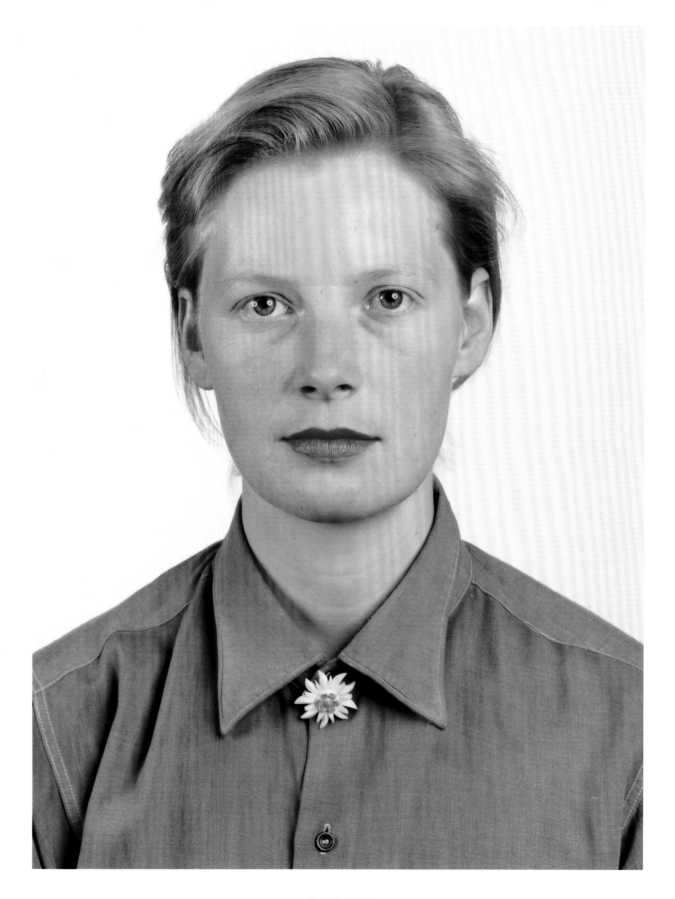

Portrait. 1988

in Ruff's pictures are left with nothing but the role of the alert, serious observer. Only their own positions can be concretely examined, only they themselves seem real.

At the same time the reality that Ruff depicts becomes subject to artificiality and manipulation. Influenced by the ideals of fashion models and omnipresent computer-animated fantasy worlds, one begins to adjust one's life and one's outward appearance according to this artificial reality. With the help of biology, surgery, and physical fitness centers, insufficient natural gifts can be corrected. The viewer almost has the sneaking feeling in front of Ruff's unvarnished portraits that the representations could be more authentic than actual reality.

When he was a student of the Bechers, he still believed in the possibility of objective photography, but he lost this belief while he was working on his portraits. What remains is the awareness of the possibilities of photography, which move fluidly within the overlapping territory between artificial arrangements and the documentation of reality. One of Ruff's concerns is to make people uncertain with his pictures, to create the most matter-of-fact photographs, apparently documentary in character, but images that are more authentic than their actual subjects. The intimate sharpness of the large portraits and the star pictures attracts us and makes it possible to zero in on the finest details, which, however, in the next instant can slip into abstraction and dissolve into its components. After these reflections, the next step was obvious for the photographer: the simulation of reality through synthetic images.

A digression: According to ancient tradition, the ambition of art to imitate Nature, and if possible to surpass it, had driven the painter Zeuxis to hire the five most beautiful maidens in the city of Croton as models for a picture of Helen [3], and the painter Raphael almost 2,000 years later, thought, "To paint one beautiful woman he would have to see several beautiful women." [4] According to this idea, the most beautiful parts of each model were to be used to synthesize an image of an ideal. With reality to look at, art can be created by adding the most beautiful segments of reality, an opposite world, an ideal world that could exist independently from the real world.

Since the invention of photography, and increasingly since photography has become accepted as art, the relationship between art and reality has slowly changed. Both planes now merge; boundaries become blurred; art appears to be truer than life; reality is more and more suspected of being a computer-generated reality. In his portrait series made in 1991, in which Ruff gave all his models blue eyes by computer editing, he pushed the doubt and insecurity that had manifested itself in his earlier portraits further, approaching an ideal norm coming from the realm of art. He realizes, with the help of a computer, Raphael's method of synthesizing a portrait and putting together the pictures according to an idea and his intentions. [5] Whereas Raphael complained that his technique was not practical "because of the lack of good connoisseurs and beautiful women," [6] Ruff, who is not interested in ideal

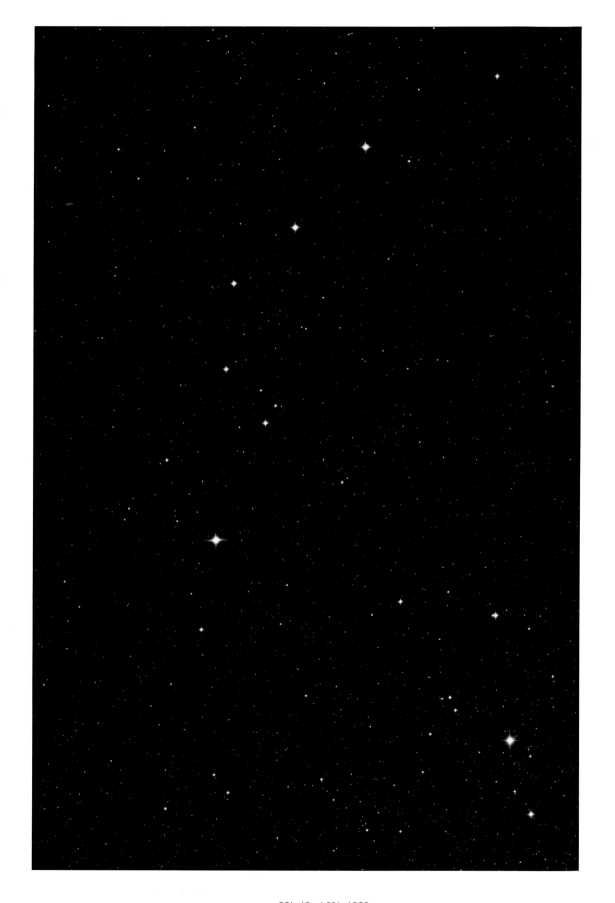

22h 48m/-60°. 1989

beauty, optionally combines objects from reality to create new people who can only exist in photography. It is precisely the alleged content of reality in the photograph that again leads to irritation. Though their apparent proximity to reality, the pictures are presented as virtual models for a reality, which thereby becomes an imitation of art.

The relationship of reality to the ideal worlds created by advertising, entertainment, and art, which appears more and more real, is carried to an extreme in Ruff's work. The computer age threatens to turn the classical dependence of art on reality upside down.

His series of house facades are also pseudodocuments of a merciless, ugly architecture. They are primarily photographs of houses, factory buildings, and warehouses from the 1950s, 60s, and 70s, from which the photographer has in part cleared away disturbing elements – telephone poles or trees – that in fact dominated the pictures. The photographs often appear purer and clearer than the actual subjects. "I was not interested in an authentic representation, but in a photograph which satisfied me formally,"[7] Ruff said.

Ruff's most recent photographs are night pictures, in which he no longer makes any secret of their artificial character. Shadowy, bathed in green, artificial light, he photographs backyards and deserted streets. The "Osram Age", according to Ruff, begins to conquer the most remote places. The technology used in the Gulf War inspired him to create these pictures. Surveillance and the ensuing destruction had reached into the most remote corners of the world. The military and the media made use of night vision instruments to track down everything. For Ruff, the greenish night pictures seen on television became metaphors for the voyeurism of the western television consumer.[8] Each place can be appropriated and is thereby potentially a place for a crime.

The circle is complete. Surveillance has become normal. Only uncertainty remains, uncertainty as to whether it is cleverly staged or only effectively documented. Artificiality is so convincing that it appears to be a natural component of the pseudonaturalistic pictures of Thomas Ruff. Reality is presented as a mis-en-scene, and the viewer is forced to ask himself whether he is not living his life within a computer-animated environment. The mis-en-scene and the document can no longer be separated from each other.

[1] Jean-Christophe Amman, "Thomas Ruff," in *Dorothea-co-Stetten-Kunstpreis* 1990 (Kunstmuseum Bonn, 1990).

[2] J Thomas Ruff, "Reality so real it's unrecognizable." Interview with Thomas Wullfen in *Flash Art*, 1992, pp. 64-65.

[3] J Ernst Gombrich, *Ideal und Typus in der italienischen Renaissancemalerei* (Opladen 1983), p.8.

[4] Ibid.

[5] In this case the series is an ironical reaction to the criticism that Ruff would show the future youth of Germany in "nationalistic aestheticism."

[6] Gombrich, *Ideal und Typus*.

[7] Ruff, *Flash Art*.

[8] Ibid, p.67.

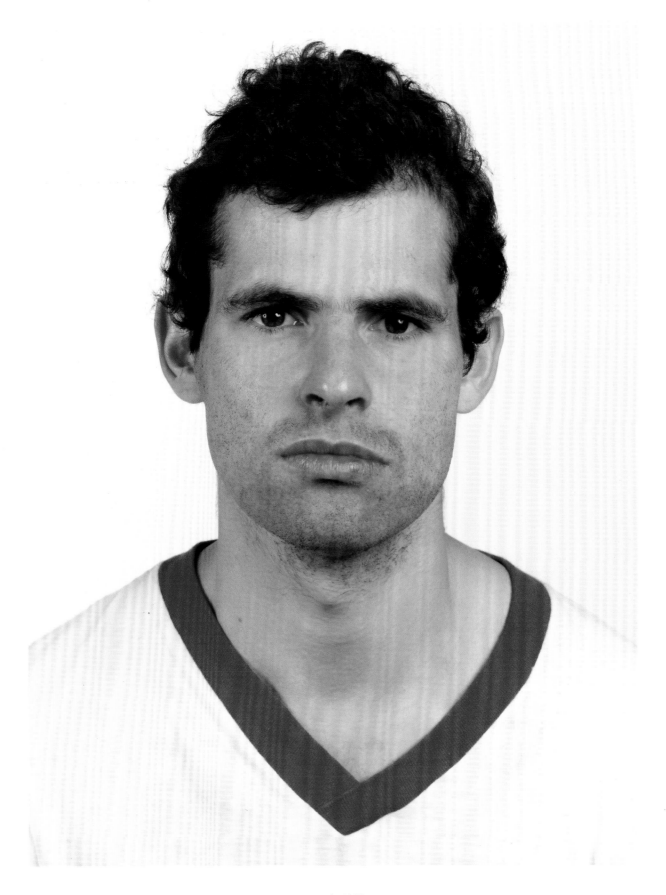

Portrait. 1988

16h 30m/-55°. 1989

Portrait. 1988

11h 54m/-20°. 1989

Portrait. 1988

11h 12m/-35°. 1989

SHARED TRUTHS

Robert Adams

Judith Joy Ross has, as an artist, no formula. She starts over again each time – the riskiest way to do it.

She has a style, of course, but it is austere. It cannot, if she panics, be used to take the place of content.

Photographer Diane Arbus said that when she stood in front of her subject she wanted to accept it as it was. "Instead of arranging it," she said, "I arrange myself." Ross's approach is like that, except that occasionally, on the evidence of the peace in some of Ross's photographs, she may enjoy an even wider freedom – to arrange neither the subject nor herself.

Ross's work is beautiful in its transparency. It reminds me of lines by Keizan, translated by W. S. Merwin:

The water is clear all the way down.
Nothing ever polished it. That is the way it is.

Ross's method promotes this clarity: she uses a view camera, which because of its size makes openness necessary in dealing with people, and she prints by contact, which results in the subtlest possible rendition of a negative.

What is it that we see, free from distortion? In spite of the smiles on many of the children's faces, we understand from her pictures that the nature of life is suffering. The children are beginning to sense how exposed they are, and to feel the pain in that.

They only know their condition a little, however. It is the photographer who knows it enough to discover the picture. Just as one recognizes innocence only after losing it, so one understands vulnerability best after experiencing it.

The photographs are a record of compassion, of shared suffering. We observe it in the sympathetic identification that brings Ross to her work, and in the childrens' tentative smiles, their brave impulse to trust her, to sense themselves in her.

It is a bond that, by its nature, even includes us. We take hope from it.

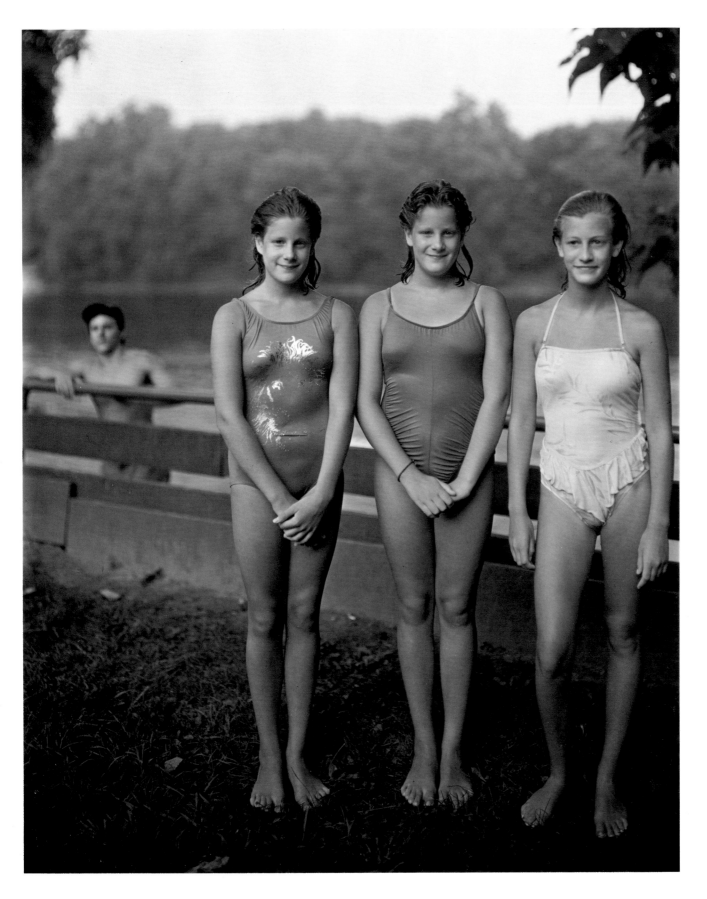

Untitled. From the Series "Easton Portraits." 1988

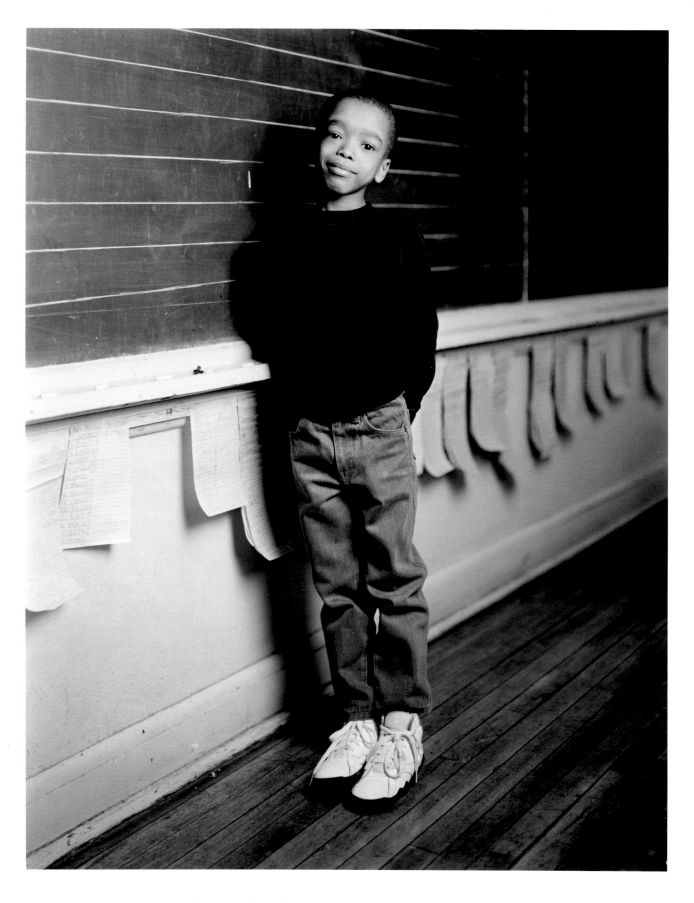

Brandon Brown, Almira Elementary School (First Grade), Cleveland, Ohio. 1993

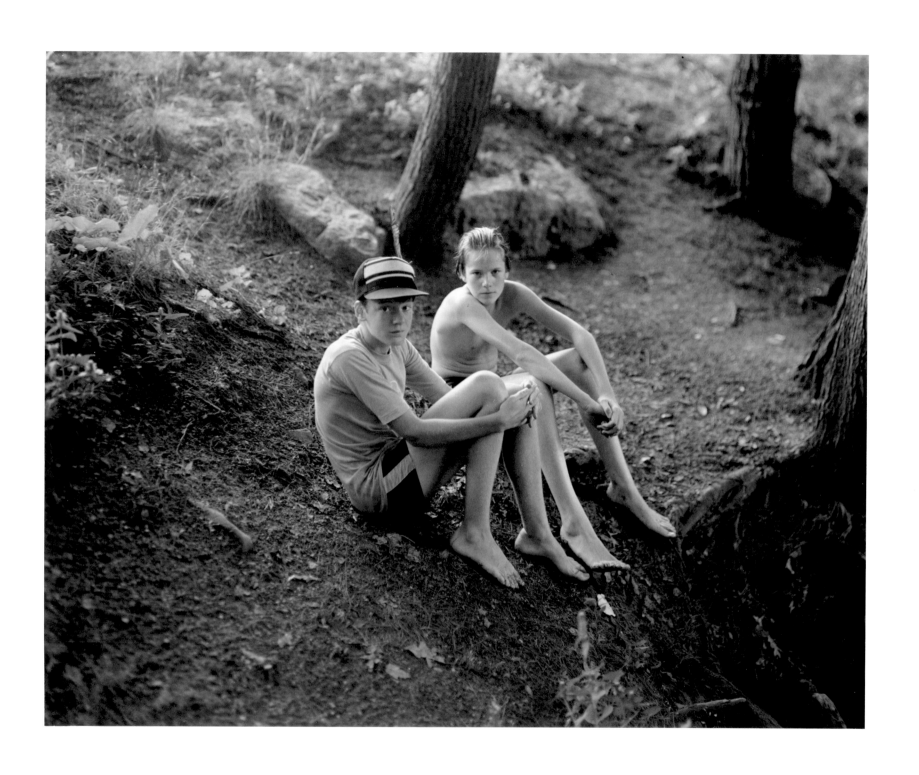

Untitled. From the Series "Eurana Park, Weatherly, Pennsylvania." 1982

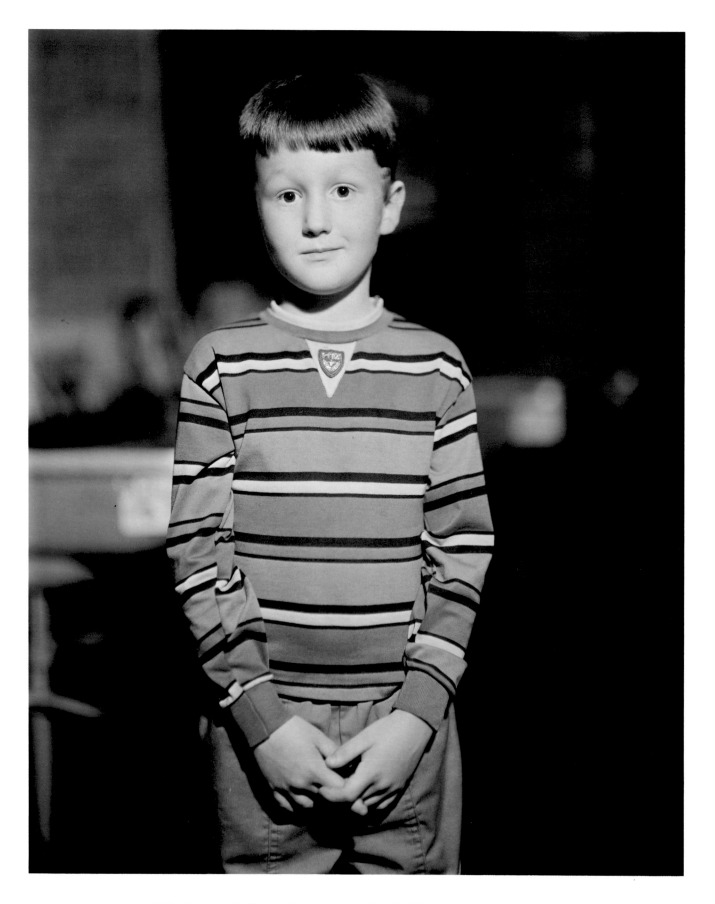

Michael Bodner, A.D. Thomas Elementary School (First Grade), Hazleton, Pennsylvania. 1992

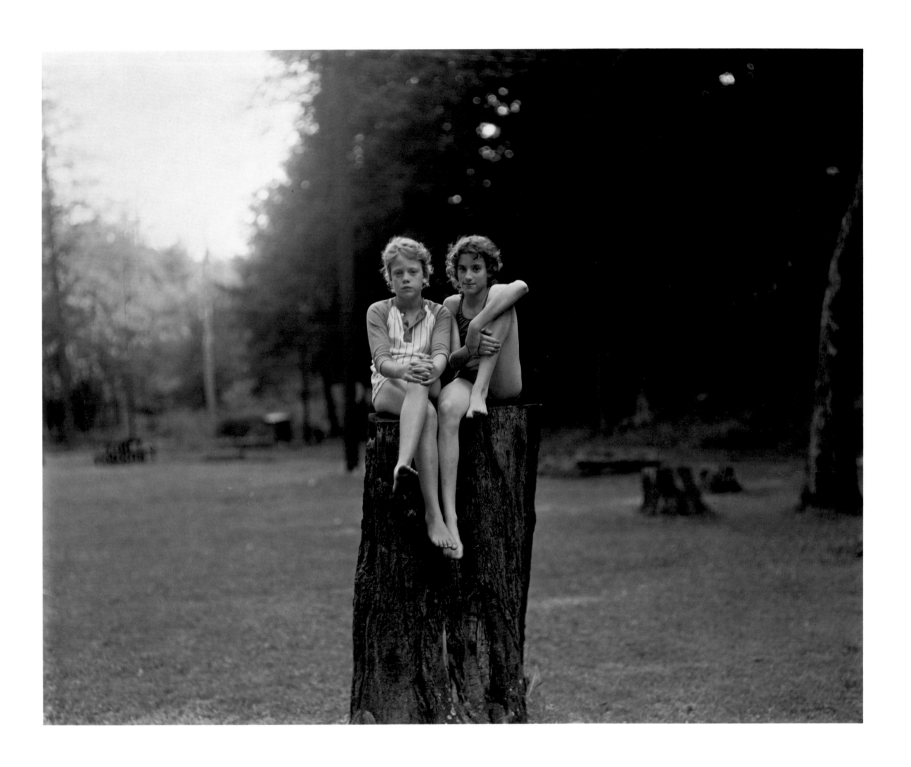

Untitled. From the Series "Eurana Park, Weatherly, Pennsylvania." 1982

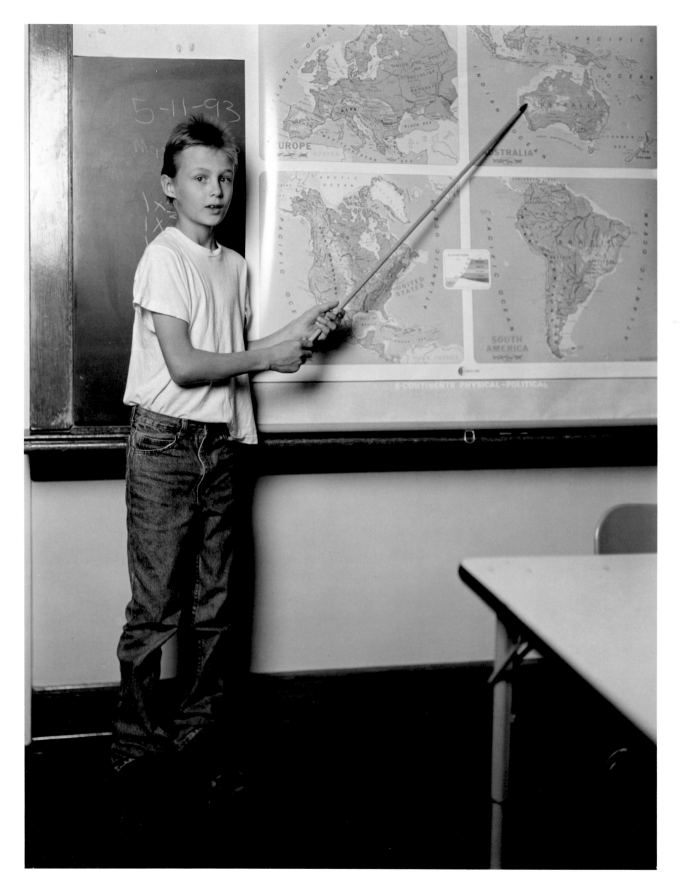

Alan Bredbenner, A.D. Thomas Elementary School (Fourth Grade), Hazleton, Pennsylvania. 1993

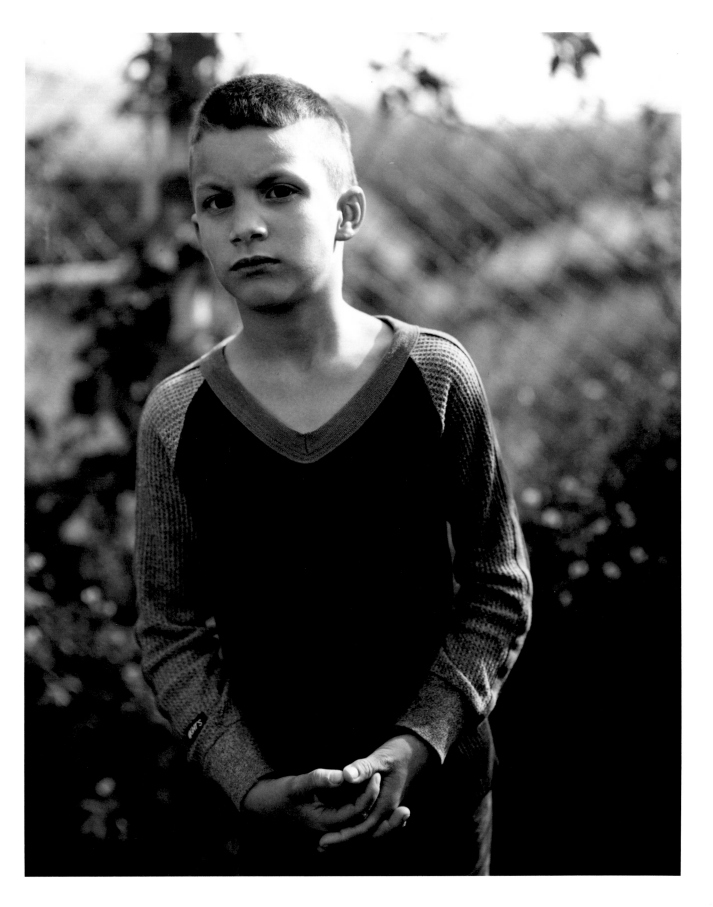

Untitled. From the Series "Easton Portraits." 1988

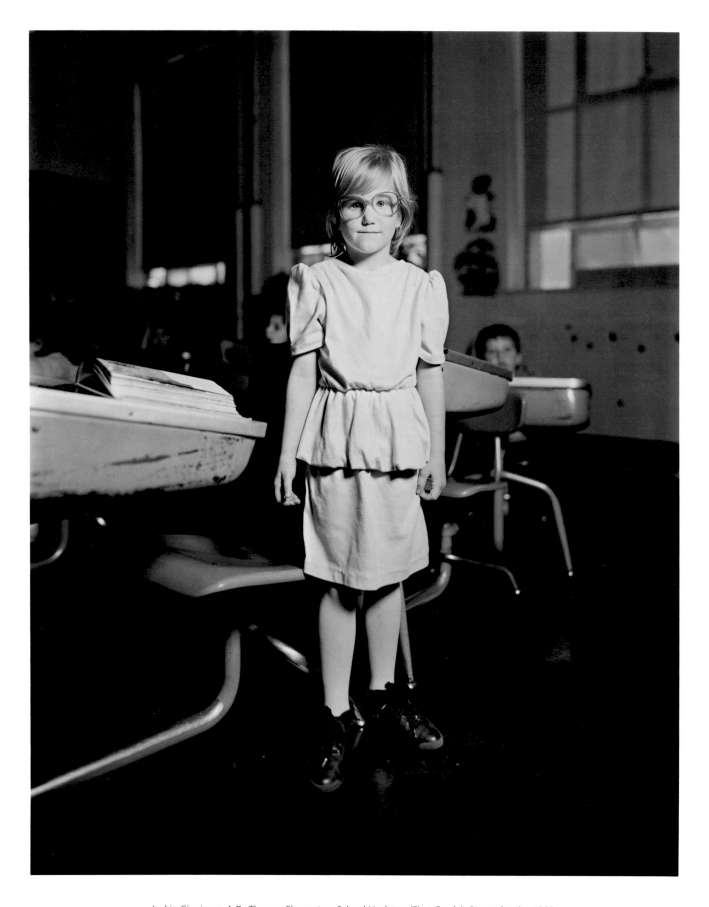

Jackie Cieniawa, A.D. Thomas Elementary School Hazleton (First Grade), Pennsylvania. 1992

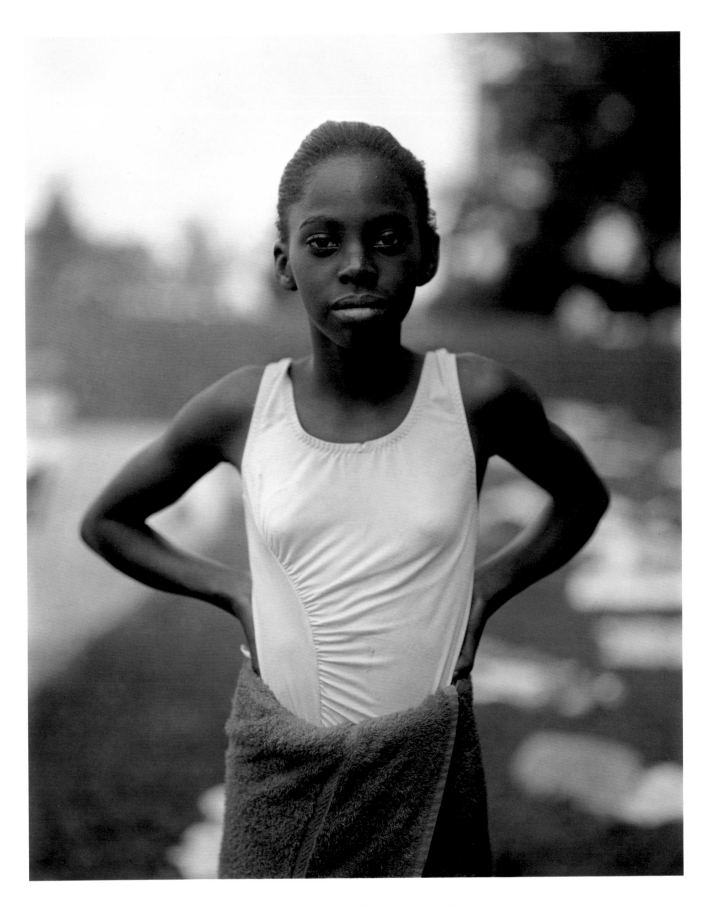

Untitled. From the Series "Easton Portraits." 1988

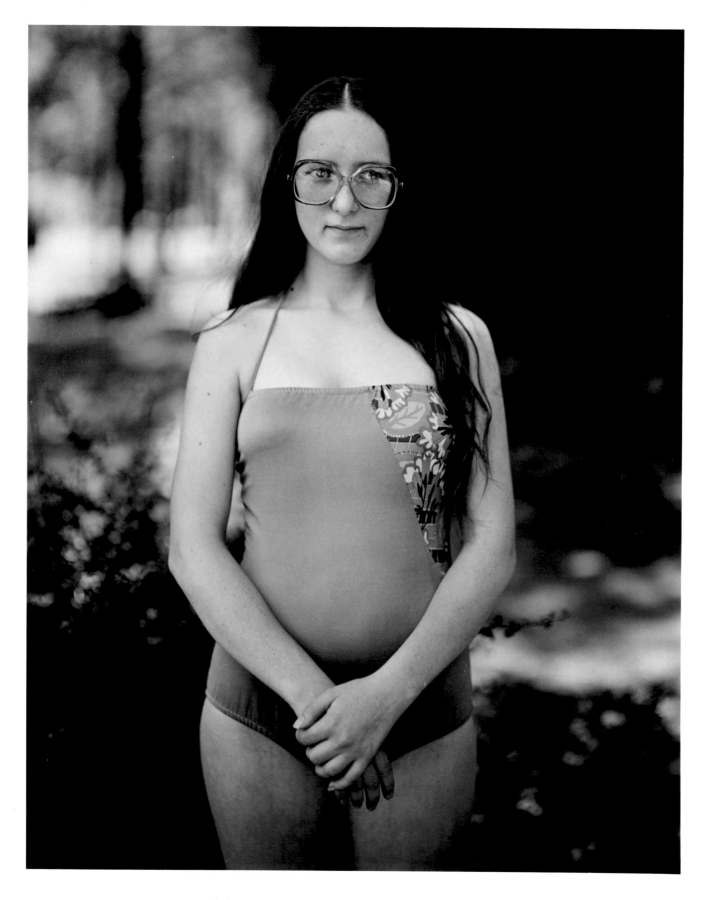

Untitled. From the Series "Eurana Park, Weatherly, Pennsylvania." 1982

ACCEPTING RESPONSIBILITY

Gertrud Sandqvist

The witness testifies to what is being said through him. Because he has said, ['H]ere I am!' in front of the Other, and because he recognizes the responsibility which rests with him in front of the Other, he discovers that he openly shows what the Other's face means to him. The glory of the Eternal is revealed through that which manages to evoke life in the witness.

Emmanuel Lévinas, *Ethics and Eternity*

Photography is a testimony. In its simplest form, a photograph shows that *someone was there*. Someone who stopped life's ongoing process of becomming , who elevated certain moments above others. The French philosopher Emmanuel Lévinas bases his philosophy exclusively on the face of *the Other*. He talks about the face as a meaning without a context, as ultimately exposed and vulnerable, as inviting violence, and, at the same time, forbidding us to kill. It is through the face that one meets humankind's humanity, a humanity that has been interrupted. And it is through this recognition that a responsibility is formed. In turn, this interaction involves what is called inspiration, a unique moment when relationship between I and the Other is reversed – the breath of intimate insight.

Lévinas parodies Dostoyevsky: We are all responsible to everyone, in everything, and I more than all others. The photograph, as a testimony, means that somebody has taken responsibility for preserving the image of the Other, as if pictures are proof of human dignity, through the poverty and vulnerability of the face. Pictures carry out the original assumption of responsibility: Thou shalt not kill!

Per Maning makes his testimony through animals. His first major series of photographs shows not just any dog, but his Labrador retriever, Leo. From being documention for a manual on dog care, the project soon takes a turn to become a testament to Leo's animal "persona", a "person" as vulnerable as a human, with a look that like that of a human – forbids and invites domination.

Per Maning's photographs of Leo do not document a topology, nor is he interested in transforming Leo into a human being. To do so would mean using superior force and humili-ation, with the photographer making an assault on the animal's character. On the contrary, time and again, the viewer is struck by a feeling that the photographer has subordinated himself to Leo, and we are reminded of the origins of the word "subjectivity." "Sujet" means subjected, the subjective is subjective for someone else. It is this subjectivity that forms the condition for inspiration, the fantastic moment when I and the Other change places, the moment that stops time and gives purpose to existence.

The suite of Leo photographs is a testimony to great love. Every strand of hair in the dog's black coat is precious, each movement, each shift of light and shadow matters. Leo

runs, swims, plays, rests, and sleeps. But above all he *gazes* straight into the viewer's eyes. Leo becomes *the Other* through his gaze, and Per Maning meets his responsibility to his subject by taking great care at every stage of the process which produces the pictures of Leo. Thus, Per Maning's photographs do not deal with aesthetics as a matter of style. He does not emphasize his own presence or the photographic process using the various props at the photographer's disposal. Each camera angle is determined by Maning's love for Leo, a love that verges on obsession, but is prevented from becoming all-consuming by the way Leo is turned into an object. His gaze is always there to meet our own.

On the contrary, Per Maning underplays his own role as much as possible by using black-and-white photographs carefully printed without aggressive cropping, without manipulating either the negatives or the prints. The only indication that the project is documentary photography is that his pictures actually show nothing other than the fact that Leo has lived and that he continues to live for those who were with him, for the witness who can demonstrated that, "I am here."

Per Maning's photography represents an ethic in that it demonstrates an acceptance of responsibility. His choice of the gaze is not the aloof, appraising one, nor one that registers things automatically. By choosing empathy – or rather by letting himself be chosen – Per Maning's photographs become images of the body of *the Other*. And the gaze becomes the enigmatic point that reminds us of our infinite aloneness. Here the two meet. Just this far, but no further.

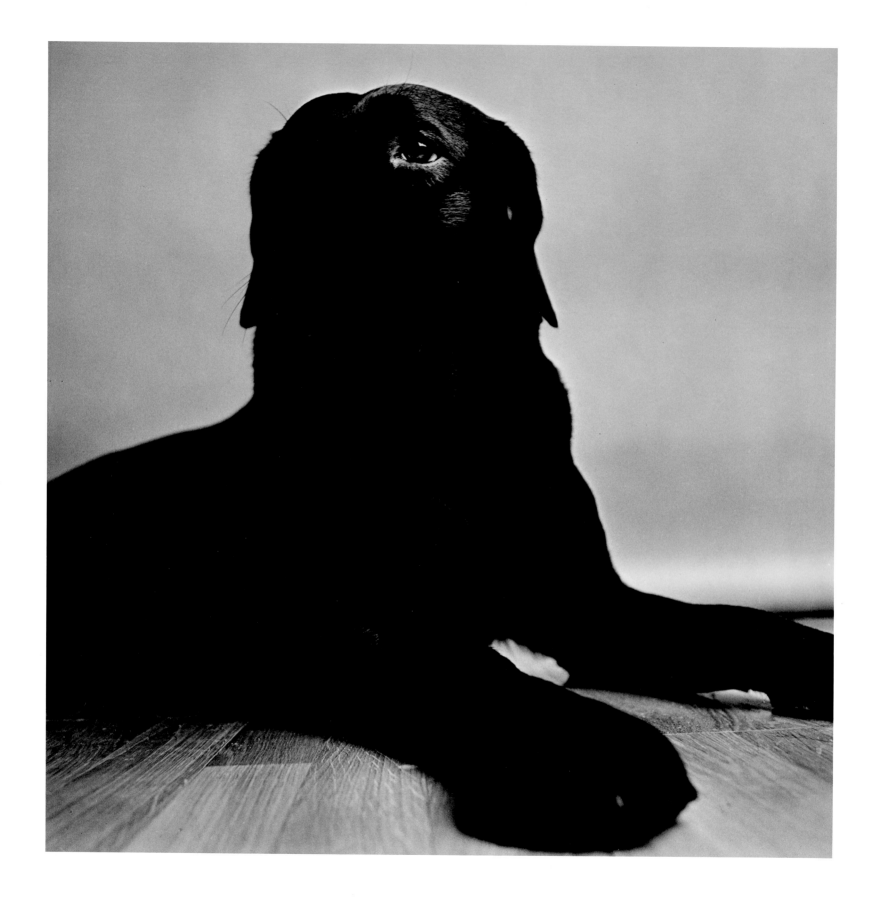

Leo. 1986

Untitled. 1986

Untitled. 1988

Untitled. 1989

Untitled. 1992

LIKE A WELL-FED BY UNDERGROUNDS STREAMS...

Hanne Holm-Johnsen

A scene in a simple room: sparsely illuminated, a man kneels in front of an equestrian figure. In one hand he holds a bunch of herbs as an offering – the other hand stretches forward in greeting. The equestrian figure – Santiago or Saint James – is dressed in the garb of the conquistadors and is seated on a rearing horse. The apostle, who is the pilgrims' patron saint, was adopted by the conquistadors as their patron. His name became a cry to battle and a symbol of power. Even though the kneeling man is twice as large as the horseman, it is the equestrian figure that represents power. The kneeling man has the dignity. In another photograph from Temalacatzingo in Mexico, where women and children carry burning candles and incense in a procession, the Santiago figure is large and dominant in the background and almost supplants a crucifix.

Flor Garduño's photographs tell us about a culture which exists at the intersection between pre-Spanish/Indian identity and Catholic-European influence. It is a reality, that for us, is unreal. A new reality is created with her photographs. I am looking at what I *believe* happened in Sauta, Bolivia, one day in 1990, or in Temalacatzingo, Mexico, one day in 1987, the specific locations and dates for these two pictures.

Like no other pictorial technique, photography is a communication medium. The relationship between seeing and knowing is the crux of the European-Western theory of knowledge, with roots that go back to the Renaissance. This belief in, and need for, knowledge seems to have become perfected with photography. But this belief is really a great delusion, a delusion more difficult to see through than most other delusions. For photography has, from its beginning, dealt with the illusion of reality and the reality of illusion.

Photographic technique creates a picture that on one hand is a "trace" of the world and on the other hand, is a real, tactile object. Photography has certain characteristics in common with the visual world and a potential significance just as rich, but it nevertheless represents something, is an abstraction, a code.

A photograph gives us a set of codes, like a verbal text, but if we are not familiar with the language, we cannot read the text. This also applies to photography. Photographs must always be understood in their historical and cultural contexts, because few codes are universal, most are conditioned by culture. We can believe that we understand a picture's meaning, while we only sense its depths. The pictures of Flor Garduño from Sauta and Temalacatzingo are examples of this.

In these pictures, Flor Garduño's compositions help us understand that Santiago and the conquistadors are important in the consciousness of the Indian-Mexican, but also makes clear that we cannot know their significance or context. We can only sense them through her pictures.

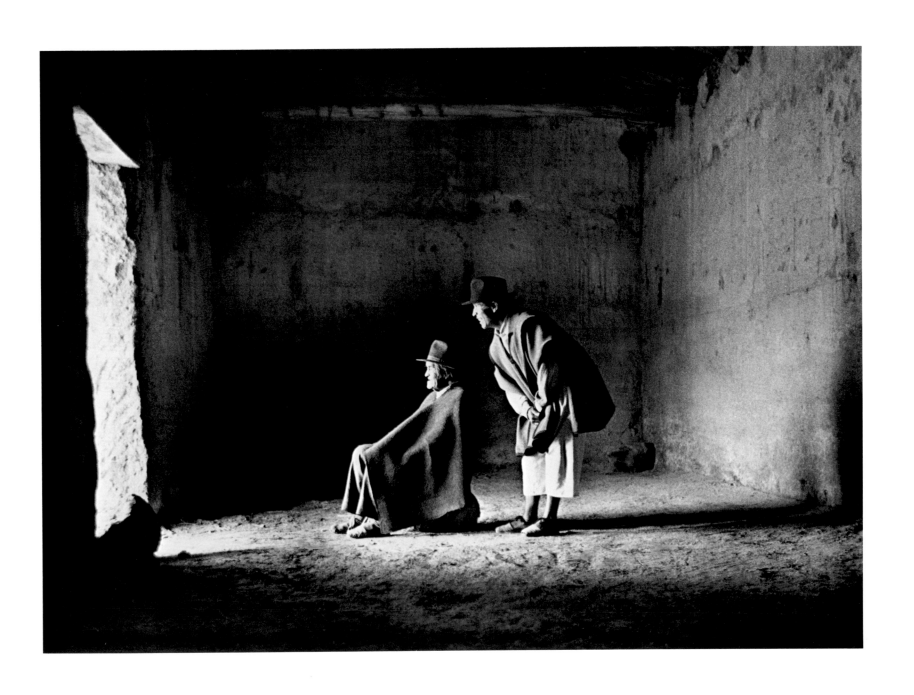

Taita Marcos, Cotacachi, Ecuador. 1988

Flor Garduño makes it easy for the uninitiated in that she uses a photographic language which is international. She works in a documentary manner without forcing any pictorial style. As much as possible, she allows her motives to dictate her composition. In this way, she emphasizes certain interests by placing them in the center of the picture, while others are brought forth by their sharpness or how she lights the picture.

Another central theme in her work is the idea of sacrifice and prayer. The pictures "Yatiri" (The Medicine Man), "Isla del Sol, Bolivia," 1990, and "Offering: Llama Foetus, Isla del Sol, Bolivia," 1990, show us rituals that have roots before the Spanish-Catholic invasion. Flor Garduño does not only tell about an exciting meeting place between people, but also between unproductive and fertile nature. A nature where sacrifice is a daily phenomenon. Both voluntary and involuntary. "Return to Earth, Sololá, Guatemala," 1989, communicates about sacrifice. Here the Indian vision of the world is evident and leaves its mark on everything. The Indians do not distinguish between living and dead things, as one does in European culture. For Indians everything is alive, and everything has its own personality and force. The earth we stand on is the very skin of Mother Earth, the source of all life. Life can only be seen in relation to death. Therefore death is not a threatening end, but a necessary stage in the creation of new life – a totally positive element.

The photographs of Flor Garduño show realism as an inescapable fact. But from our Western standpoint, her pictures often exude a surreal character; which is found in Latin-American literature. The meeting ground between Indian and Catholic thinking becomes a stage for contrasts and integration, which for those uninitiated can be exciting and thought-provoking, but always strange.

Octavio Paz wrote the Indians were the skeleton of Mexico, while Elisa Ramírez Castañeda, in her epilogue to Flor Garduño's book, *Witnesses of Time*, compares the rise of Indian culture in the Americas with a well fed by underground streams. Common to both of them is the emphasis on the significance of wholeness. Flor Garduño conveys this wholeness through the nearness in her pictures. Her Indians provide the "real" world with a perspective. The world of possibilities is extended. We get a chance to stop for a moment, to listen, and to discover something which may have relevance for our lives in an entirely different place.

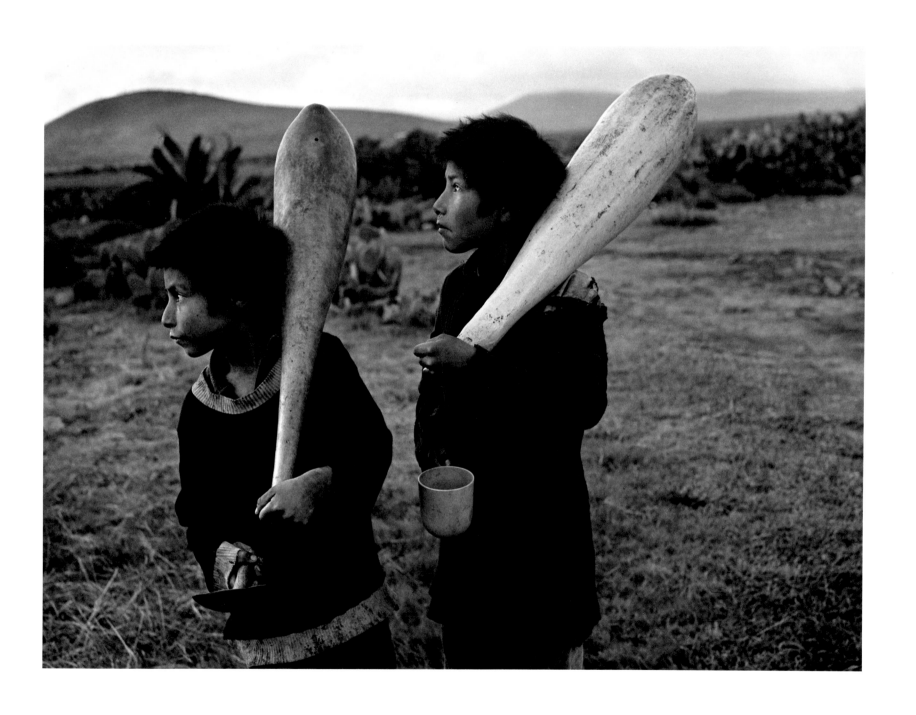

King of Canes, Tulancingo, Mexico. 1981

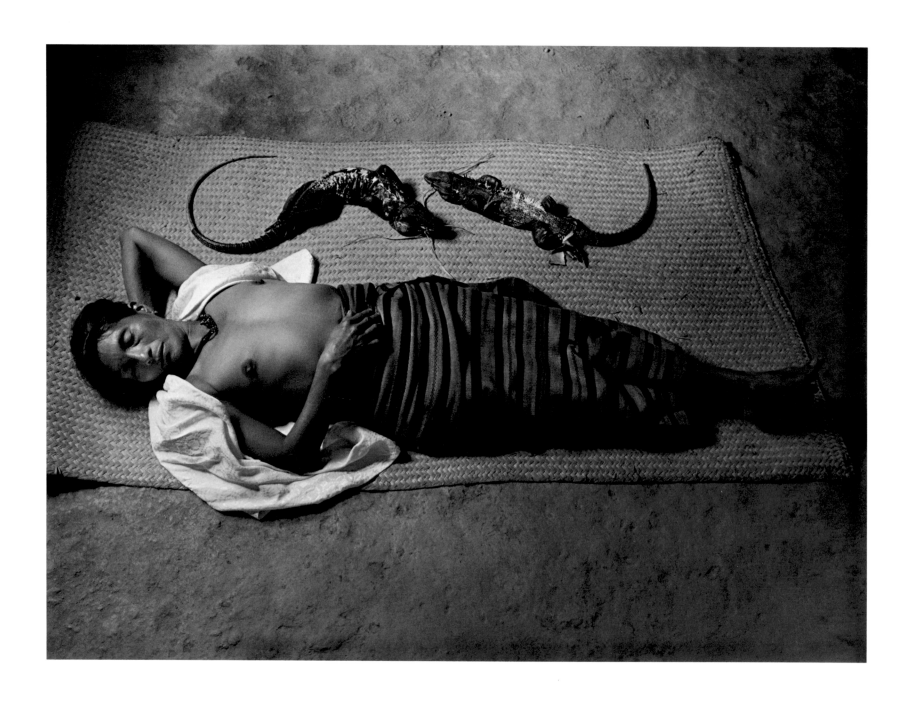

Dreaming Woman, Pinotepa Nacional, Mexico. 1991

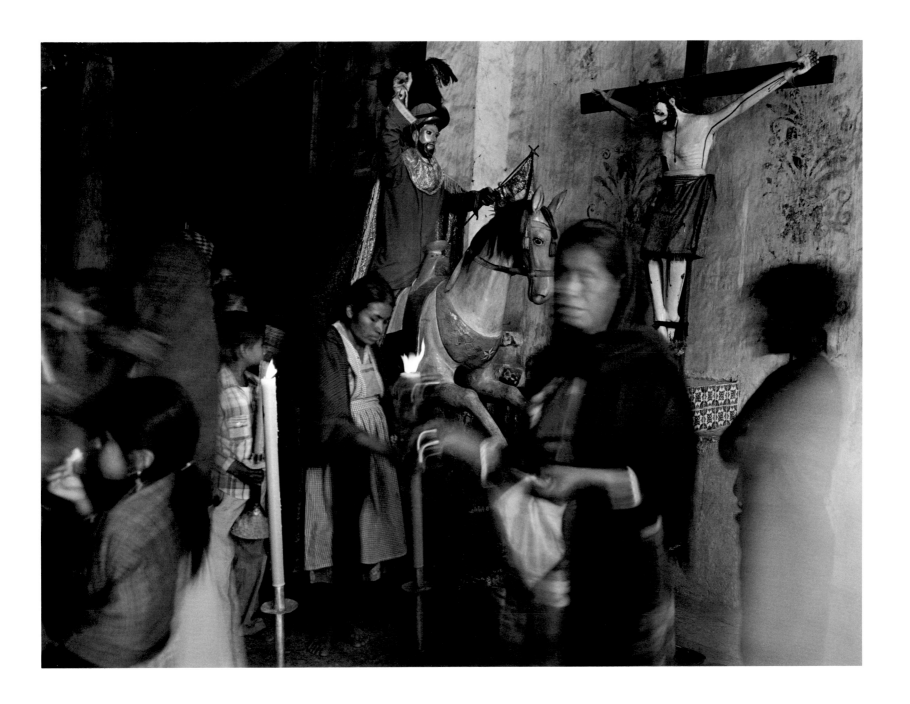

Santiago, Temalactzingo, Mexico. 1987

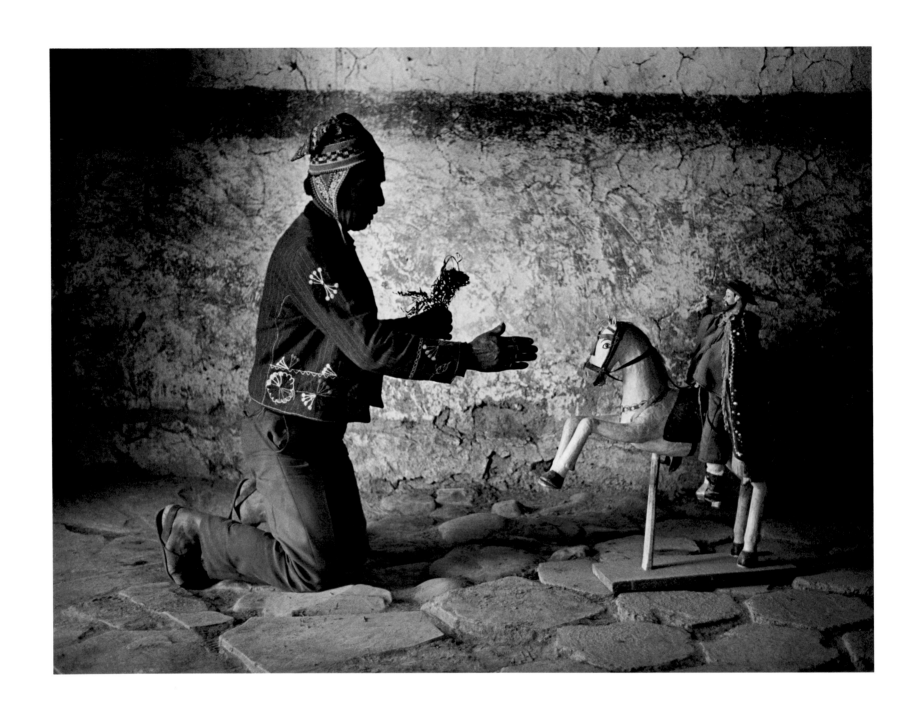

The Lightning, Sauta, Bolivia. 1990

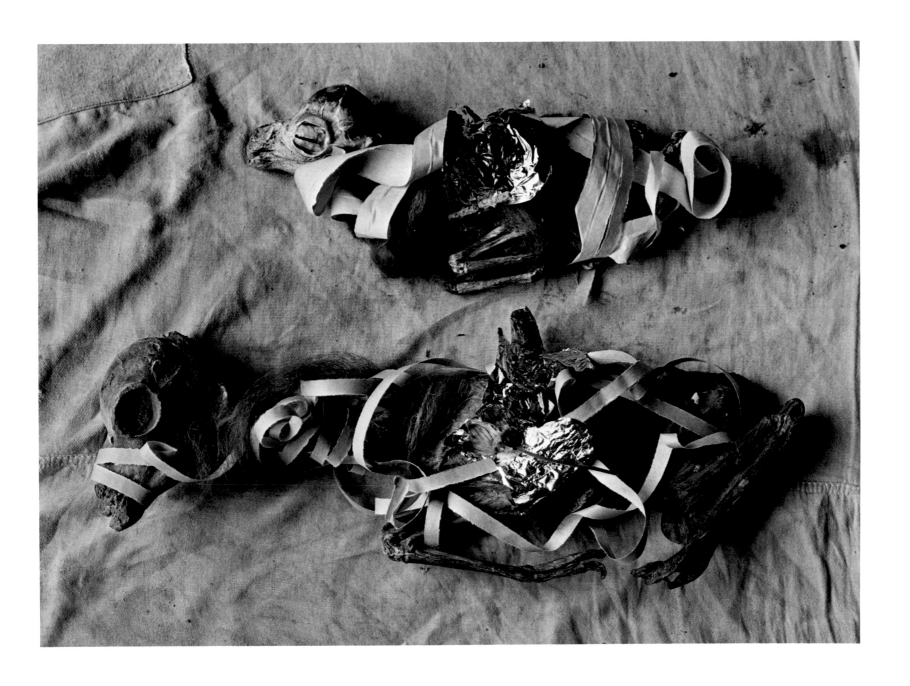

Offering; Llama Foetus, Isla del Sol, Bolivia. 1990

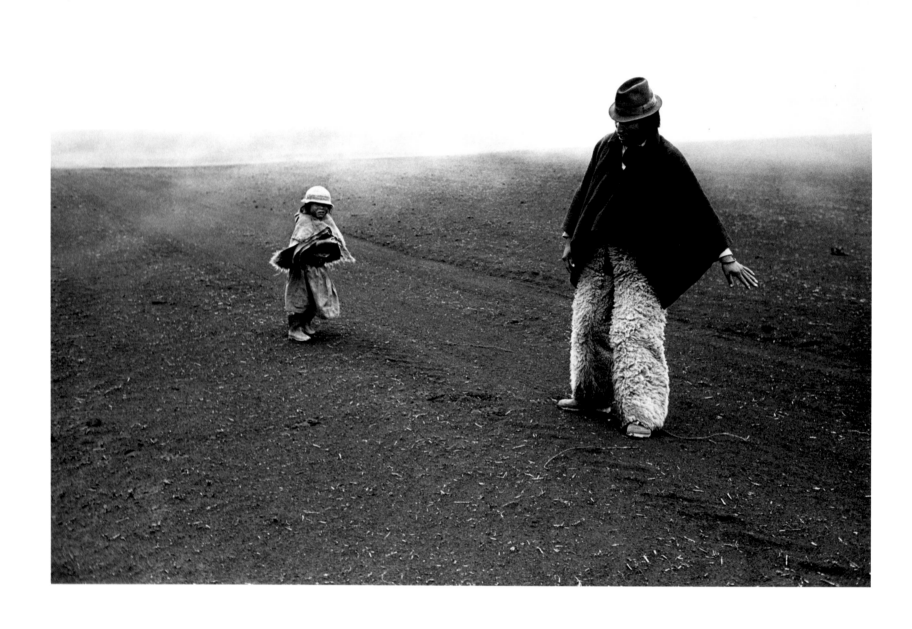

Just here, San Carlos Chuquera, Ecuador. 1991

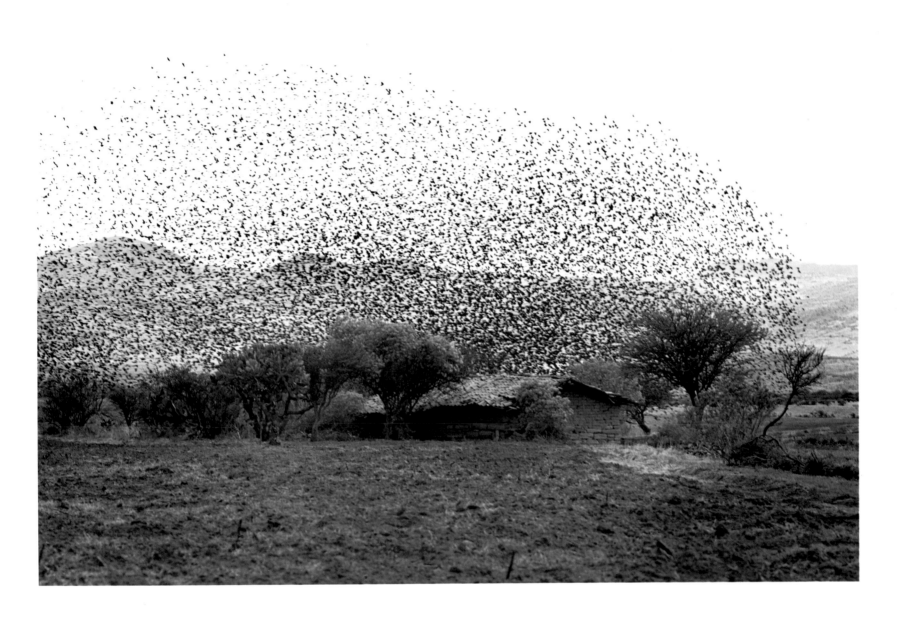

Cloud, Jocotitlán, Mexico. 1982

Return to Earth, Sololá, Guatemala. 1989

SHOMEI TOMATSU

REALITY IN RUINS
Toshiharu Ito

Writing without a fear of being misunderstood – Shomei Tomatsu's ruins are beautiful. The Uragami Tenshudo church, destroyed by the bomb blast; the remains of the Toyokawa Navy barracks, where light and darkness exist together; a ragged passport photograph, marred by rain, wind, and nails; the fresh debris of houses washed away by a typhoon in Ise Bay; broken, plastic fragments on a dark beach; an old, discolored, peeling map of the abandoned Ashio Copper Mine; the collective beauty of cherry blossoms just before falling. All of these ruins that Shomei Tomatsu photographs are amazing. One feels as if one were temporarily viewing a piece of stained glass, floating in a deep, dark blue universe, and forced to ask if ruins aren't the best subject matter for a photographer.

Tomatsu's photographs of ruins are about three kinds of time. They are about the time of the instant in which the photograph was taken; the time that preserved the homogeneous structure of the subject before it changes its quality, discoloring, cracking, or corroding; and that very distant time, which passes through the light and smoke of the ruins. In Tomatsu's ruins, time doesn't progress in a straight line. His three layers of time exist together, sometimes stopping, moving backwards, subtly mingling. Time is multilayered, tied together in a kind of montage. His photographs of ruins embody the process of creation and destruction and the crevice that exists between insanity and normalcy. And in his vision, the ruins are independent of their relationship to specific places in postwar Japanese history. The passage of time is symbolized in the changes in the material in his pictures. He confines time by recording the intensity of that instance between adventure and memory, which is kept alive by a strong and continuous historical consciousness.

It is too easy to write that Shomei Tomatsu's style of photographing ruins reveals his skepticism about our materialistic civilization, or that it is a means of opposing the acceleration, mechanization, and modernization of urban space. Instead, he devotes himself to reality as it changes, and he wants to photograph how we might retrieve our will to accept reality again. I would like to believe that it is essential today to treasure what is disclosed by Tomatsu's point of view, because whether we view his photographs of the atom bomb or of debris on a beach, we are responsible for holding onto a feeling for History and Time, and not just seeing them as frames in a passing, superficial flow of images. If one doesn't think about how Tomatsu's ideas relate to oneself by halting the nonstop relay of image after image, under which human emotions are buried, then even if one is still able to understand the photograph as a perspective of space, a temporal factor reminding us of reality, we will be rendered ineffectual.

Untitled. From the Series "Plastics." 1987–89

In his approach to photographing ruins, Tomatsu has not rejected traditional photojournalism, but rather has taken up documentary photography in a more extensive, more difficult, more tenacious form. His photographs make the present vividly transparent by disturbing our power of imagination about his ruins. His ruins merge with reality and break the law of the present, boldly spreading and amplifying the beat of life.

A melted beer bottle, which looks as if inorganic matter is changing into organic matter; screws, springs, and rings scattered about in the dark; the withered remains of a frog, which have assimilated with the sand and grass; a refuse dump where an abundance of empty cans undulates in white smoke; a gloomy underground room empty of occupants. These are subjects that bring the viewer to a vivid, real world of phenomena and make him recognize a way of being conscious of the present, by seeing what is there and preparing himself for *being* in the present.

Shomei Tomatsu has written: "In short, it is a matter of turning loneliness into thoughts," but really what his growing collection of photographs tells us is, "In short, it is a matter of turning *ruins* into thoughts." Photographs of ruins are *actually* the ruins of matter, which are recorded as they change. Just like the details of the ruins before the camera, the physical photograph is something that praises the tension, the battle between life and matter, and makes it reappear. Photographs *as* ruins and the ruins *in* the photographs overlap. When the new feeling for time emanates, the ruins are not the carcasses of destruction and devastation, coffins or symbols of death, instead they move us toward life. This means turning ruins into thoughts, being familiar with the effective use of the camera by asking questions like, "Why?", and "For whom do I take these pictures?", and "Why do I approach reality with a camera at all?" Throwing the camera away and dodging reality, questioning reality becomes possible only when one reaches the limit of the progress of photography as a means of expression. It becomes a vector that destroys the inner pattern of the photographer, and that, within a public relationship, tries to recover a personal interpretation of History.

One must affirm that Shomei Tomatsu's reports, with their unique and strongly infectious power, cannot materialize without the strict understanding of the statement: "Photography means releasing oneself from one type of gravity and placing oneself in a space where a different force is trying to move you." More than anything, Shomei Tomatsu's photographs form a tension against relentlessly advancing time. His pictures relieve this struggle for an answer to the question of *how* we might live.

The ruins go round and round in Shomei Tomatsu's head, forcing their way through the impurity of our present space to discover a serene place. The unbounded sensation of coming in contact with a window, which leads to a different space, happens because there is fresh darkness that fills his photographs, his unique way of manipulating light and dark, which results in an eroticism. A sensual shiver collides with something in this universe, and it

Untitled. From the Series "Plastics." 1987–89

is extraordinarily vivid, surpassing our common sense. With a feeling that grips our hearts, we know the depth, silence, and beauty of the world. Every time ones sees Shomei Tomatsu's ruins, one feels as if one had just experienced a shower, and one is absorbed by the un-restrictedness of the moment, as if one had not yet noticed the passing of time. One is made to take a second look at all that ages and multiplies. The photographs become a moving echo that greatly expands our concept of time. Rather than being "the compression of post-war Japanese history," his photographs are vivid and rich perspectives of his intuitive reaction to the continuous experience of living in Japan today. They force us to rethink and recapture the feeling of being in Japan.

Reaching to the bottom of my soul, I am convinced that Shomei Tomatsu's photographs of ruins, which are ostensibly about Japanese scenery, are an attempt to establish our own identity by posing questions such as: "Who am I? As a photographer and as a Japanese person?" "What is a reality?" It is as if this process is an attempt to brand us with our "redis-covered roots." Shomei Tomatsu conceives of the photograph as a means of communication about basic experience. His point of view takes on a truly refreshing glow.

Untitled. From the Series "Plastics." 1987–89

Untitled. From the Series "Plastics." 1987–89

Untitled. From the Series "Plastics." 1987–89

Untitled. From the Series "Plastics." 1987–89

Untitled. From the Series "Plastics." 1987–89

93

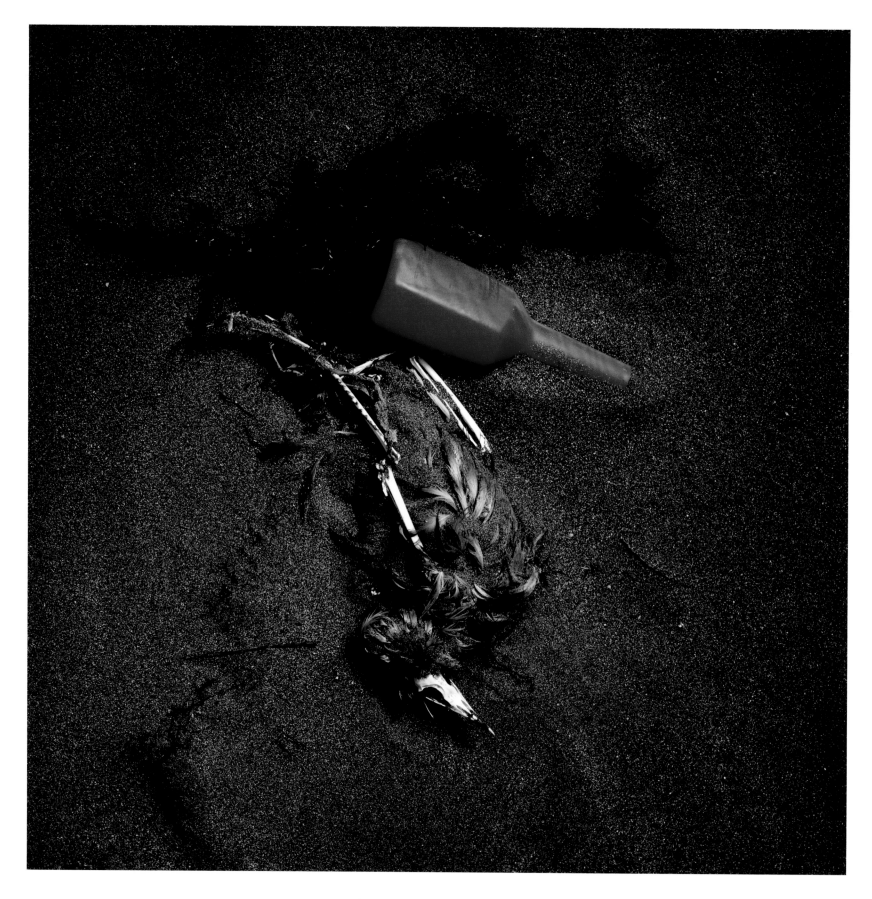

Untitled. From the Series "Plastics." 1987–89

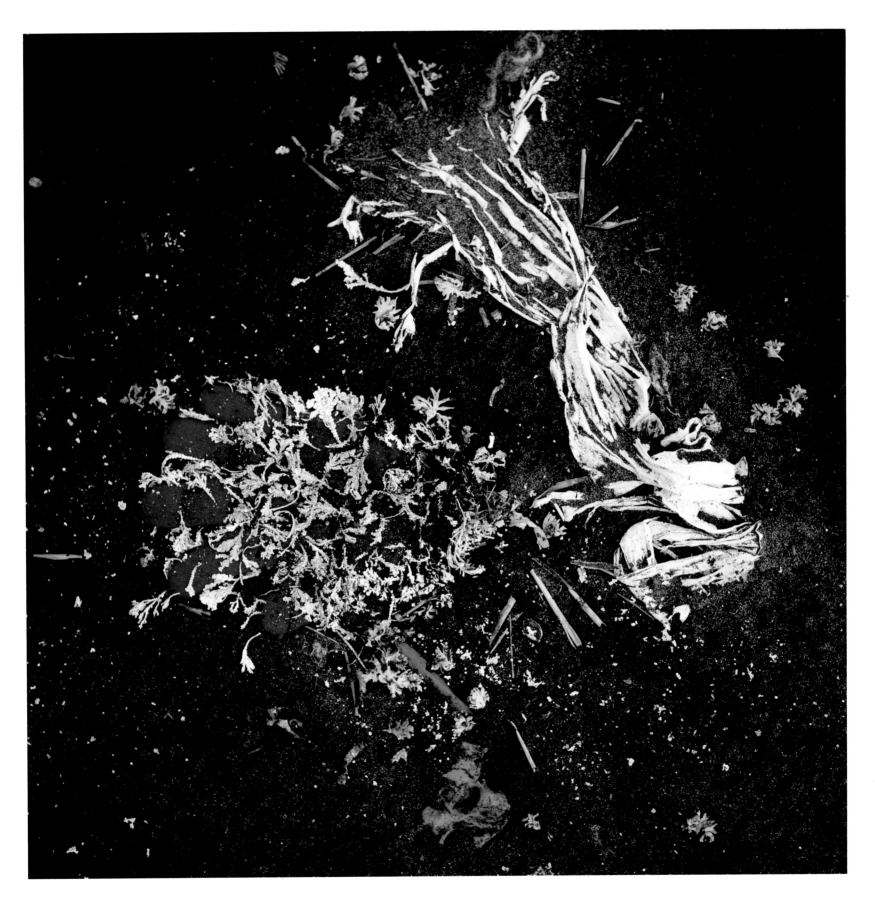

Untitled. From the Series "Plastics." 1987–89

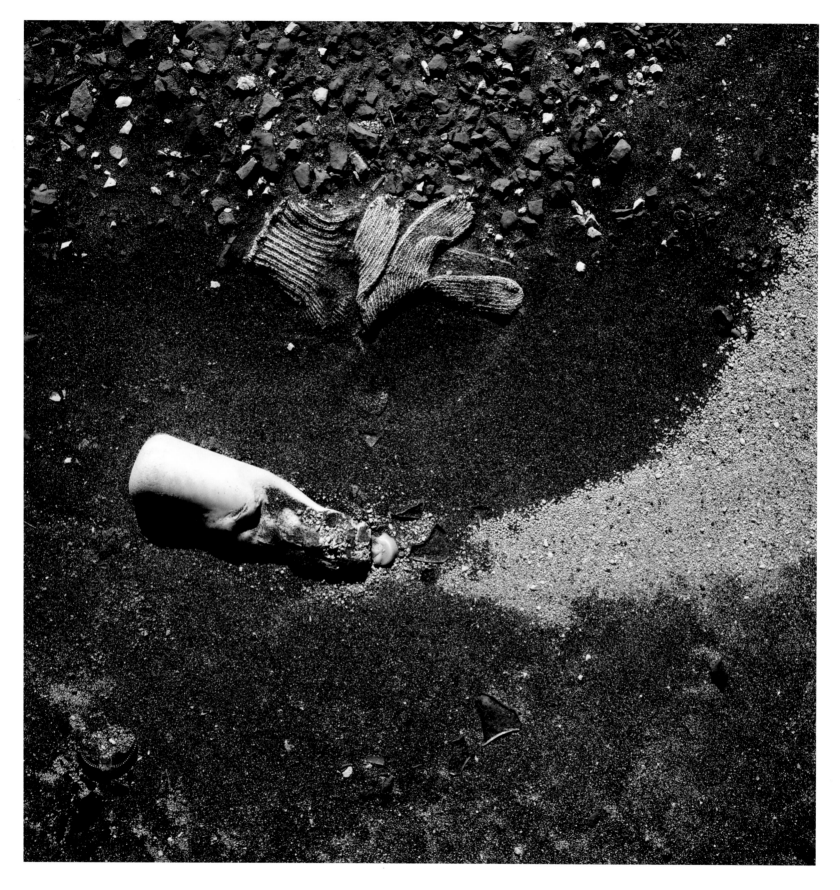

Untitled. From the Series "Plastics." 1987–89

TOM SANDBERG

THE SENSUOUS SHADOW
Robert Meyer

Film director Oddvar Einarsson engaged Tom Sandberg to photograph the facade of a house during the filming of his award-winning film *X*. "I didn't see him take pictures, but he took the pictures I wanted just the same," Einarsson said later, quite amazed. "Actually I have never seen Sandberg with a camera." In the movie he used Sandberg as a model for the main character, perhaps more inspired by his pictures than by his person.

However, Sandberg does use a camera, even if he doesn't wear it on his chest. And he is deeply engaged in his artistic approach. Despite his youth, Sandberg has become a key photographic artist in Norway. His influence on contemporary Norwegian photography has been, and continues to be, of form-creating character. Many artists have arrived at their personal artistic expression by studying Sandberg's simple, expressively charged pictures. He has also been an important bridge in Norway between traditional pictorial and photographic artists.

Like many young Norwegian photographers Sandberg was educated abroad in the 1970s. He attended Trent Polytechnical College in Nottingham and the Derby College of Art, where he studied with American and English teachers. Thomas Cooper, particularly, came to influence his visual development.

Sandberg works within a modernistic language, which he explores and utilizes in a concentrated, compact, sensuous pictorial expression. He has found *his* form and does not attempt to appropriate the dominant contemporary currents, in which circumstances somewhat related to the picture – the relationship between art and society or between the work of art and spectator – play a deciding role. Intellectual theories and concepts have little or no importance to Sandberg's work. Instead, he uses the immediate presence of his subject – as he personally experiences it – as his departure point.

Sandberg's pictures point inward toward himself, rather than to anything else. This is especially evident in his city pictures, where the viewer is confronted with apparently meaningless fragments of anonymous city reality. What is actually depicted is of subordinate importance to the picture's depiction of itself. His motives seem to formulate during the photographic process, and he abstracts his visual impressions of light and shadow onto a photographic surface. He is not concerned with what is actually there, but with what he actually *sees*.

One can say that Tom Sandberg's photography clearly refers to a picturesque modernism, in which the work of art as a sensuous object is central. His means are unmistakably photographic, deeply rooted in photography's history. Early on a handful of artists discovered on the special qualities of the photographic shadow. Just as illustrators and painters strive to give deep shadows meaning by indicating details in the darkness, so does the photographer.

Krzysztof Penderecki. 1987

Photographic shadow is a black hole devoid of detail, that cannot be exhausted. A photographic shadow not only confirms the power of light, it also affects the knowledge and experience of the viewer. In this way it becomes an active element with its own character. Just as the picturesque shadow derives its spaciousness from light, so does the photographic shadow demonstrate the capacity to give light its substantial character.

By studying the earliest photographs from the 1840s and 1850s, calotypes in particular, it is clear how just the shadow in photography has come to play such an active role. For it was the shadow that gave substance to a shape; it was the shadow that created the basis for the experience of space; and it was the shadow that concealed superfluous elements. The shadow was formerly an aesthetic tool, but with photography it attained authentic credibility.

William Henry Fox Talbot, the inventor of the calotype process, learned early on that the photographic shadow could play an active part in picture-making. The Scottish photographer Robert Adamson had a similar understanding. In many of the portraits Adamson, in collaboration with the Scottish painter David Octavius Hill, took in 1843 for their picture *The First General Assembly of the Free Church of Scotland*, Adamson asked models pose against a black background. Making the subject stand out against the dark was a picturesque technique. Models lost their physical contours, but their characteristic features became more apparent. The photographic darkness allowed greater room for the onlooker's imagination to work.

One of the first things one encounters in Tom Sandberg's pictures is his precise use of shadow. He allows shadows to be compact and black, not dead and colorless, suggesting an absence or an interruption, a grief or sorrow, but an active, powerful, and dynamic force. Sandberg's shadows are fertile, potent, and capable of change, the very substance on which he builds his pictures.

Sandberg also photographed people who have made their mark, especially within Norwegian artistic and cultural life. In his portraits, he projects a distinctive style by utilizing tradition rather than breaking with it, but from quite another starting point. The distinctive quality and strength of his portraits are not based on tricks or the eccentric attitudes of his subjects. They are simple and conventional in their composition. By means of intimate details, he searches for the sensuality unique to each subject, in which the subject's face conveys the expression.

The size of his portraits is also carefully considered, believing, as he does, that each subject suggests its own format. Sandberg was one of the first photographers to use a large format camera, pushing photographic abstraction to the maximum. The enlargement does not destroy details, but instead opens the physical texture of the photograph. The portrait ceases to be an intimate portrayal and takes on a monumental, authoritative significance. The artist is more important than the viewer; and as the viewer we cannot avoid a confrontation.

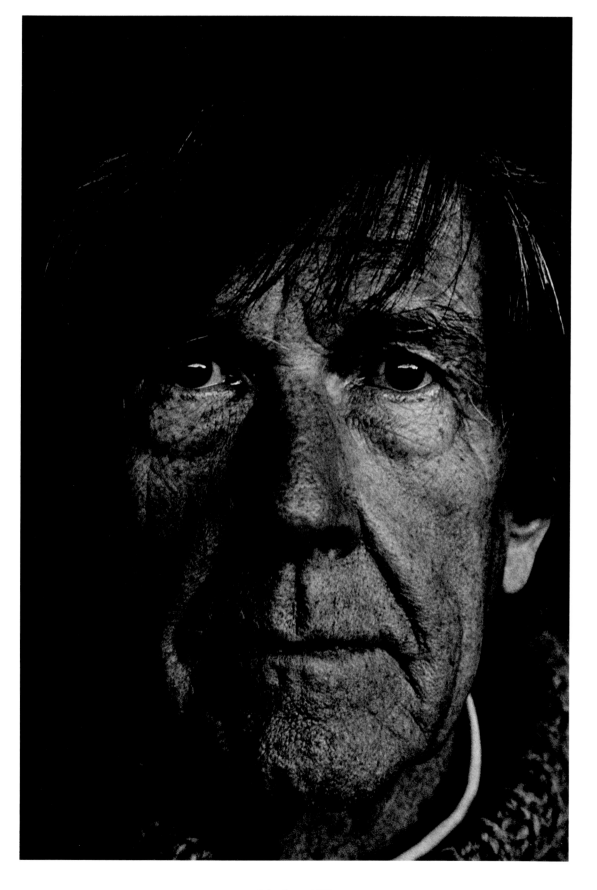

John Cage. 1985

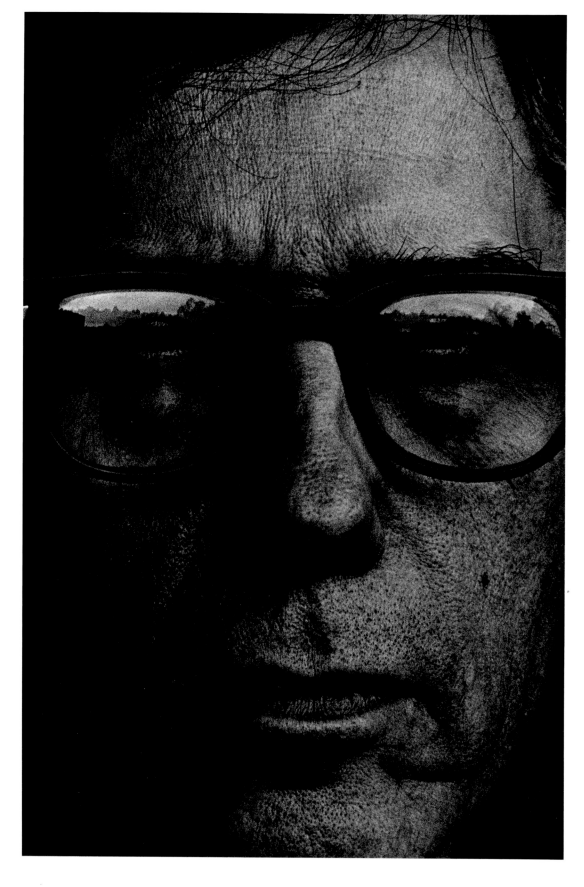

Christo. 1986

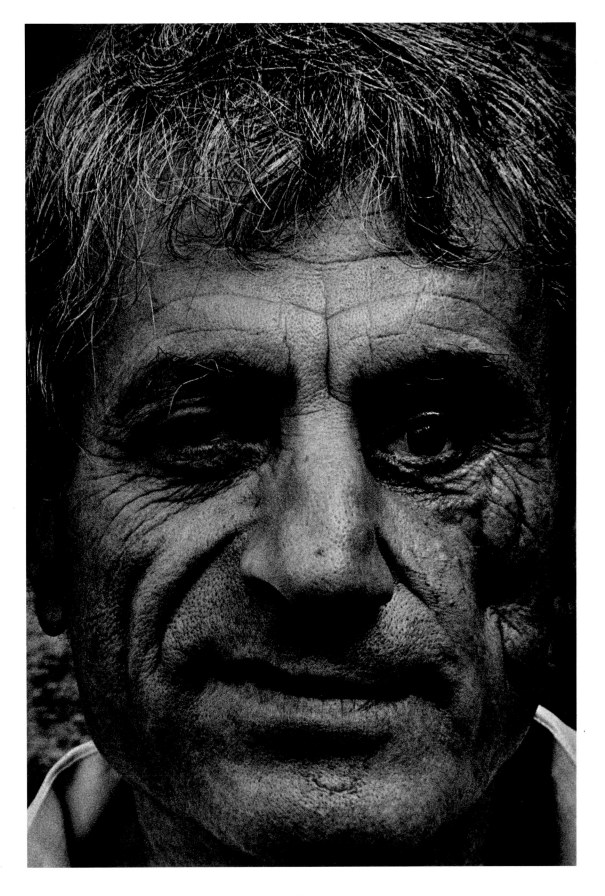

Xenakis. 1988

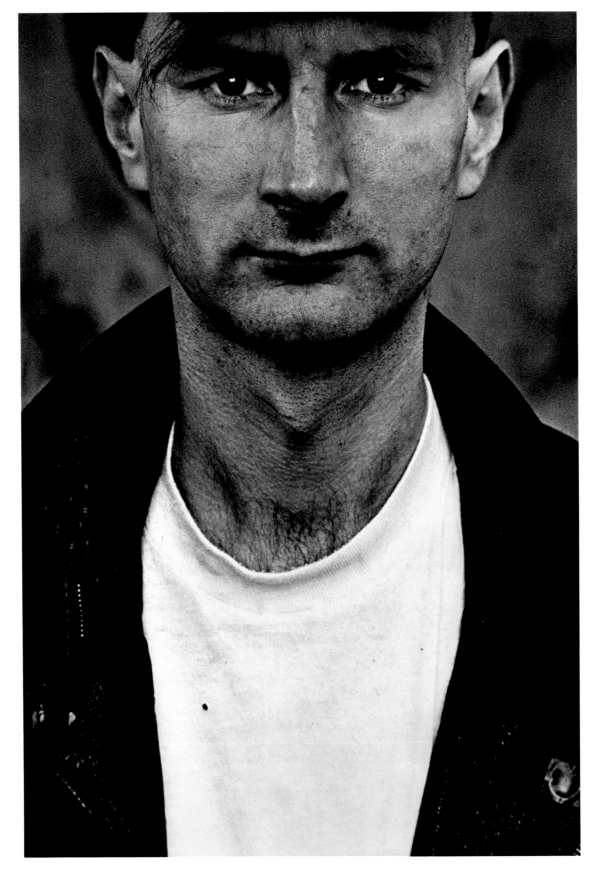

Andrej Nebb. 1985

Untitled. 1980

Untitled. 1987

Untitled. 1988

Untitled. 1987

WHO IS SPEAKING?

Catherine Grout

Among the most persistent misconceptions about photography comes from its depedence on nineteenth century materialist ideology. From its origins, photography was confused with unmediated reality, taken as its index and as its proof. To challenge the status of the photograph as unimpeachable, mechanical evidence is tantamount to calling into question the objective reality of the world, and by extension, the possibility of attaining its truth. Scepticism is inconsistant with this mentality.

Lewis Baltz positions himself on the boundaries of this closed system in two defining ways: first his nearly obsessive concern with the contradictory notion of photographing the "invisible," which is to say, those visual phenomenon that have been exiled to the margins of cultural recognition – those visual phenomenon which refuse to surrender meaning to the camera's gaze – and secondly, by doing so in such a manner that his results can be seen neither as proofs of, nor surogates for, reality. Baltz's work is, in large part, an examination of the tension between the phenomenal world and its representation.

Baltz's photographs reveal and bring into relativity the ideology of photographic naturalism. Usually this is accomplished by giving priority to a subjective vision, an individualistic style, or an expressive point of view. What is notable in Baltz's work is his preference for a language that is impersonal and distant, exploiting the intrinsically photographic qualities of heterogencity and fragmentation.

For Lewis Baltz the photograph is the reification of the act of seeing; that is, it is an assertion that seeing, per se, is a significant act and that the photograph is its manifestation. Baltz does not pass through the world, camera in hand, awaiting the nominally unexpected. He has little interest in the photograph as report, which would locate the image within an explanatory system, and even less in the photograph-as-object, which would locate the photograph in a commodity system. Baltz protects this concept by devalorizing the materiality of the photograph. Thus his work reveals far less about his private vision than it does about the visibility of his nominal subjects in their context.

In his recent exploitation of anti-classical photographic techniques, including his peverse use of color, Baltz raises the stakes in questioning authorship and style. If it is possible today to identify a signature style in Baltz's black-and-white works, this was not so clearly the case at the time they were made. Time imposes style on even those works in which it is least evident.

The most consistent link between Baltz's earlier and later works is his insistence in photographing the manifestations of what is culturally denied or inadmissible. The vast majority of Baltz's black-and-white works, among them the celebrated *San Quentin Point* and *Candelstick Point,* series paid special attention to banal territories: construction areas, peripheral zones, areas where non-heroic human activity and entropy pursue each other. These landscapes indi-

cated, both in and beyond themselves, the absence of an innocent vision, rather its opposite: an overdetermined cultural inability to perceive marginal and transitional material. Baltz compares the "invisibility" of such subjects with repressed psychological material. That is why, "in [his] research, [his] interest has always been with the phenomenal margin, those areas that are not quite landscape, not quite visible, the marginally taboo, the nearly obscene".[1] The obscene – that which assaults both vision and propriety, that which is not within the scene of social purview, that which is not scenic, the repression of vision.

Since 1989 Baltz has also investigated the immateriality of recent technologies, with their implication of altering human relationships to both the visible and invisible worlds. His mutable non-sites define a precondition for a kind of contemporary nomadism, a matrix of undetermined and homogeneous locations as a metaphor for the virtual world new technology technologies imposes.

The images that Lewis Baltz makes are disquieting in their apparent vacuity. The central paradox in his work derives from his insistence upon divorcing vision from knowledge. Everything is shown, *but what is there to see?* The spectacle of vision heightens this absence of information. Moreover, Balz's work subverts another, lovert assumption, that to photograph is to possess. Everything is offered, *but there is nothing to possess.* Photography is a sub-species of language, photography is naming, but Baltz's allegiance is always to the unnameable. Photography usually treats the world as definitive, and offers the viewers the total possession of it through omnivorous vision. Everything is photographable equating to everything is consumable. Baltz outwits this by privileging the unseen, insisting on its significance.

The traditional procedures of photography, framing and fragmentation, details of the world torn from space and time, is carried to an extreme by Baltz in his choice of subjects, and in his refusal to construct a narrative which permits the viewer to locate himself in relation to either the subject or its representation. But at the same time, he undermineds traditional objectives by his claim that there are neither "good" nor "bad" pictures and by implementing this assertion using numerous photographic elements to constitute a single work. These works achieve a studied neutrality in their overall effect and in each constituent element. Composition is passive, even haphazard, the margins are equivalent with the centre. Content, in the usual sense of the word disappears. Nothing connects the different parts other than convenience, that is, the simultaneous presence and juxtaposition of details within the work. This can be taken as a metaphor for our natural way of looking at things, or at least as the reflection of visual habits so deeply embedded in our world-view that we mistake them for natural.

"Ronde de nuit (The Night Watch)," from 1992, is one of the most complex of Baltz's works in this respect. A mural of impressive dimensions (200 cm x 1200 cm), the work exploits the three points of Baltz's photographic procedure, but places them in the service of referencing the social intensification of technology.

"Ronde de nuit" calls into question the distinction between natural and artificial vision. There is no correct viewing distance; each panel demands a different position from the viewer.

The dominant blues, mismatched, are derived from, or refer to, video surveillance. To the view of an escalator or a restaurant, is added a cybernetic component of terminals and wires. The piece evokes a circuit of surveillance/spectacle, "a dossier that is never closed."[3]

The recent installation at the gallery of the Centre de Creation Industrielle at the Centre Georges Pompidou imposed itself on the spectator in a number of ways. The destabilizing effect of confronting a work with no narrative and no continutity to its reading, heightened the disomfort of the gallery space itself, already too small to maintain the usual distance between the viewer and the work. The viewer's unease was heightened by the video-blue of the piece which created a cold, hostile zone. A recording of Olivier Boissiere's Checklist," an alphabetical grouping of words, difficult to connect with one another, read in monotone, evoked surveillance and state or police authority.[4] The spectator was assaulted by the piece, which was reflected on the stainless steel floor of the gallery and whose cold blue light filled the low, black, ceiling. The spectator became a voyeur, an unseen seer, by the means of distant cameras, but what did he see? A reality without a history. Imperceptably the spectator was led to reverse roles, himself caught in the surveillance mechanism of his daily life, entering a store, or bank or restaurant, captured twice by the camera. The audio component of "Ronde de nuit" became the release mechanism, sparking a twinge in the spectator's awareness of his dual role.

To achieve this effect, Baltz, as usual, effaced himself, using predominantly anonymous pictures which are, one could say in this context, desperately obscene. Everything is captured, and in the abscence of specific memory and criteria – hierarchy, value, interest, content – everything is equivalent. All that counts is the network. Nothing is offered to justify or explain the picture; its presence is simultaneous cause and effect. The circuit of panoaptic captivation, evoked by the installation, is the project of a society that organizes itself along two essential terms identified by Michel Foucault: surveillance and punishment.[5] Most of the images in "Ronde de nuit" are from police surveillance videos in Roubaix, a town in the north of France. With "Ronde de nuit", Baltz unmasked the Gorgon of our times, the video circuit which transmits directly the almost entire universe through an inhuman, or extra-human network which may soon dispense with the need for retransmission.[6] The world is duplicated silently, without arbiter. There is no longer any direct confrontation, no linearity in time or space, only a distracting ubiquitous presence.

While dealing obliquely with new technologies and the spaces and activities linked to a new nomadism, "Ronde de nuit" is born of these very same, irreversible modifications of the passage of direct experience to the filter of retransmission and the closing of the distance between the world and the spectator.[7] "Ronde de nuit" is not the simulation of a video circuit nor its illustration.

"Ronde de nuit" operates through the spatialization of the ephemeral image, by making a crisis out of the confrontation between the viewer and the object, by reaffirming that sight is inseparable from the body, from a point of view, and from conciousness.

[1] This quotation is extracted from an interview with Lewis Baltz by the author and appeared in *Artpress*, no.178, March 1993.

[2] Ibid.

[3] Michel Foucault

[4] In 1993 Boissiere updated the checklist with two new names: SARAJEVO and SOUTH CENTRAL [Los Angeles].

[5] Michel Foucault, *Surveiller et Punir*, Gallimard, Paris, 1975, published in *English as To Condemn and Punish: the Birth of the Modern Prison.*

[6] See the writings of Paul Virilio.

[7] This direct experience of viewing was the subject of Rembrandt's *Night Watch.*

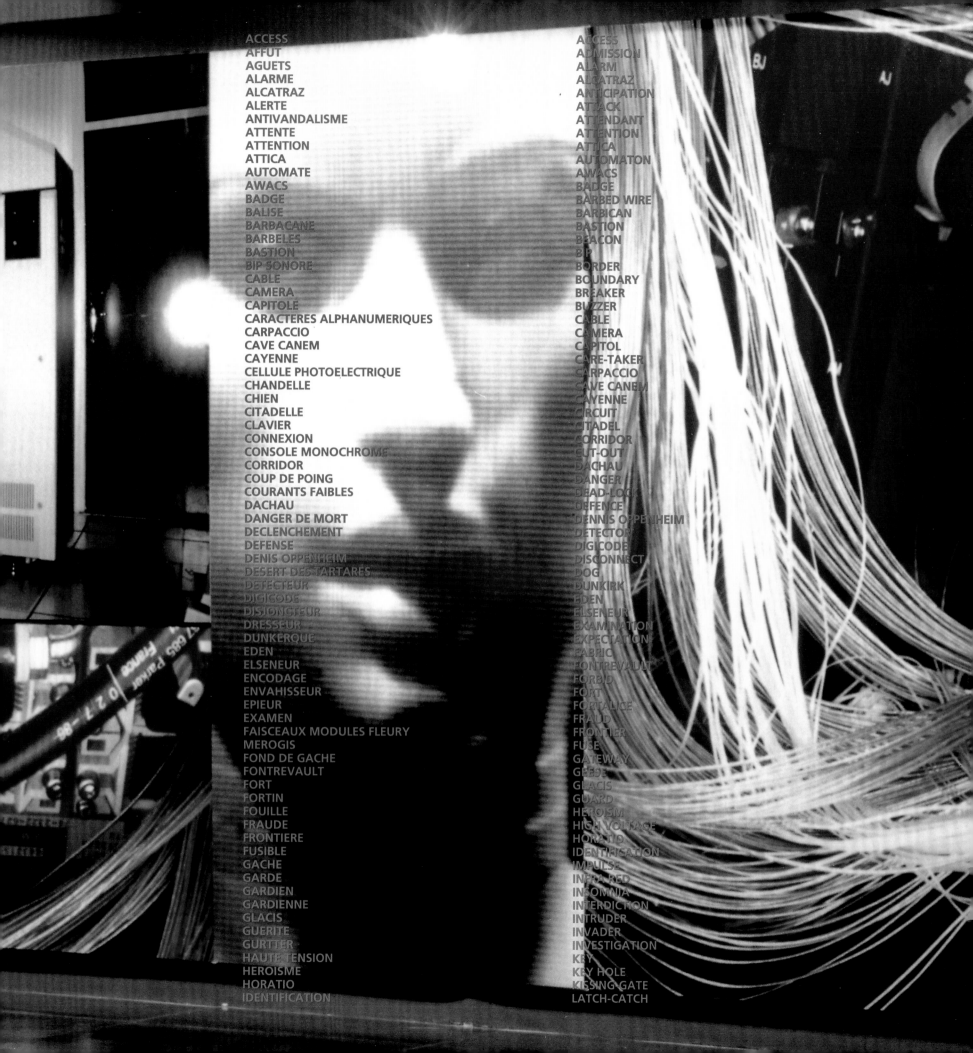

ACCESS
AFFUT
AGUETS
ALARME
ALCATRAZ
ALERTE
ANTIVANDALISME
ATTENTE
ATTENTION
ATTICA
AUTOMATE
AWACS
BADGE
BALISE
BARBACANE
BARBELES
BASTION
BIP SONORE
CABLE
CAMERA
CAPITOLE
CARACTERES ALPHANUMERIQUES
CARPACCIO
CAVE CANEM
CAYENNE
CELLULE PHOTOELECTRIQUE
CHANDELLE
CHIEN
CITADELLE
CLAVIER
CONNEXION
CONSOLE MONOCHROME
CORRIDOR
COUP DE POING
COURANTS FAIBLES
DACHAU
DANGER DE MORT
DECLENCHEMENT
DEFENSE
DENIS OPPENHEIM
DESERT DES TARTARES
DETECTEUR
DIGICODE
DISJONCTEUR
DRESSEUR
DUNKERQUE
EDEN
ELSENEUR
ENCODAGE
ENVAHISSEUR
EPIEUR
EXAMEN
FAISCEAUX MODULES FLEURY
MEROGIS
FOND DE GACHE
FONTREVAULT
FORT
FORTIN
FOUILLE
FRAUDE
FRONTIERE
FUSIBLE
GACHE
GARDE
GARDIEN
GARDIENNE
GLACIS
GUERITE
GURTTER
HAUTE TENSION
HEROISME
HORATIO
IDENTIFICATION

ACCESS
ADMISSION
ALARM
ALCATRAZ
ANTICIPATION
ATTACK
ATTENDANT
ATTENTION
ATTICA
AUTOMATON
AWACS
BADGE
BARBED WIRE
BARBICAN
BASTION
BEACON
BIP
BORDER
BOUNDARY
BREAKER
BUZZER
CABLE
CAMERA
CAPITOL
CARE-TAKER
CARPACCIO
CAVE CANEM
CAYENNE
CIRCUIT
CITADEL
CORRIDOR
CUT-OUT
DACHAU
DANGER
DEAD-LOCK
DEFENCE
DENNIS OPPENHEIM
DETECTOR
DIGICODE
DISCONNECT
DOG
DUNKIRK
EDEN
ELSENEUR
EXAMINATION
EXPECTATION
FABRIC
FONTREVAULT
FORBID
FORT
FORTALICE
FRAUD
FRONTIER
FUSE
GATEWAY
GEODE
GLACIS
GUARD
HEROISM
HIGH VOLTAGE
HORATIO
IDENTIFICATION
IMPULSE
INFRA-RED
INSOMNIA
INTERDICTION
INTRUDER
INVADER
INVESTIGATION
KEY
KEY HOLE
KISSING GATE
LATCH-CATCH

IMPULSION
INFRA ROUGE
INSOMNIE
INTERDIT
INTRUS
LIMITE
LISTE NOIR
LUX
MAITRE
MASQUE DE SAISIE
MELANCOLIQUE
MIRADOR
MITTERRAND MARCHAIS
MONITEUR
NAMUR
NIXESON REAGAN
OIES
ONCLE TOBY
OUESSANT
PANOPTIQUE
PHARE
PIOMBI
PLAGE HORAIRE
PORTE
PORTILLON
POSTE
POSTICHES
PROJECTEUR
PUNIR
PUPITRE
RADAR
RAIL
RAVENSBRUCK
READING
RECONNAISSANCE
RELAIS TEMPORISE
RESEAU
RIVAGE DES SYRTES
RONDE DE NUIT
SABOTAGE
SAINT QUENTIN
SANTE
SATELLITE
SERRURE
SEUIL
SIRENE
SONNERIE
SPRINKLER
SURVEILLER
TABOU
TOURNIQUET
TRANSGRESSION
TREBLINKA
VAMITE
VEILLE
VEILLEE
VEILLEUR
VEILLEUSE
VERRINE
VERROU
VIDEO
VIGIE
VIGILANCE
VIGILE
VOYANT
VOYEUR
ZOO

LIMIT
LOOK OUT
MAKE-AND-BREAK
MASK
MELANCHOLY
MIRADOR
MITTERRAND MARCHAIS
NETWORK
NIGHTWATCH
NIXON REAGAN
NO ADMITTANCE
NO THOROUGHFARE
OBTRUSIVE
OUT-WORK
OVERSEEING
PANOPTICON
PHOTOELECTRIC CELL
PIOMBI
POLE
POST
PROHIBIT
PROJECTOR
PROTECTION
RADAR
RAVENSBRUCK
RECOGNITION
RELEASE
RINGING
SABOTAGE
SAFE
SAINT QUENTIN
SARAJEVO
SATELLITE
SEARCHING
SENTRY-BOX
SIGNAL
SITTING UP
SOUTH CENTRAL
SPRINKLER
SPY
STRONGHOLD
SURVEY
SWITCH
SWITCHBOARD
TABOO
TOCSIN
TO ARMS
TRAINING
TRANSMITTER
TRABLINKA
TRESPASSER
TURRET
UNCLE TOBY
UNWELCOME
VALVE
VANDALISM
VIDEO
VIGILANT
VIGIL
VIGILANCE
VOYEUR
WARDER
WATCH
WAVE
WIG
ZOO

PAUL GRAHAM

THE ALIENATION REMAINS:
PAUL GRAHAM'S PHOTOGRAPHS OF NORTHERN IRELAND
Max Kozloff

"We spend most of our lives pulling bits of plaster off walls–in other words, contemplating reality without either entering into or understanding it. This is a perfectly normal condition, which leads many people to passivity, to resignation, to something like complacent hedonism." Alberto Moravia, writing in 1961, was speaking of the cinema of Michelangelo Antonioni, whose characters sometimes refuse to accept this condition, a refusal that brings them anguish. Paul Graham is an English photographer, with a very Northern sensibility, who traveled through Europe of the late 1980s. The psychic world alluded to in Graham's images, even after thirty years, would still be recognizable to Moravia. In the earlier European scenario, overall prosperity was on the rise; in Graham's, it wanes. Languid and shiftless though it be in first case, bitter in the other, alienation nevertheless remains.

Graham has always been an observer with demonstrable social concerns, realized in voluptuous color, that have lately become enigmatic. He first came to note with a photographic essay "A I, the Great North Road," the one-time main highway from London to Edinburgh. When he followed that project with studies of the endless waits in unemployment offices in England, *Beyond Caring* (1986), and of strife in Northern Ireland, *Troubled Land* (1987), his path became clearer. Though on the move as an itinerant stranger, varying his locale within his chosen theme, Graham implies a gradual weakening of what we might call progress, a forward drive. People cross space, but no one's really going anywhere. The same applies to the sense of time, for the present in Graham's images is accented only by obscure litter from a past that repels nostalgia. Finally, it makes little difference whether he describes people or objects, for each has been immobilized by some unseen but still forceful closure.

At first he could have been taken as a *pastoral* artist, for he had a fine eye for the nondescript appointments of industrial landscape, scrutinized at odd places along roads. Such beauty can be absorbed all the more because Graham looks for something else, the signage of transport, the absence of comfort in barren, bright rest stops, and the insignia or code of political faction. When he later examines the lot of the unemployed in Thatcherite England, Graham's work seems imbued by a *genre* accent, contradicted by the lack of any action. Working in medium format, the effects he achieves are anything but spontaneous. Whatever inertia he depicts in those sad interiors is longstanding, even if his view of the proceedings is dynamic because prohibited, and therefore taken from strange, concealed angles on the floor or maybe his lap.

Untitled. 1988

Graham's evident identification with the working class is distanced. Though he's concerned with class strata and political history, he excludes any outright view of social relations. By rejecting active story interest, he makes sure that no one will regard him as a reporter. Rather, he is a particular kind of solitary artist, wandering in disparate zones, curious but disaffected, who picks up marks of unforgotten violence graffitied or inscribed on surfaces. In more recent work, Graham comes close to these surfaces and studies them. Throughout his travels in contemporary Europe, we recognize that he's essentially a *still life* photographer with humanitarian instincts, and that he has, perhaps, been one from the beginning.

It would be difficult to overlook the growing tension of this work, in which the odds against artistic success are increased because of conflicted goals. Here is an artist engaged with a definitely large frame of reference, nothing less than collective states of mind. Yet, he wants to externalize them by describing things, as if the things could replace or stand in for events. Moreover, the things themselves are quite incidental – a fence post, a shelf, bricks – all lacking context within the pictorial field. Graham acknowledges the narrative inadequacy of photography, but he seems to want to overcome it by a correspondingly oversized scaling of his pictures, which amplifies their presence. In the broadest sense, while he appears to be a minimalist, clinical almost and hard-hearted, he also hopes to reveal the life of memory somehow illustrated in the bruteness of matter. So he comes on finally as an artist of yearning, whose work is suffused with romantic undertones, in keeping with the defeated mood of his subject.

There exists, not exactly a school, but a trend in recent European photography, that treats a desolated spirit in more or less poetic terms. One thinks of Jorge Molders in Portugal, Craigie Horsfield in England, the Germans Gerhard Richter and Michael Schmidt, any number of Belgians, and Boris Savelev, a Russian who works in color. They like nothing better than weathered textures and damp, unpeopled corners. Effects of low light. Blankness of space. Spasmodic gestures, weary faces. And why not? Just when it had seemed only a few years ago that there would be economic union in Europe, at the end of the Cold War and the dawn of democracy in the East, the Europe of our day is going through unexpected crisis and breakdown. Its governments are revealed as corrupt and are forfeiting their legitimacy, its economies overheated or undeveloped and failing, and everywhere there is a moral paralysis in the face of the mass uprooting and decimation of peoples. As for the Cold War belief, or rather myth systems of old, as they've ceased being centers of geopolitical gravity, they are being replaced by older, newly energized tribal hatreds, expressed with pathological intensity.

These photographers are students of physical phenomena – in most cases, the phenomena of the streets, of open space, and of rooms. Their work undertakes an artistic response to this European environment and has shown itself to be very chastened in its appetite for the world. To be sure, they still hanker after sensation, and they pick at surfaces, but with an ever more introverted consciousness.

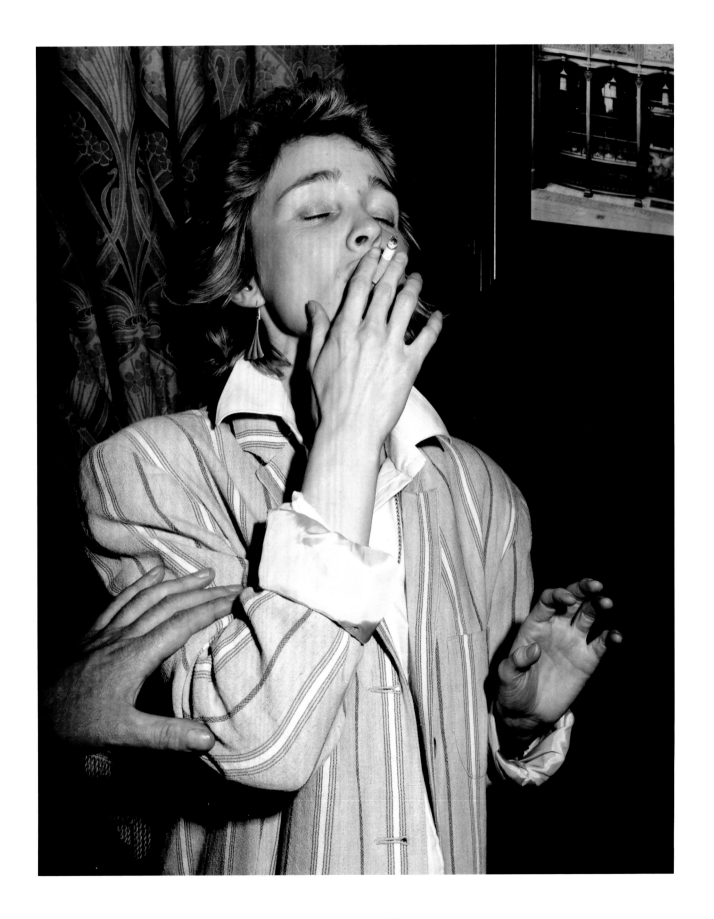

Untitled. Belfast 1988

The Englishman Paul Graham returns to Northern Ireland. For him to have nosed about there must have been like an Israeli meandering around the occupied West Bank with a camera. One can imagine this a touchy business even for a foreigner, let alone a citizen from the country of the occupiers. On the continent, from 1988 to 1990, he zeroes in on hints of disorder – references to a Fascist past, drug culture, and sex parlors. These allusions to authoritarian control or bodily release are shown to be just about the only paths open to general behavior. Sometimes, the intemperance within his highly selective view is condensed in one frame, as in a closeup picture of spittle on Franco's tomb. Working before the latest upward tide of European right wing parties, with their jingo cant, Graham guesses at the way things are likely to be, and, of course, declares the way they have always been. By 1990, his implacable still life style was realized in *In Umbra Res* [In The Shadow of It]: *Sixteen Photographs of Northern Ireland.* He makes the point that toxic psychic conditions are to be found everywhere. Conceivably his earlier Irish sojourn had prepared him as he fanned out from the British Isles throughout Europe. But since discontent is in the mind, and the mind is very portable, it is just as possible that Europe has clarified his view of Northern Ireland, that the two places were seen together as one extended malignance.

But the photographs are not in themselves clear, if by clear one means unproblematic communication of a signal or message. Whereas his work on the *A I Roadway* can be *interpreted* as a social enquiry in pictures, his similarly motivated later photography withholds social data, so that we have to *project* the social aim back onto the images. Fewer material clues than previously, far larger, portentous size of picture – whatever the relative scale of objects--and a deliberately, haphazard sampling of motifs: all these baffles slow the intake of Graham's truculent images. We have to go into projective overdrive to make sense of them, and the energy for it can only come from our own anxieties.

For one thing, the viewer's relation to the thing observed is generally too close to be described by any social purpose. No one else can share in the almost percussive intimacy of the viewing process, so that the picture's effect is weirdly voyeuristic. This abruptness of contact might have an expressive value, provided the subject can sustain the social reading that is presumably an aspect of the artist's agenda. A night shot, with flash, of a beat-up fence post shrouded by barbed wire has a kind of emblematic potential. The condition of the object, when Graham discovers it, speaks of a battered community. But what is the meaning of three bricks, propping up a heavy, corroded weight, illuminated by a flash a few inches away – apart from their circumstantial function? A viewer is free to intuit from the way the bricks are photographed, heavy thoughts about the fragility of existence or pressures in a fratricidal country. But this freedom leads only to over-determining the content in the image, which is, in fact, very little determined by Graham himself.

Still, such is the objective of many photographers: to get the mind to work when only material is furnished. Graham's atmospherics encourage fancies that are not otherwise

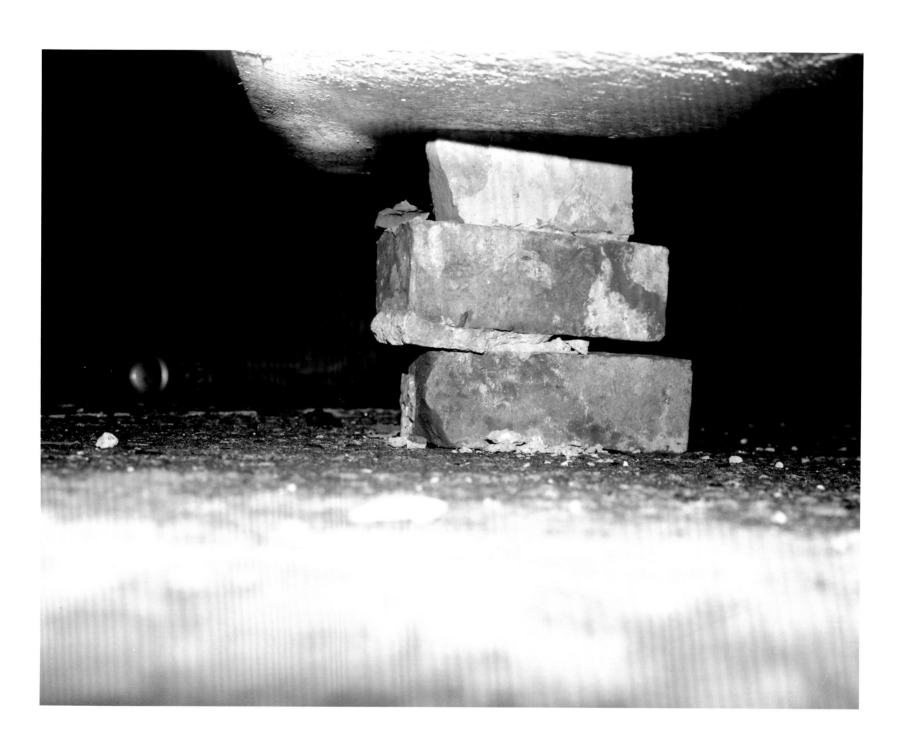

Untitled. Belfast 1988

warranted by his physical account of his subject. The environment that he evokes is located somewhere between *A Clockwork Orange* and Richard Serra's crushing, rusted steel walls. What comes through is the hardness or density behind surfaces and the self-absorption of nameless people. Reckoning with their particular milieu, Graham approaches it with a mute stare on a collision course with physical impasse. How often does Graham's work stress margins and barriers, or ledges, things that block the gaze? In the end, they act as metaphors of a consciousness, out of tune with an historical moment that the photographer may have defined only too well.

Untitled. Belfast 1988

Untitled. Belfast 1988

PHOTOGRAPHY, REALISM, AND SOME WORKS BY MICHAEL SPANO

Robert Simon

As the present exhibition invokes various notions of realism as part of its organizational prin-
ciples, it is useful, and only a little perverse, to recall Baudelaire's famous damnation of the
photographic enterprise as he saw it in 1859:

> *In these deplorable times, a new industry has developed, which has helped in no small
> way to confirm fools in their faith, and to ruin what vestige of the divine might still have
> remained in the French mind. Naturally, this idolatrous multitude was calling for an ideal
> worthy of itself and in keeping with its own nature. In the domain of painting and statuary,
> the present-day credo of the worldly wise, especially in France...is this: I believe in nature,
> and I believe only in nature...I believe that art is, and can only be, the exact reproduction
> of nature...Thus if an industrial process could give us a result identical to nature, that
> would be absolute art.' An avenging God has heard the prayers of this multitude;
> Daguerre was his messiah. And then they said to themselves: 'Since photography provi-
> des us with every desirable guarantee of exactitude...art is photography.' From that
> moment onwards, our loathsome society rushed, like Narcissus, to contemplate its trivial
> image on the metallic plate.*

Baudelaire had a horror of mass society and was an enemy – albeit in a complex way – of mid-
nineteenth-century realist projects. But most of all, photography, as he saw it, was not and
could not be art because it was a transcriptive rather than an imaginative undertaking, and
then transcriptive only within very strict limits. The idea that photography could move freely
across the visual world, with a kind of magisterial realist confidence, was a ludicrous one.
Film, lens, and camera technology had a very narrow and clear function:

> *Photography must...return to its true identity, which is that of handmaid of the arts and
> sciences, but their very humble handmaid, like printing and shorthand, which have neit-
> her created nor supplanted literature...Let it be the secretary and record-keeper of
> whomsoever needs absolute material accuracy for professional reasons...But if once it be
> allowed to impinge on the sphere of the intangible and the imaginary, on anything that
> has value solely because man adds something to it from his soul, then woe betide us!*

Baudelaire's criticism was the product of a particular temperament and moment, and it would
be difficult to find anyone in today's culture industry who would be willing to dismiss, deni-
grate, or describe the medium in anything like these terms. But photography – its avatars,
salesmen, and practitioners – has always been burdened by a sense of anxiety and inferiority
with respect to painting: why else, if not defensively, does the distinction between the straight
and the manipulated image continue to offer, in the daily discourses on the medium, a moral
appraisal of the photographic enterprise as a whole, of its genres, its boundaries, its *essence*.

Portrait of a Man. 1986

For Baudelaire and his contemporaries, there was no such thing as the manipulated photographic image; the concept had not yet emerged. But it is possible and interesting to read in Baudelaire's text an anxiety about the imaginative basis of figurative art itself, not simply an anxiety about the ways realist aspiration damaged true art, or even about the ways the transitional painterly injunction to imitate nature had haunted and confounded French art-making for one-hundred-and-fifty years, but a worry that photography had abruptly transformed – no, shattered – the very concept of imitation by concluding and exhausting the realist game. This was nature, then, or at least the surface of the visible world, in its purest, most absolute, ultimate form: "a trivial image on the metallic plate."

The confrontation between the camera and the metropolis has been a central idiom of twentieth-century photography. Many of the major terms of the confrontation are already on display in a well-known Daumier lithograph, which was made in 1862, just a few years after Baudelaire's salon review, and which participated very directly in the same context of concerns. Entitled "Nadar Elevating Photography to the Height of Art," it shows the famous photographer as a reckless daredevil thoroughly absorbed in the task of taking aerial pictures of Paris from the wildly swinging, tipping, wind-buffeted basket of a hot air balloon. Each and every building below bears a sign announcing the presence of a commercial photography studio. The comedy, of course, is the domination by photography of the urban marketplace, with Nadar at the height of his profession, but the print also announced the ubiquitous position of photography, and the photographer, on the modern cityscape. Urban photography – at least in its most ambitious forms – is associated with an extreme risk-taking. Yet the specific character of the most dramatic meeting between the city and the photographer is marked by distance, a panoramic view that not only connects Nadar's aerial work to Daguerre's professional origins as an entrepreneur of the panorama, but implies – certainly with great irony – that the reality of the city, its bulk and sprawl, is best seized at a distance. And if the notion of risk-taking remains ever-present in the image of twentieth-century photography, this risk is often displayed through the aggressive, insistent collapsing of distance, the confrontation – physical, emotional, spatial – between photographer and human subject, whether crowd or individual, on the street or in the public interior.

All of which brings me to Michael Spano, whose practice of taking pictures of people in urban spaces has been one of the major currents of his immensely diversified production over the last twenty years. The initial sense one gets from these pictures is of the chance encounter and quick decision, the photographer prowling, wandering, walking the streets, coming upon a moment of interest, and seizing it – for example, shooting a woman sitting on a park bench, searching through her shopping bag, and withdrawing a newspaper, whose half-seen headline announces the world's latest disaster. The image offers a moving array of correspondences, at once direct, oblique, and ironic: the journalistic melodrama and the elegant arabesque of the art deco dancers, the shopping bag fashion scene and the woman's ribbed

HiFi TV. 1987

hat and heavy pearls like luminous planets strung around her neck, the overall black, white, and gray graphic architecture built up out of interrelated mass and detail.

Among the visual arts, nowhere more than in the realistic photograph and in the urban street photograph–one of photography's quintessential forms–does the rhetoric of realism disguise itself more effectively behind masks of realist enterprise. Precisely a rhetoric, a set of tropes, a structure of articulation, that means to persuade and so say, in the case of the photograph: "This is not posed. This is a glimpse pulled out from the flow of time and motion, the happy union between chance encounter and quick decision."

A photograph is not really realistic in some naive sense of the term, it is realistic looking, and so, even the kind of transcriptive work to which Baudelaire banished the photograph, involves any number of interventions on the part of the artist. Of course, I simply state the obvious: choice of camera, lens, speed, aperture opening, event proximity, framing, darkroom procedure, scale, display–these are all potential sites of intervention in the process of photo-making. But what I have most particularly in mind is the realistic photograph that marks the moment of intervention on its surface, deploys this mark as an element of its realist narrative, and so thematizes a tension between realism and artifice. I am thinking of how solarization is deployed in Spano's pictures.

In a recent interview, Spano "rejects the idea that his panoply of effects are simply willful manipulation." "All photos," he says, "are manipulated–reality doesn't look like a photograph anyway." To this might be added: nor are photographs easily confused with reality, as they are framed, flat, and in Spano's case, black and white.

These pictures operate within the domain of a more or less codified range of "reality effects," to use Roland Barthes formulation, that have informed the later twentieth-century genre of street photography, and more generally, the imaging of the metropolis since the second half of the nineteenth century. Spano uses seemingly random composition and cuts off figures at the edge of the frame, as if asymmetry, randomness, and particularity of view restage the fundamental forms, motions, views, and conditions of urban experience. But–to repeat–these are in fact components of a naturalized and naturalizing rhetoric deployed in the representation of the city scene.

Spano's portrait of an old man is a study in sorrowful intensity; a lined and furrowed face find a powerful echo in the wide expanse of empty city street, which stretches out across the lower register of the picture surface. By situating this man within certain "tragic" urban biographical narratives, the play of solarization across the photograph gives powerful presence to such a psychological and topographical drama. The physiognomical concentration and density that serve as the conditions for contextually and psychologically complex portraiture take shape by virtue of the general solarized dematerialization of body and environment.

Daily Dancers. 1985

Solarization – roughly speaking, the exposing of the film or paper to light, prior to chemical stabilization in the developing process – brings about tonal reversals and the dissolution of discrete form into luminous, flat, banded, or floating disconnected mass. The process is extremely difficult to control, but Spano seems to solarize with great precision, and this solarization yields, or makes possible, the thematic drama of these pictures.

We feel the heavy, slow, lateral momentum and the massive bulk, albeit psychologically and visually detached, of the businessman – his light-blasted profile etched in place by a defining black line – as he moves against the ghostly flow of a landscape that is a screen opening onto the spatial depth of the cavernous avenue. The cigar vibrates in his mouth, both comical sign of sexual authority and divining rod, navigating the journey and pointing the way through the day's affairs.

The delineation and dissolutions of the solarization order the scenario, but it is more than simply evidence of the artist's skill that this ordering is accomplished with such rigor. The appearance of instantaneity, spontaneity, and randomness that girds the genre of street photography – all functions of varying degrees of artistic intentionality and control – finds its analogy in the process of solarization itself, where the play between chance and control occurs at the level of studio work. The game of photographic realism is extended from the moment of image-taking to the vagaries and fortuitous happenings of the darkroom and are all brought under the sign of a rigorous artifice that seems to make visible the meaning-laden scenarios of the city street.

It is worth taking some measure of how a thematic vision takes shape in these pictures by Michael Spano. Against the myth of natural, transparent, transcriptive, or unimpeded visuality that has been associated in various ways with photography from the start, *seeing* is most often a compromised and problematic activity in Spano's work. The cigar man's eyes are wrapped in opaque glasses and black shadow; the seated man wears the mask traced by solarization across his face; the woman on the bench searches for something almost within her grasp; the old man stares across memory-time for something that is no doubt irrevocably lost. And then there is the picture of the man who shields his eyes, struggling to see, in which the project of a pure photographic vision, operating across a blinding, phantasmatic, and unmasterable image world, finds its most realistic, which is to say, mediate form.

Seated Masked Man. 1986

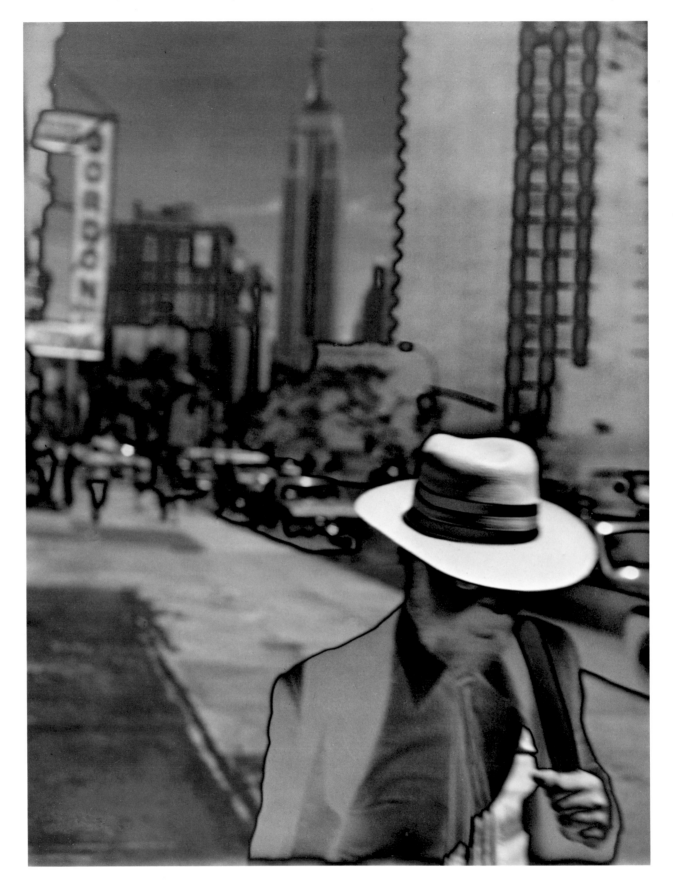

White Hat. 1986

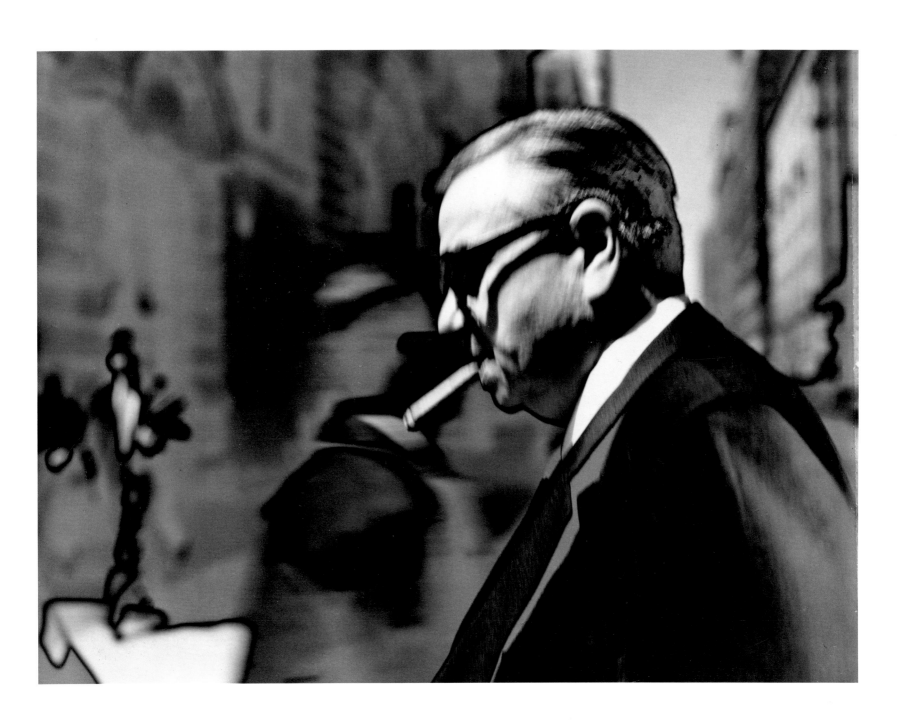

Man with a Cigar. 1986

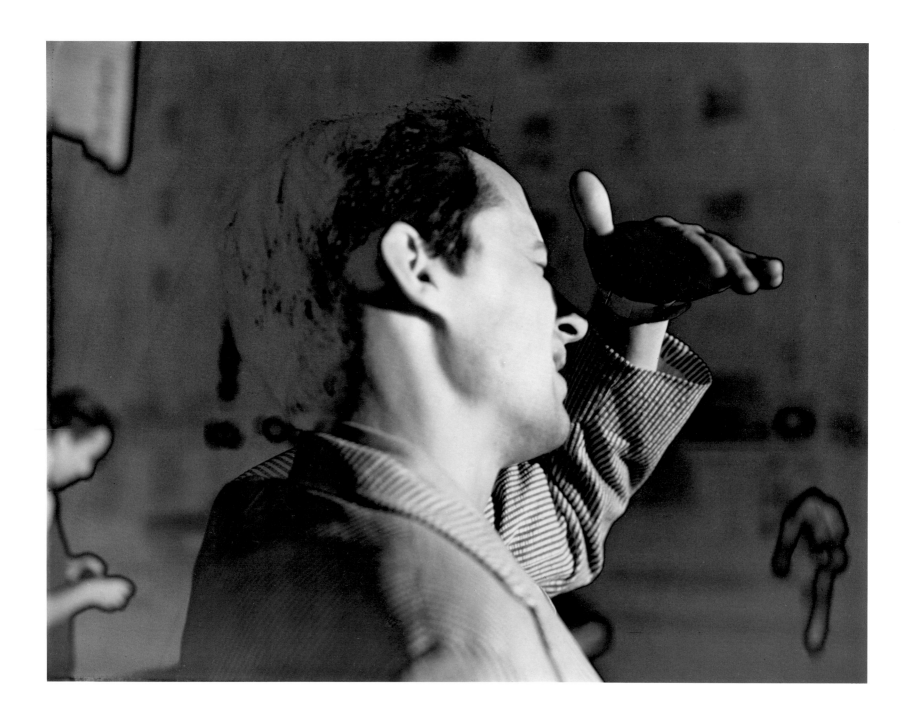

Shielding Eyes. 1985

BLOOD KNOT: GILLES PERESS IN NORTHERN IRELAND

Philip Brookman

*It certainly is a strange monster that one encounters if
one reads the historians first and the poets second.*[1]
– Virginia Woolf

"Hello, it's Gilles. Please leave a message. If you want to send a fax..."

"Bonjour, Gilles, it's Philip. Where are you today? I'll try Paris. I saw a picture in the *Post,* and I thought it might be one of yours. Bosnian no-man's-land, graffiti, the shadow of a gun-running figure disappearing around a corner, dodging a sniper's sharp eye. It could have been Belfast. How is life on the front line between your MTV version of the Republican National Convention and that canoe heading up the Magdalena River following the path of Bolivar? Be careful in your travels, O.K.? Send me a message if you can."

Walking down New York's Second Avenue late one night, neon shushi reflecting off a pavement polished silver by a recent rain, photographer Gilles Peress tells me a story. Born just after the World War II, a Parisian student in the late 1960s, he was an activist, an organizer holed-up in a factory with a group of other militant students. They hadn't thought much about the media and its impact on how people perceive the world, yet Peress grew increasingly interested in observing the insights of the people he met, bringing their experiences into the light. Late into the night the students engaged in lengthy debates about the politics of image-making.

Out of nowhere, filmmaker Jean-Luc Godard arrived at the factory. Smuggling in a video Porta-Pak, he passed it among the students, asking them to capture their views. "Talk to the workers, record what they say and what they feel," he urged, petitioning the generation of Marx and Coca Cola. Godard returned later, hoping to create some sort of *verité* linguistic ballet, but the students instead had aimed the lens out of the window, looking at the industrial landscape, talking among themselves about their own lives, the future, and what they might discover if they sought truth through the lens of a camera, beyond the confines of local politics. Peress remembers thinking then about the possibility of creating multilayered stories from images that might reveal more about people and the complexities of world cultures than could be found in a filmmaker's artful passion for the moment. Abandoning his video project in the factory, Godard didn't seem to mind leaving behind a few students with idealistic insights of how new sorts of images might be made. With his searching eye, he propositioned the group to question its own role, and one of them, Gilles Peress, soon began to make photographs.

Peress began working as a photographer in 1970, embarking on an intimate portrayal of life in a French coal mining village as it emerged from the ashes of a devastating labor dispute. Soon after, he traveled to Northern Ireland to begin an ongoing examination of a society engaged in a struggle for civil rights while balanced on the precipice of a civil war.[2] "I first went to Ireland when I decided I wanted to deal with relatively free images, and not with words...so as

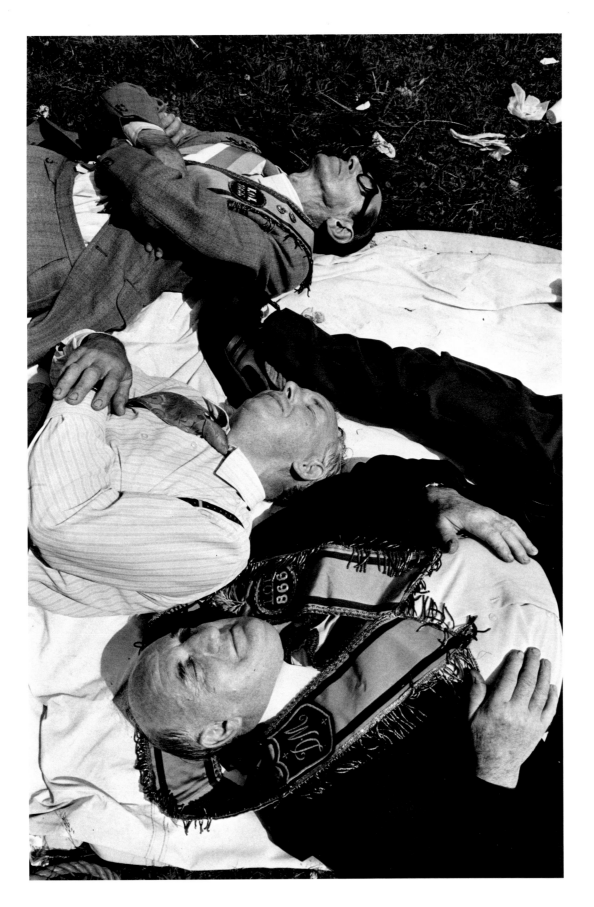

Nap at the Field on the 12th of July. 1981

to expose the estrangement from reality that results from language," says Peress. "I was very much on the rebound from many years of political activities that were totally embedded in verbal language.[3] He began to develop a new visual language which could, through the use of photographic imagery, encompass and formulate the rhythmic arguments and open-ended linguistic structure of oral speech. Those first images earned Peress membership in the prestigious photographic agency Magnum, which enabled him to continue his Ireland project while on assignments as a freelance journalist. He returned again and again to Ireland over a period of almost twenty years.

Gilles Peress's photographs of Northern Ireland are distinguished by their visual inventiveness and the appearance of an overt aesthetic struggle to understand the psychological foundations of a contradictory society. The social dichotomies inherent in this history are apparent in Peress's pictures themselves, as well as in the complex narrative structure he has developed to document his findings. By creating a psychological entry into a world that is usually portrayed only through images of violence, hatred, and extremism, Peress encircles the metaphors that focus a people's struggle in a politicized landscape of colonial poverty.

Peress is currently completing *Power In the Blood,* a book about Northern Ireland, which organizes his photographs into a series of symbolic days, leading an uninitiated visitor from the outside into the depths of Irish history, mythology, iconography, and ritual. Entering Derry through a segregating wall that cuts through the city, a visitor moves visually into the heart of the modern civil rights movement, grown from centuries of struggle. The "Troubles" began hundreds of years ago and encompass Irish history, from the victory of Dutch King William of Orange over Catholic King James at the 1690 Battle of Boyne, through the ensuing political reign of Protestant Loyalists over Catholic natives in the north, to the 1921 partitioning of the island by the Anglo-Irish Treaty. Renewed in the late 1960s, the civil rights movement focused on housing and employment rights in Northern Irish urban centers. Gilles Peress's visual argument erupts dramatically, juxtaposing the internment of Irish Republican Army (IRA) sympathizers, hunger strikes, funerals, and bombings of the 1970s and 1980s, with the life and landscape that characterizes his everyday experiences. Such a span of images over time is difficult to grasp at once, yet the tension inherent in the world he depicts is implied by signs and symbols, myths and rituals, as well as by dramatic moments that litter the social landscape he portrays in these photographs.

It is "...a cold, melancholic, lonely day where one perceives fragments that are barely intelligible, barely rational, where nothing is really explained. Things pop out at you in unexpected and strange ways," writes Peress.[4] Driving down a wintry gray lane he encounters a bride, her veil blowing back as she rushes down the walk, her gown glowing white with the snow, silhouetted against a dark, brick home. Seen at a distance through the window of a car, her world is one of mystery and hope, an incongruous apparition in a landscape splashed with the shadows of masked gunmen, graffiti, and barbed wire.

On January 30, 1972, Gilles Peress was present as 25,000 people marched in a nonviolent civil rights demonstration along William Street in Derry. His unerring eye records the ensuing

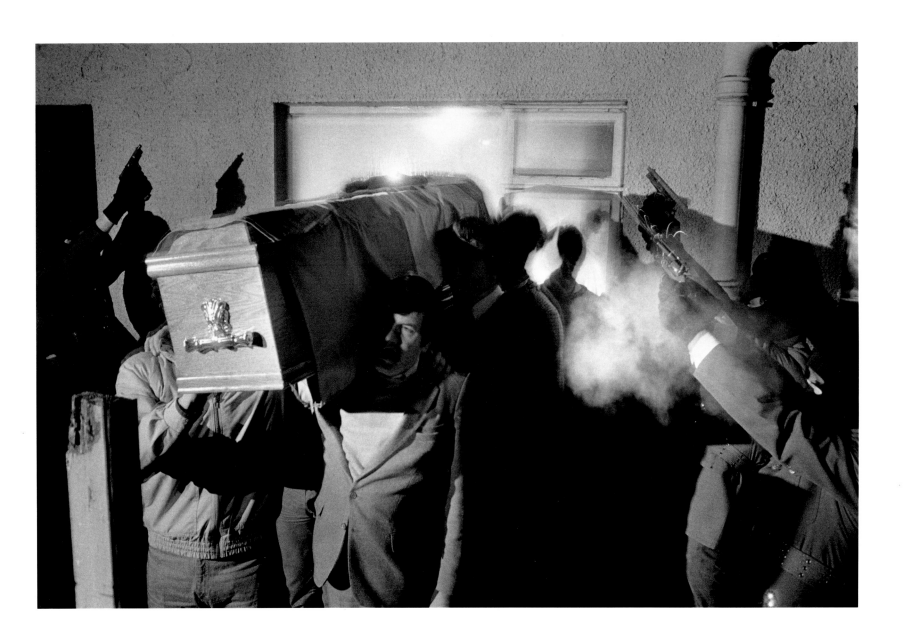

The Wake of an IRA man, Strabane County, Derry. 1985

tragedy when soldiers of the British Parachute Regiment fired into the crowd, killing thirteen men. This day became known as Bloody Sunday. Irish historian Liam de Paor writes: "The success of Bloody Sunday was in ending the effective civil rights movement, and preparing the way to present the political conflict in Northern Ireland as a struggle of law against terrorism."[5] As enrollment in the IRA swelled, and cities were again divided by sharp steel walls, the media was held at bay by increasingly repressive censorship laws. After Peress's photographs were published in London, they helped provide evidence that the demonstrators were unarmed on that portentous day.

An image of two British soldiers guarding a murder scene on Cambrai Street graphically depicts the ensuing militarization of Belfast. Heavily armed and dressed in riot gear, the soldiers aim their weapons in cross directions, covering the street and their own insecure position, while two young boys look on, casually leaning against a wall. A steel bar cuts across the image like a nation divided, hoisting a mirror which partially obscures the face of one soldier. Reflected in the mirror are the figures of two other boys, superimposing the gaze of an angry-spirited youth over that of the armed soldier. This complex image reflects the dramatic confrontation of colonizer and colonized, while everyday life continues in the background.

"This work is more about being inside people's minds," says Peress. "Anybody who spends enough time in Ireland slowly drifts away from the surface of things, because, simply, you live a daily life there....The violence is a symptom, as in a disease."[6] In order to develop an understanding of the psychology of both the place and its presence in history, Peress has created a body of work that functions as a series of tightly structured individual symbols, which combine to create a metaphorical narrative, sparking new subjective insights. In the presence of disorder, he attempts to visually isolate its symptoms and to observe the various mechanisms that allow them to function. His compositional framework often banishes fragments of figures to the edges of his photographs, limbs jutting into space from outside his sphere of vision. One is forced to imagine the entire scene, structured as it is by the architectural geometry of a claustrophobic arena. Given just enough information to guess at the extremes of activity beyond, observers are brought into the image, becoming a part of its chaos in order to complete a cryptic gestalt. Like some photographs by Peress's mentor, Henri Cartier-Bresson, figures are caught in motion at the height of a solitary moment in time, acting out a theatrical scene from some real life tableau.

Gilles Peress's photographs of middle class leisure in Northern Ireland seek out social rituals in which nature symbolizes perfection. In contrast, his images of underclass rituals explode the natural order, using the landscape as a palette on which to paint gestural expressions of historic disorder. Gardens, roses, beauty contests, and the gentility of sport all offset the ceremonial bonfires that consume the effigies of history, providing a smoke screen for the underlying dirge of inequality between classes. A photograph of a towering veiled woman, alert astride her horse, reveals an elite obsession with style, as the immaculately dressed rider sets out on a ritual hunt for the elusive fox. Her expression is vigilant, taught, mimicked by an equally poised man to her rear. Her hat, gloves, scarf, and riding crop are like silk armor, projecting a

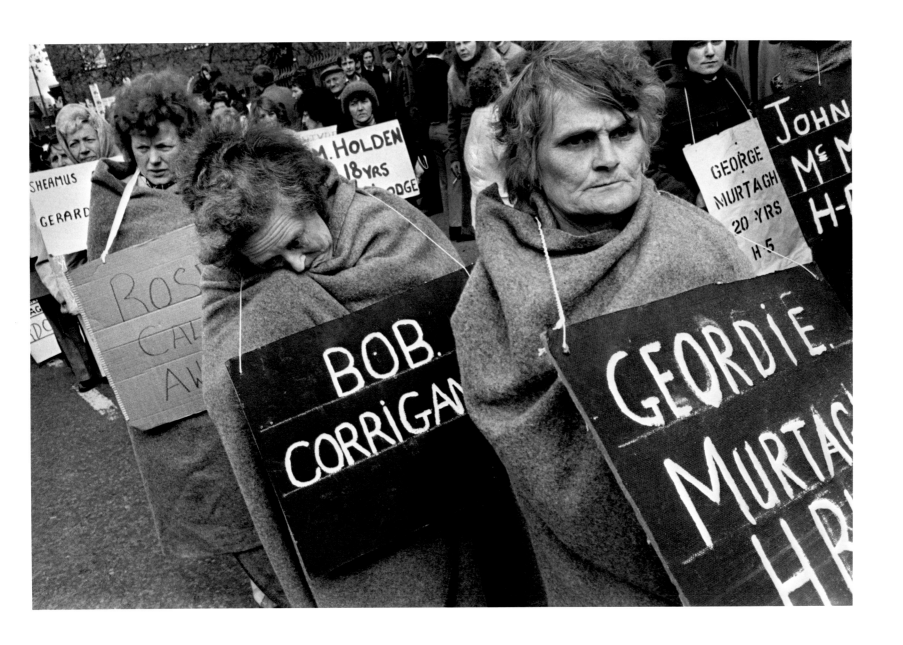

Mothers of Hunger Strikers, Falls Road, Belfast. 1981

composed sheen that stands in sharp contrast to the rough, textured animal nap of her mount. The horse, hurling out of the frame, seems barely in her control, creating a chaotic visual tension equal to Peress's direct depictions of violence.

An image of outstretched arms, lunging forward from outside the picture, creates the focus of another photograph, depicting a Loyalist salute to a ceremonial figure burning in effigy. This image dissolves into another one of disembodied arms emerging from nowhere, hoisting pistols in a final volley over the casket of a fallen Republican soldier. A third photograph reveals an idyllic stone figure, looking down sardonically at a funeral procession, as a somber crowd escorts a slow-moving hearse shrouded in beautiful roses. Multiple metaphors emerge from Peress's complex construction of layers of meaning in these photographs. Together the images equate the historical position of the Irish underclass to that of the unseen fox, hunted and hiding, exhausted at the end of a seemingly playful game.

"The role which place and landscape play in the psychological battle for hearts and minds in Ireland cannot be underestimated," explains Irish artist Willie Doherty. "If place is inextricably bound up with ideas of home and identity, then it is at the very heart of the struggle between colonizer and colonized."[7] Gilles Peress heard the stories embedded in the Irish landscape when he entered homes to interview many people on all sides of this age-old struggle. His images merge together to lament the class-bound structures of a civil war, in which lyrics nailed to trees blow freely, never to be written down, but sung nightly for all to hear.

Weeks later a fax from Gilles rolls in like fog off the ocean:

"Dear Philip, I got your note in Paris just before leaving again for Yugo. The BBC World Service is on the shortwave with that ridiculous '40s style jingle clashing on the hour with the church bells. Tomorrow I am going back to central Bosnia. Back to the madness, the killings, the ethnic cleansing, the mass graves, the burned-out villages, the refugees, the snipers. Back up a strange river of Black Blood to another time.

"I think I've got a peculiar disease. I call it the 'the curse of history,' and it has to do with the fugitive absence/presence of both personal and collective memory. At first I thought it was a kind of personal illness, just related to time, private time, time that passes in one's life. So I decided to *forget* and throw myself into the *future*. I still can hardly write those words and leave for Bosnia. I traveled through the muddy roads at the end of winter to Tulza, Sarajevo, Tulza again. Then Vitez, back to Sarajevo, through a blur of snow and blood and endless visions of refugees, amputees, men with guns, morgues. The flashbacks started in a hospital room in Tulza, filled to the brim with legless, armless men, sometimes totally memberless torsos, all grimacing from the pain. I remembered my father and his amputation, his pain, his addiction to morphine, his descriptions of World War II, of German occupation of the camps. He told me all this when I was a kid.

"Then this flood of buried images came back to me. Pictures of destroyed villages like Oradour, executions of partisans, bodies, camps. I started to think I had actually come to Bosnia to see, to reenact the vision buried in my childhood memories. The flow started to submerge me like a tidal wave, and I realized that the Yugoslavs (Croats, Serbs, and Bosnian) must have

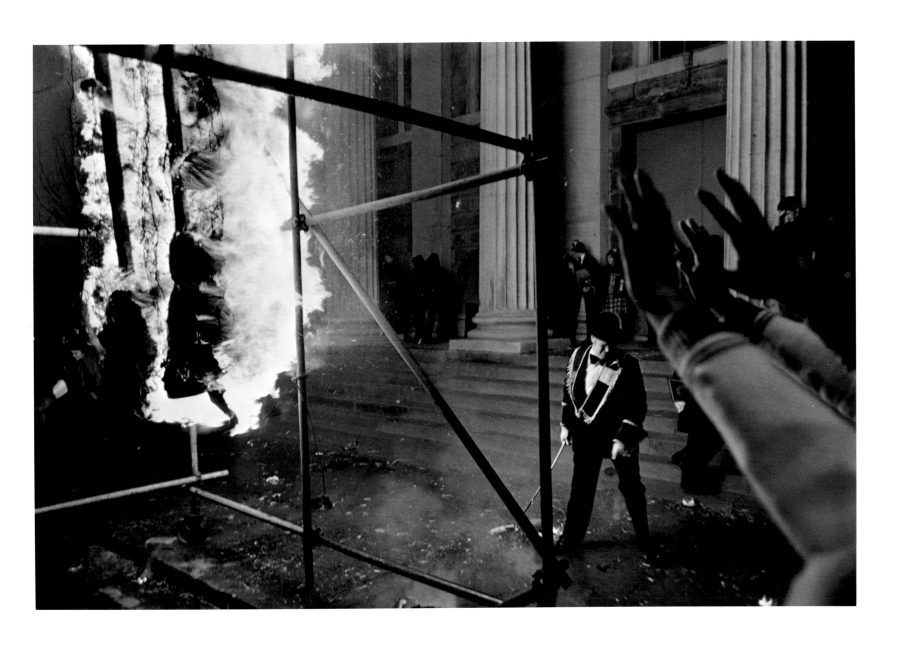

The Burning of Lundy in Effigy, Derry. 1981

[1]) Woolf, Virginia, *A Room of One's Own*, (New York: Harcourt Brace Javanovich, 1969).

[2]) Gilles Peress has since completed a number of major documentary projects, including a look at the lives of Turkish immigrant workers in Germany, an in-depth study of Iranian people and culture in revolution, published as *Telex Iran, In the Name of Revolution*, (New York: Aperture, 1983), an atmospheric look a the cities of Minneapolis and St. Paul, "It Is What It Is: A Double Diary of the Twin Cities," (First Bank St. Paul Gallery, 1986), and an examination of the contemporary legacy of Latin-American liberator Simón Bolívar, 1991. He is currently photographing the civil war in Bosnia, as part of an ongoing documentary project he calls "Hate Thy Brother."

[3]) "H Murray Martin, "Northern Ireland, Gilles Peress," in *Creative Camera*, June 1983, p. 973.

[4]) Peress, Gilles, unpublished outline for Power In The Blood, work in progress, November, 1992.

[5]) Liam de Paor, quoted in Cal McCrystal, "In Cold Blood," *The Independent Magazine*, January 18, 1992, p. 25.

[6]) Murray Martin, op. cit. pp. 972-73.

[7]) Willie Doherty, quoted in Trisha Ziff, "Restricted Visions, Images of Ireland," *Afterimage*, February 1992, p. 6.

had the same experience – fathers who told horror stories from the war to their kids, creating mental images so horrific that people must be compelled to actually see them to deal with them. And to see them you must act them out. There starts the curse of history, another illness which may not be so personal anymore. It may, after all, be a very European disease.

"The collision course accelerated. By accident, my traveling companion was an ex-British Army soldier who had converted to the vicissitudes of freelance photography. When we first met he said, Gilles, you may not remember, but the first time we met was in Derry at the ritual Burning of Lundy. I was an M.P.' Here I was dealing with a true, tortured intellectual, British Army style: Northern England, son of the working-class, Manchester, Fog beer and fries. Imagine me in an endless succession of twin-bed rooms, lying parallel to this guy whose emaciated body and Christ-like long hair could only evoke the image of Bobby Sands, the hunger-striker, and whose monotone death-like monologue rambled until the wee hours of the morning, flawlessly moving from the necessity to execute all IRA suspects to the existential question of becoming a photographer, bucking the system.

"I am bad at memory – this is why I shoot pictures. When I left Bosnia weeks ago, I slept my way from Split to Zagrev, through Frankfurt to Berlin. I dozed on the road into East Germany to wake up a couple of days later in Hoyeswerda, your archetypal late-Kloeneker style concrete-upon-concrete city. Something so gray that a spot of color should have been sufficient to send you to forced labor for fifteen years. We followed death to Soligen, where a neo-nazi skinhead torched the middle class home of a Turkish family, leaving seven bodies reduced to ashes. My own pictures of the Turkish immigrants who made Germany's wealth, taken twenty years ago, came back to me: images of labor camps, of living ten to a room between railroad tracks, assembly lines, loneliness, with a dream for their families. Their children's attempts (and mine) to forget the Germany and Europe, where war crimes have to be dusted under the carpet of history, have become a raging fire.

"Back again now to the old Yugoslavia. I realize the nature of the disease. You are damned if you remember, condemned to relive and reenact the images of your father. You are damned if you don't remember, condemned to repeat this hypocrisy. It's Munich all over again. 15:49, eleven minutes to the BBC news. The shadow of a pigeon glides across the shiny pavement. Soon I will know where people died today. Coming back to Europe, I realize that *la Madeleine baigne dans le sang* and that Bolívar was probably right when, in his alleged discussion with a Frenchman on the Magdalena River, he declared Europe the bloodiest, the most violent continent, so corrupt it could not morally pretend to give lessons to the rest of the world. 16:00. Jingle time. This time it is Travnik. Hundreds of people are dead. We have blood on our hands. By the way, do you know that many of the ruthless Serbian leaders are either ex-psychiatrists or poets. Bonsoir Philippe." Gilles, Zagrev, June 8, 1993.

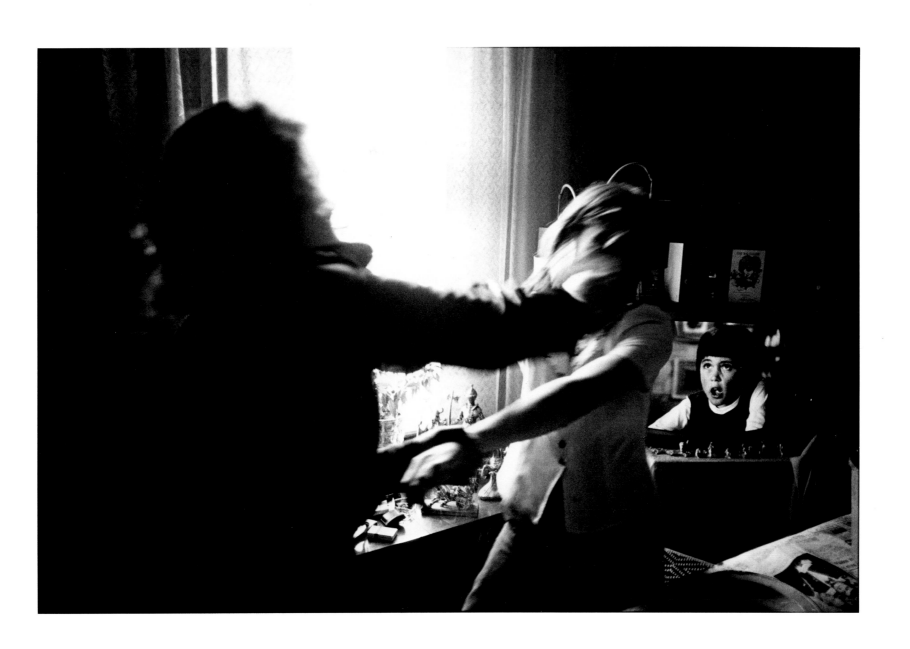

Mother and Daughter, Roden Street, Belfast. 1974

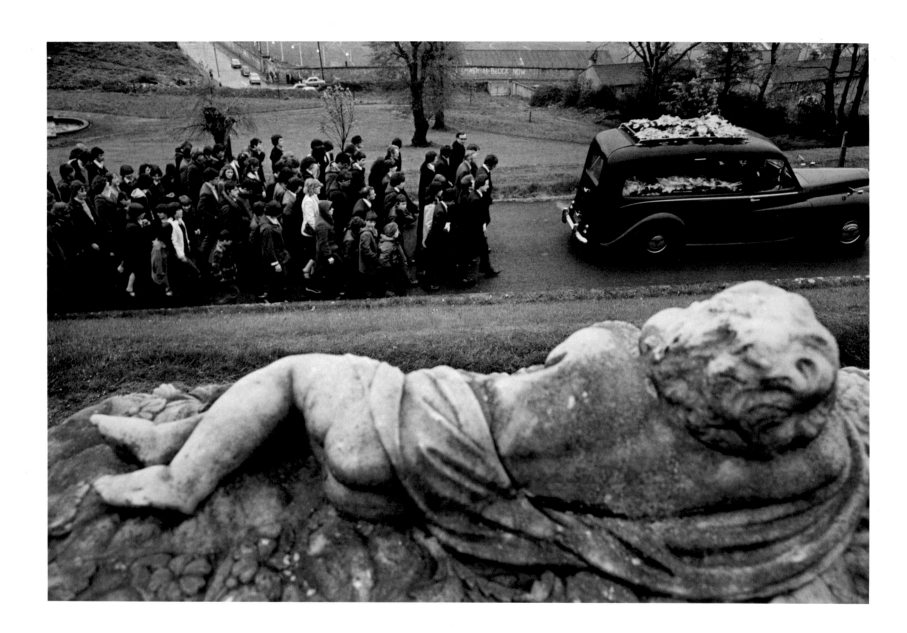

Burial of Gary English Run Over by a Police Landrover, Derry. 1981

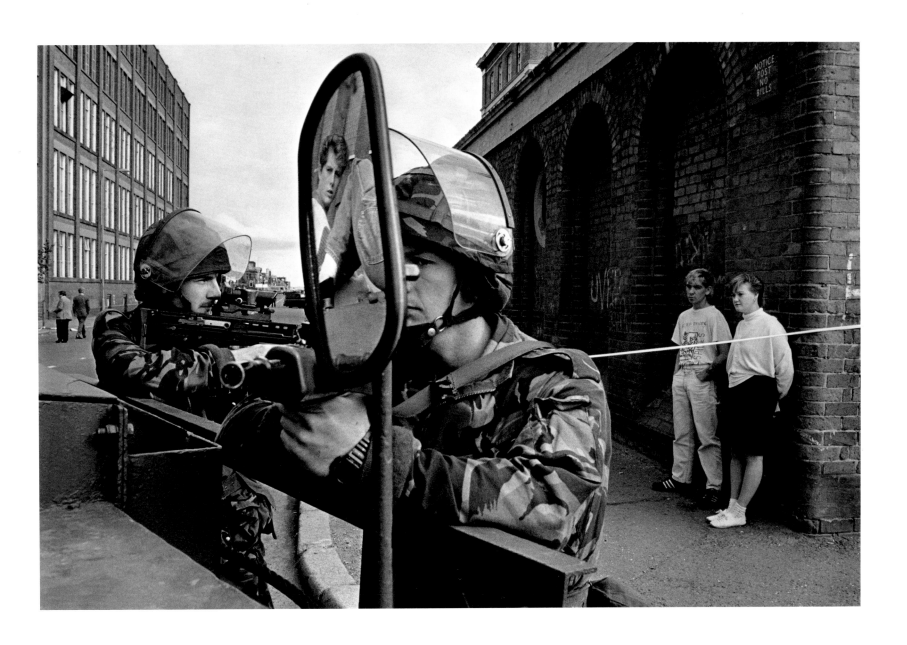

After a Shooting on Cambrai Street and the Crumlin Road, Belfast. 1989

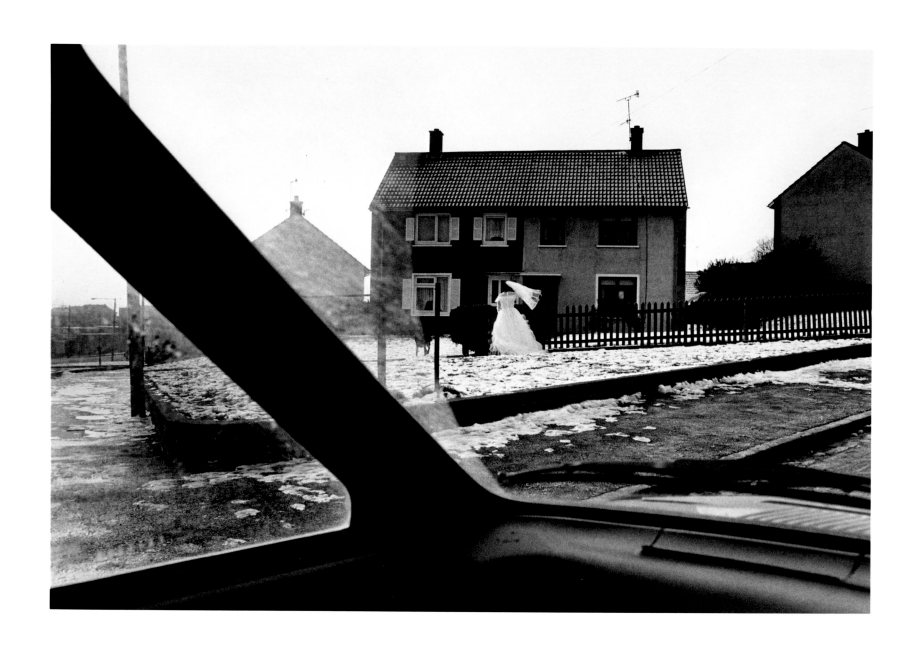

Wedding, Andersontown, Belfast. 1985

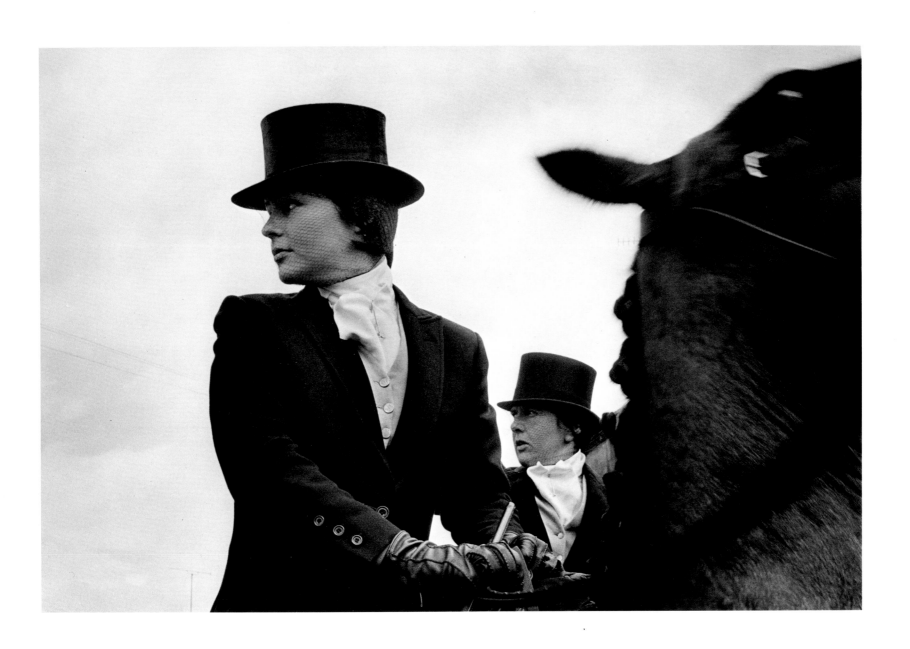

Boxing Day, County Antrim. 1984

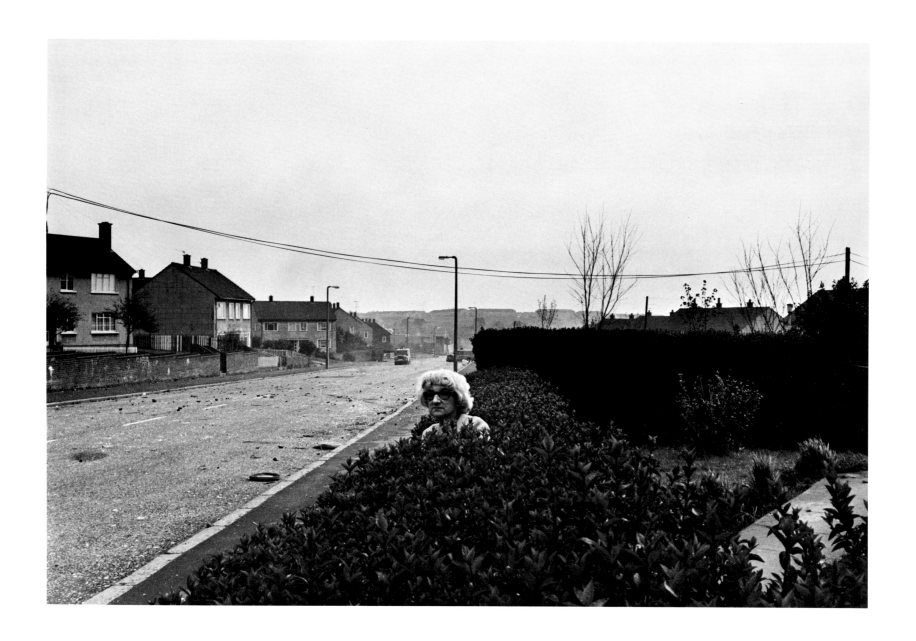

The Morning of Bobby Sands Death, Ballmurphy, Belfast. 1981

LOOKING FOR LEE FRIEDLANDER

Frank Gohlke

Writing about Lee Friedlander is like studying a particularly delicate organism, where even minimal handling might produce lethal damage, or like trying to observe some subtle behavior that is altered by the mere fact of one's presence. Friedlander practices an art of suggestion rather than description. His material is the stuff of our everyday lives, nudged into unfamiliarity by the pressure of his glance, as impalpable and as real as a rain of photons. This transfiguration produces a gap between expectation and effect; our customary responses to the things in a picture do not account for our response to the photograph itself. Positioning himself a half-step to one side of where we ordinarily stand, Friedlander imparts a characteristic spin to the objects of his attention; given the option, he goes for the bank shot rather than rifling the ball straight into the pocket.

Frustrated in our compulsive search for Meaning, we often find ourselves irritated, amused, bemused, or enlightened. Friedlander's photographs are sometimes like the Zen Master's stick, whacking us with contradictions when our response is superficial or obvious, and sometimes like those paradoxical teaching stories whose violations of common sense and logic lead us beyond the ordinary boundaries of thought. Not that Friedlander is trying to teach us anything. He does not profess any interest in what his audience thinks, beyond a general hope they find his pictures as interesting in the viewing as he does in the making. His consistent personal refusal to satisfy demands that he explain his work parallels the way the photographs themselves, by their improvisational structures, resist summary or translation into any other form.

It is paradoxical that Lee Friedlander, of all photographers one of the least willing to talk about himself in public, should have devoted so much of his attention over the years to self-portraits. Of course, in the Friedlander lexicon self-portrait does not mean self-revelation, as even a casual viewer of his 1970 book *Self Portrait* will discover. But neither does Friedlander use the genre simply to parody the idea of self-portraiture. He has a wonderful time spoofing pretentiousness and self-importance, but the game he is playing is much more interesting than mere mockery, and its outlines emerge only when we ask the question: What self is being portrayed? The persona of *Self Portrait* is by turns prankster, magician, cheeky kid, hipster, tired, and befuddled Everyman. When we see the photographer's face, it is usually in this last guise: droopy-lidded, sleep-fogged, maybe even hung over. However, this is not the person I know as Lee Friedlander, whose eyes always seem to be popping with excitement. Whether he's relating an experience, recommending a book or movie, or appreciating a mutual friend, Friedlander's enthusiasms are intense and apparently uncomplicated. He pays attention to things he likes; he is one of the most positive people I know.

Why then does he so often create this sad sack as his stand-in? Puzzling about this question leads me to think about the myths that are being disassembled throughout Friedlander's work,

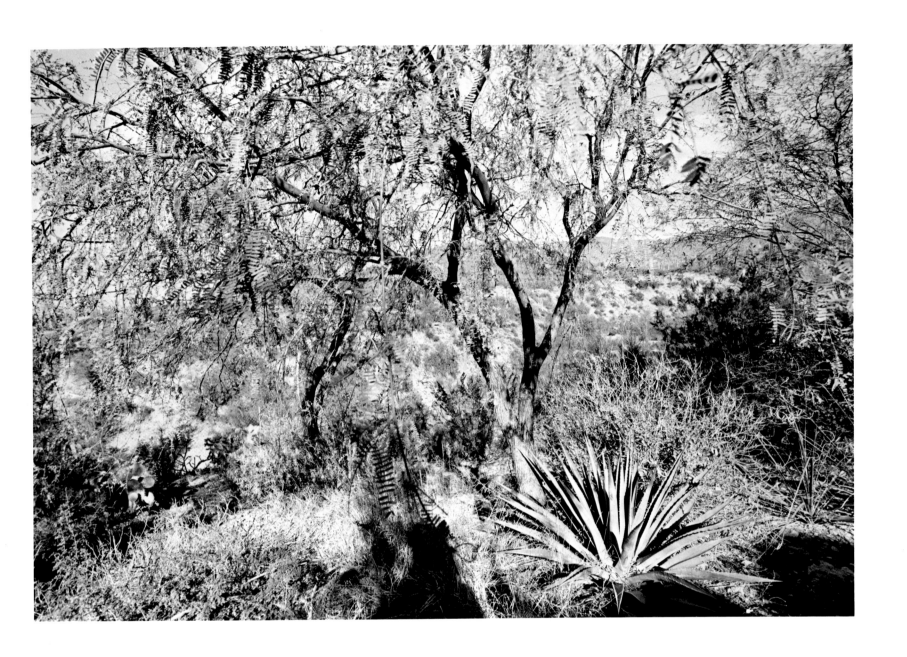

Sonora Desert. 1990

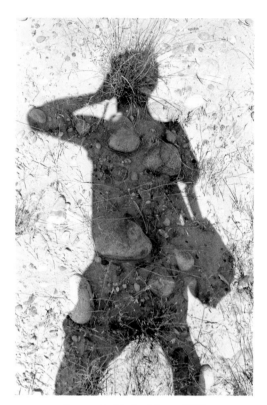

Canyon de Chelly, Arizona 1983

Kokopelli

starting with the myth of the artist as romantic hero. This artist in *Self Portrait* is certainly no hero; it's hard to say exactly what he is, beyond protean. Like the putative subject of *Self Portrait,* Friedlander has the ability to reinvent himself from picture to picture, and, as John Szarkowski has said, from decade to decade as well. From the American icons of the sixties–Ike, the Kennedys, LBJ, movie stars–to *The American Monument,* Friedlander catalogues the changing status of the heroic ideal in American culture, often with tragicomic effect. In succeeding decades, myths of small town innocence, pastoral simplicity, the perfection of the female form, the dignity of toil, and the grandeur of Nature all pass before the deflating gaze of Friedlander's camera.

It is indicative of the nature of Friedlander's art that any statement one makes about it must be immediately followed by its opposite. If the reigning pieties are given rough handling, they are also savored. If immense tracts of our surroundings are shown to be miscreated and incoherent, they also glow with familiarity of home. One might conclude, looking at his photographs, that however unsparing Lee Friedlander's observations are, there is nothing of which he fundament-ally disapproves. This is different from reserving judgment, a negative virtue. It is rather a recog-nition that embedded in every circumstance is evidence of some aspiration toward the good, the ideal, Life, call it what you will. The fact that such strivings are often shown to be foolish, misdirected, or hopeless of achievement does not diminish the power of the impulse or its capacity to hearten us.

Lee Friedlander's public persona effectively deflects attention from himself to his photo-graphs, at the same time that the persona revealed in the photographs remains contradictory and elusive. In this context it is interesting to note the resemblance between Friedlander's shadow in "Canyon de Chelly, Arizona, 1983," the cover image of his book *Like a One-Eyed Cat,* and the figure of Kokopelli, the humpbacked flute-player ubiquitous in the rock art of Canyon de Chelly. Kokopelli is a benign figure of mysterious origin, a changeable symbol of fertility, creativity, and magic.

In the same connection I recall Bix Bolling, the protagonist of *The Moviegoer* by Walker Percy, a novelist Friedlander admires:

Whenever I feel bad, I go to the library and read controversial periodicals. Though I do not know whether I am a liberal or a conservative, I am nevertheless enlivened by the hatred one bears the other....Down I plunk myself with a liberal weekly at one of the massive tables, read it cover to cover, nodding to myself whenever the writer scores a point. Damn right, old son, I say jerking my chair in approval. Pour it on them. Then up and over to the rack for a conser-vative monthly and down in a fresh cool chair to join the counterattack. Oh ho, say I, and hold fast to the chair arm: that one did it: eviscerated! And then out and away into the sun-light, my neck prickling with satisfaction.

This contrary bent is apparent throughout the course of Friedlander's career. The photographic conventions operating at any moment are there to be manipulated, subverted, or stood on their heads. Prohibitions exist to be violated; good taste is the prime target. When Friedlander was

Sonora Desert. 1991

formulating his approach to the medium in the 1950s and early 1960s, the dominant conversations in photography revolved around Beauty and Form. Beauty resided both in subject matter, primarily the natural world, from its intimate details to its epic vistas, and in the aesthetics of the print, Ansel Adams being the most notable exponent of the metaphysics of craft. Form embraced a wide range of ideas, including Alfred Stieglitz's equivalent, with its mystical implications, Edward Weston's Platonic universe of correspondences, and the tense geometries of Henri Cartier-Bresson's decisive moment. Although it would be a terribly incomplete account, one can see in Friedlander's early work a systematic rejection of most of the qualities that were thought to distinguish photographs as works of art from their manifold other uses. By the late 1970s, the work of Walker Evans, Robert Frank, Garry Winogrand, and Friedlander himself formed the basis of a new orthodoxy, and Friedlander jumped the ship he had helped to launch. He began reclaiming genres and subject matter he had formerly avoided, at least publicly. Many of his portraits of friends and family, his landscapes from Japan, his nudes, his photographs of flowers and trees, the Sonoran Desert, and other unpeopled places, all address photographic issues against which Friedlander's earlier work had seemed to be a reaction.

One is tempted to say that the more unacceptable the subject, the more likely Friedlander is to be attracted to it. This has less to do with calculation than it does with being in control of one's choices, although I imagine it can't have displeased him that the publication of *Nudes* occurred at a time when it was bound to cause maximum consternation among his friends and maximum outrage among his detractors. The refusal to be defined from the outside, even if that includes one's own past, is instinctive and informs the spirit with which Lee Friedlander goes about his work. That spirit is manifested in the pictures presented here by the delirium of vegetative growth in an exceptionally harsh environment, by the determination of flesh and hair to follow the laws of their own growth regardless of the prescriptions of fashion, by the power of the personal and idiosyncratic to resist, barely, erosion by the conditions of industrial work. There is a confidence and an elation in this spirit, the result of having crafted one's own freedom choice by choice, picture by picture. There is a humility in it that arises from repeated exposure to what cannot be known, no matter how hard we look.

Friedlander usually chooses to let the words of others introduce his work, but in *Self Portrait* he did the job himself. It's not surprising he didn't feel he needed to do it again. This is the second of two introductory paragraphs:

> *I suspect it is for one's self-interest that one looks at one's surroundings and one's self. This search is personally born and is indeed my reason and motive for making photographs. The camera is not merely a reflecting pool and the photographs are not exactly the mirror, mirror on the wall that speaks with a twisted tongue. Witness is borne and puzzles come together at the photographic moment which is very simple and complete. The mind-finger presses the release on the silly machine and it stops time and holds what its jaws can encompass and what the light will stain. That moment when the landscape speaks to the observer.*

Sonora Desert. 1990

Sonora Desert. 1989

Sonora Desert. 1986

Nude. 1979

Nude. 1978

Nude. 1979

Nude. 1977

Nude. 1978

JOEL STERNFELD

CHAOS: THE ORDER OF THE DAY
Carole Kismaric

A photographer's job is to make order out of the chaos of unmediated experience. His decision to concentrate on one sliver of the seamless, neutral stretch called reality, when he chooses one subject over another, is the first clue we get that his chosen subject is worthy of our attention. "This, not that. Look here, not there." Each picture challenges us to pause, to look closely, as if we might see something for the very first time.

Depending on how accomplished a photographer is with his medium, his decisions about how to picture his subject tell us about his connection to the slice of reality that has caught him in its net. If the photographer shows us more or less of his subject, that tells us one thing. Where he places his subject within the picture frame tells us something more. How long he looks, where he stands, are further clues that fill in gaps about how he wants us to regard what he is considering. Then looking at his picture sends the viewer on a parallel journey to find out how relevant the connection he's made is to us. So while a body of photographs describes how the photographer regards the character of his subject, it also reveals how he understands its meaning and its place in our common, contemporary experience.

Joel Sternfeld's photographs are traditional, carefully crafted images in virtually every sense that we understand straight photography. We see Sternfeld's fix on reality from an omnipotent, neutral viewpoint. Like nineteenth-century photographers before him, he scrutinizes his subject, and with intense concentration, deliberates on every detail, waiting for telling juxtapositions of form and light. For the most part, Sternfeld includes as much of his subject's context as he can, so relationships we don't normally get to see cruising through our quick-paced world, are made apparent. We get to see more. Mountains roll on endlessly. Landscapes sprawl. Rich fields unfold. The immense space that is America is reassuringly confirmed. In the midst of what still feels like untouched territory, man's claim stands out distinctly – old cinder block shacks, abandoned refineries, new housing developments, sparkling buildings that reflect America's wealth and prosperity. Its invention. Its pride. Its right to happiness and progress.

Sternfeld's compositions are meticulously constructed. Ordered. Precise. They exude reliability, even predictability, about how we expect the world to be. How we *want* the world to be. Light venerates a subject, and even if there are shadows into which we cannot see, or a threatening shift in the mood of the light, Sternfeld's pictures are as still as still photography gets. We are reassured just by the way a Sternfeld photograph *looks,* that Beauty is eternal and order still prevails. Formally, Sternfeld's pictures look the way they do because of his fierce intelligence. They are a response, to some degree, to how he sees the world.

Canyon Country, California. June 1983

But, even though Sternfeld is committed to observing Nature, Beauty, and even History, he lives in the 1990s and not one hundred years ago. So *what* he sees is mediated by how complicated everyday life has become. How twisted. How funny. How surprising and shocking. That is why we are jolted, struck, startled when we move beyond what a Sternfeld picture *looks* like to what it is a picture *of*. Calm slides into uneasiness. Order into disruption, and we wake up! What seems resolved is revealed to be a stream of conundrums. Beauty may endure. Order may prevail, but, Sternfeld makes it clear by *what* he chooses to honor that we are living through a time in which what we've come to take for granted is unraveling. In Joel Sternfeld's world, chaos is the order of the day. What his pictures are about comes from his deeply felt reaction to what it means to be alive today, his understanding of the epic struggle that faces each of us. The predictable contrasting with the unexpected. The dependable with the spontaneous. Order pitted against anarchy. In short, what is in and out of control–in our society, our experience, our heads.

We all manage to wrench precious time from our hectic lives to appreciate the beauty that usually passes unnoticed. We sit alone to think about life's meaning and what we understand our relationship to it to be. Concentrating on the edge of a shoreline, as light fades and shimmers against the water, we pause, see, and are reminded of the epic scale of life's spectacle. We can even attempt to stop the harried flow of daily events to reach another level of comprehension. But as we yield, zing! We can't grasp the moment, let alone the thought. Beauty and calm dissolve. We remember our best friend is dying someplace far away. That the machines we assume will last a lifetime, break down constantly. That most people in our world are starving. And that most of us are oppressed in one way or another. Those moments, when calm and order are disrupted, are the moments and the subtle but dynamic shifts that are the subjects of Joel Sternfeld's photographs.

The world according to Sternfeld may be beautiful, but it is not, in any way, "normal." It is weird, and it is painful, and it is more than a little out of orbit, and so are each of his photographs. Instead of extinguishing a fire blazing through the roof of a house, a lone fire fighter stands nearby in a field of pumpkins, thoughtfully judging rows of similar, perfect pumpkins arranged for sale–his best choice so far, tucked under his arm. His concentration is palpable. Are we to believe that the house afire is less important–in his scheme of things–than the search for the perfect pumpkin? Is his indifference to destruction a gentle reminder about how we take everything too seriously? Or is it a warning that we are not paying attention where it matters?

In the country, somewhere in America, a jumble of vehicles clog the road. It's the kind of motor accident that frustrates. Onlookers perch or hover near the edge of the scene. But on closer inspection, what appears to be just another annoyance in everyday life, takes a bizarre twist as we focus on the source of the slowdown. An elephant, drenched with water, tries clumsily to rise to its feet. Wildness brought to its knees, the beast touchingly struggles. For a

McLean, Virginia. December 1978

second, as we blink for a closer look, our hearts race. Can it be? Is this the metaphor that summons up our downward spiral? Nature pathetically tamed by technology, civilization, progress?

Pink flowers run amok, cascading down a front yard like water down a slope, only to be abruptly dammed by a white-picket fence at the edge of a stone wall, next to a dirt road on which sits a fluffy dog who looks at Sternfeld and at us. Nearby houses peek from behind thick, green trees. A pink convertible is parked in the shade of a nearby bush. It's as if the riotous pinkness of the flowers has been translated by man into a technological equivalent of "pinkness" in the jazzy sports car. The friendly dog stares, wondering as we do, what to make of the fact that anyone "sees" the difference, let along cares enough to make something of it.

In Sternfeld's pictures Nature is kind and cruel. The glorious mountains that ring Palm Springs are juxtaposed against the wedge of earth that has given away after a flash flood, taking with it a very expensive, brand new automobile. Pieces of steel, edges of metal, jut from inside a pile of gravel near the edge of an Arizona lake. As the sky turns an exquisite gray-blue, lightening slices through the thick atmosphere. Someone is sending a warning.

On and on Sternfeld takes his inventory, making order out of chaos, then twisting the beautiful by waiting for the contemporary undercurrent to reveal itself. Pointing at the sacred and contrasting it to the profane, he asks the questions that uncomfortably slide around in our heads, the ones we often manage to avoid. What is to be valued? What is to be appreciated? What is to be protected? One minimal picture sums up all the pain implicit in this body of work. At first it looks like a traditional seascape, the sky an impressionistic, fragile blend of grays yielding to violets to beiges. But in Sternfeld's version, beached sperm whales line the shore. The touch of rust color, ringing the water's edge, can only be blood. Aimless onlookers huddle, stand alone, or move cautiously nearer to the whales, maintaining a safe distance from the dark piles of bloated flesh. When you look at the picture long enough, from your omnipotent, safe vantage point, you see it all. That we are big and we are small. That we are alive one moment and dead the next. That we are part of a chain we think we have conquered. That we are teetering on a delicate, ever-shifting balance, where chaos, instead of order, seems to be getting the upper hand. And it breaks our heart.

Man on the Mississippi, Baton Rouge. August 1985

Architecture Museum, Princetown, Massachusetts. July 1980

After a Flash Flood, Rancho Mirage, California. July 1979

The Poet Jane Moller Doing Stretches, Plainfield, Vermont. May 1980

Lake Powell, Arizona. August 1982

Rustic Canyon, Santa Monica, California. May 1979

Exhausted Renegade Elephant, Woodland, Washington. June 1979

Beached Sperm Whales, Florence, Oregon. 1979

LOST IN SPACE
Bruce Boice

A row of young tulips forms a vertical, slanting stack that rests on the handle of a yard cart, the same color as a bottle that seems pressed against it, while being on a board next to an upside-down revolver whose handle is confused with the cart's shadow on a rectangular bed of white stones. The cart handle points like a Renaissance finger at a white, plastic chair, which is balanced symmetrically – and roughly equidistant from the cart on the other side – by a teapot whose oval opening is perfectly aligned with the horizontal edge of the bed of white stones, and whose opened lid forms another oval on the other side of the edge, on the rectangular – in perspectiv – plot of grass. The spout of the teapot also, though more gracefully, points at the chair. The two stacked ovals formed by the teapot's handle and the lid at the base of the grass are also at the base of an irregular column of grass growing up an otherwise denuded hill, above the grass rectangle and opening into a vertical rectangle of trees some distance away, which are pushed and held in place by a wall. The teapot rests in the foreground on one end of the board holding the bottle and gun, but appears to be on the same plane as the cart and the chair, at both of which it gestures. There are young and old trees of various kinds; most of them not yet in leaf; a sledge hammer; an antique type pedestal column holding a glass and another bottle; a hand – as if from a mannequi fused with the jawbone of what was not a small animal; a second white, plastic chair, nearly invisible though in the central foreground; a third, white, plastic chair by the wall on the right at the base of the hill; a table under a tablecloth, which unites with the bed of white stones to form a much larger, clear zigzag shape; and a black rectangular-like thing that we can know nothing about, including it's position. All this is described in shades of gray.

If this is reality, it doesn't sound like what we normally mean by reality. Not what you would expect to come upon on your walk, unless you walk in my backyard.

Artists know no more about reality than anyone else. What's to know? Whatever is, is, and is real. When we say some *thing* is real, we suggest that something else is not. What? What could possibly be *not* real, *not* be part of reality? Reality, in this sense, its large, weighty sounding sense, which includes everything, is meaningless. By denoting everything, reality points to everything and says nothing. For real to be meaningful, it must be opposed to something else, and this can only be done by reducing the scope, and the force, of its meaning, such as by putting reality in opposition to illusion, the imaginary, or the fictional. The apparent irony of Realist writers being writers of fiction is the product of Realism, in that case, being in opposition to something else, Romanticism. These many and varied reduced contexts of meaning can yield a lot of confusion, a confusion compounded by the larger, unreduced, more apparently profound sense of "real."

Untitled. 1992

Why do we have such an obsession with the real? Why do we expect or credit photographers, and other kinds of artists, with showing us reality? There is the idea that reality always seems to elude us; to be just beyond our grasp as if there were something more to it than our experience suggests. What more are we looking for? We seem not to trust our experience, which is to say ourselves. We seem to think we need help in experiencing reality; and if by chance we do, are we going to find that kind of help in a picture? Should we really expect to see reality, if that's what we're looking for, if that's what we're hoping might be made clear, in an art gallery?

A photograph cannot fail, in some way, to describe visual reality. It can only fail to seem worth looking at, to hold us, to matter to us. When we've been captivated by the powerful sense of reality rendered in a photograph, it is more an escape into its reality than a confronting of reality. And what we escape is ourselves. We value anything that makes us, if only for a moment, forget ourselves and our existence. To get lost in something – lost in admiration or in some other way – is to lose ourselves, lose our awareness of our being. I don't expect ever to understand why there should be such a persistent need and drive toward temporary oblivion, but it seems to be at the core of our existence. Fulfilling the need, diverting us away from ourselves to the point of total forgetfulness, occupying us, is the ultimate aim and function of an artwork, a photograph. This same loss of self is the underlying aim of all human endeavor; but except for certain kinds of play, other forms of occupation have a layering of another purported function – to succeed, reproduce, relax, earn a living, or simply to get rid of the clutter of dishes in the kitchen sink. Art is different because it has no other aim; no disguises, ideally, just raw oblivion.

What will accomplish this complete diversion away from ourselves cannot be prescribed, in part because we are different and are diverted by different causes and things, but also because we cannot know what will affect us. We cannot accurately predict the character of our experience. Often, when we are completely taken, totally lost, we don't know why, and sometimes we are, in fact, surprised that something, which usually has no effect on us and isn't expected to, has riveted us, and made us, whether we still do that sort of thing or not, feel the need for a cigarette.

Usually, we don't expect to find much excitement in a still life. What could be very interesting about some fruit, bottles, and other stuff on a table? Certainly we've seen enough of them. Everything has been photographed over and over again. Even subjects which were once taboo, if not illegal, are now available to us in enormous quantity. A certain person in a photograph may be a new subject to photograph, but only to the extent that the person has not existed before and not appeared in other photographs we've seen. But, like apples and pears, such a person, though specifically unique, cannot be substantially so different from others we've seen as to surprise us, or constitute a new object in photography. If it's true that all thumbprints are different, it is also true that they all look the same: a thumbprint is a

Untitled. 1992

thumbprint. As photography is essentially anchored in the visual world, it would seem to be hampered and limited by this severe shortage of new objects to photograph.

But art is a world of vagueness, a kind of no man's amorphous land of endless, seemingly arbitrary choices and decisions. It desperately needs limitations. Limits exist to be bounced off and pushed against; they provide a certain grounding. For photography, this limitation of a limited supply of objects to picture is perhaps more than anything else, what makes a photograph art. Otherwise it and its history amounts to little more than a record or a catalogue of different objects and situations. A photograph must be newer than the newness of its objects; if for no other reason than the fact that once seen, or seen a few times, perhaps, like its objects, it is no longer new; it is now known and can no longer hold us. Edward Weston's photographs of toilets in Mexico were new in just that way: toilets weren't new, but they were new in a photograph. But we're past that now. The surprise of a toilet itself no longer means anything to us, but the photograph might.

That we are familiar, by now, with all the basic objects and situations in photograph means that if a photograph is going to matter to us, it will have to be in terms of how and what kind of picture is made with those objects. How objects relate to each other and to the space in which they exist have to provide the surprise and tension, the charge of a photograph.

There is nothing surprising about three, white, plastic chairs, a yard cart, a teapot, and other assorted objects in a somewhat domestic landscape being pictured in a photograph. But to name the objects in the picture and describe the situation is nothing like looking at the actual photograph. At first, the general appearance is one of casualness, as if, perhaps, some of this stuff ought to be put back where it belongs instead of being strewn about. But that's only a first impression. The reality into which we can escape, if we do, is of a dizzying, spellbinding order that won't sit still. It is hard to know where anything is; and just as we piece the reality of the space together, we lose it. Understanding the causes of this tension, the craziness even, doesn't lessen the photograph's force. If there is a continual surprise in looking at the photograph, it is not in the specialness of the objects, nor is it in some reality that shows us something about the world; it is that we cannot grasp an apparently simple and obvious situation. We cannot know it. Once we know it, it's over.

Plain Fields. 1981

Plain Fields. 1981

Plain Fields. 1981

Plain Fields. 1981

Plain Fields. 1981

Plain Fields. 1981

Plain Fields. 1981

Plain Fields. 1981

PARALLEL EVOLUTION IN THE BROOKLYN NEOLITHIC

Stuart D. Klipper

I lived in Brooklyn, New York, once when younger. Earlier in his life, Jim Bengston also lived there. We lived only about two blocks from each other. We lived there at the same time. We never met when we lived there. Nonetheless, we walked the same gray-slated street. We saw the same things. The soot-darkened rows of old brownstones; the august and sesquicentennial churches; the sycamores and ginkos, their buds and birdsong in the thin, crisp light of early spring; all the smoky, watery, ruddy, New Jersey sunsets. We dwelt concurrently in the same place and absorbed its ambiance. We knew its names, we knew its nature. While in parallel, our experiences were separate. We never knew the other was around.

Years later, we finally did meet. We became friends and grew to know one another. When histories were spoken, there was surprise and concession. We easily agreed that, no matter where our lives subsequently had taken us, we indeed – oddly, gladly – always shared the same neighborhood. Our ways and our ways of being in the world (in our worlds), our manners of observation and response had placed us in conversation long before our first introductory Olso, "Hello."

That old Brooklyn neighborhood, Brooklyn Heights, has been of historical importance to the cultural life of America. Perhaps, too, it has been of historical moment in our tandem lives as artists, and in the longterm life of our friendship.

WHAT IS THE REAL WORLD, ANYWAY? AND WHY?

Arguably, no world is more real than another. The "Where" where we exist, where there are events, energy, and stuff, where there is life, process, and entropy – the "Where" of us, began as, and likely remains, virtual. Also, there are those worlds that seem only imagined; imagined when out of context, of course. Neat worlds, messy worlds; partial and paltry worlds and full. Fusions and fulfillments. It never stops; one world defines, demands another. All in one, one in all. A grand equanimity. Real and one. In singularity, in symmetry. In vortices of synthesis.

A world. Clearly seen and linked by the artist, by the physicist, by the poet, by the pious. The world we are in.

Grace is a circle; it is balance. Grace is what we come to when we do find the right place – simply, the "Where" where we ought to be; where we feel free. One way to look at it is to look, to point, to find that sought and important balance, and possibly then, as amongst our ilk·(Jim for one, for sure), make the photograph. One that is right; one that is real. This is what we do.

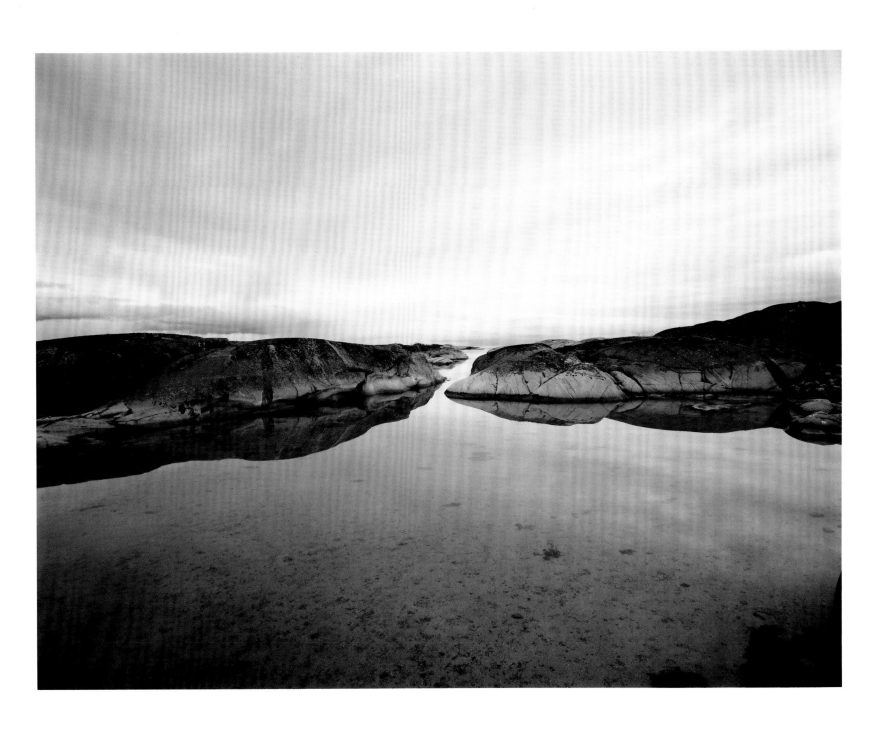

Untitled. From the Series "Empty Landscape, Portør (Norway). October 1992"

TRAVELING LIGHT

Once there was Up and Down. Long gone. Right and Left also no more. And now, I've just learned, recent theoretical insights in astrophysics about the gravitational happenings in the neighborhood of Black Holes, tells us the old In and Out are kaput, too.

There is new light on the matter. At certain critical radii, light's straight lines swerve into circles—they turn, turn, and turn again. Truth is loose. Gravity loops Space. Centrifugal is centripetal; all expected directions reverse and remain contrary. Things are not what they seem. There is a new norm. We need new bearings.

So, basically, where great attractions prevail, light doesn't go where we presume it might. At foci of intense concentration, manifold dimensions flatten to plane, and any point or pointing becomes pointlessly transfinite and Aleph-like. Here is where our stance and stature, though stilled, can still be transporting; the centered lens-like spots where external space and surface find reified being and gain congruence with our spiritual interiors. And, ultimately, where the horizon, apprehended or not, albeit forever the ever-present, all embracing merging of Heaven and Earth, is intrinsically, always becoming another center, another pivot. Relentless circles. Restlessness. Enigma.

There is no standing still, is there, Jim? No way is certain, right?

THE SOUND OF SILENCE

Jim plays a saxophone. Stringing his riffs genetically into jazz. Jim looks at silence, but then there are Jim's photographs—what Jim hears when the music stops?

Corollary: Jim is a ceaseless, tireless talker, so it would be my further surmise that, in this case, Jim's photography must start with what he can no longer frame in words.

THE EDGE OF THE WORLD

We all need to be the geographers of our lives. Plotting the points where we've taken notice; potentially positioning each Now from how we've reckoned where we've just been—and how we must next proceed. Global as we know our world is, it still has edges. Perspectives, horizons. Horizons—near, far, middle—beckon and daunt. We need centers; we want to get home.

In my house in Minneapolis on Xerxes I have a wall with twelve of Jim's photographs, positioned in two two by three constellations [2x6=12=Sefiroth]. Of snowy paths trod through high crags, of watery twistings between coastal skerries. Sastrugi, surf; ancient glacial scoring, odd eroded snow. Places strongly seen, slight scenes; points acutely noticed —again, plottings. Jim's work. Good maps; indeed, a concise atlas (Nordic, boreal—not only so). The scale just right, and true to life. Telling where we can be. And how we can know where we're at. Leaving still an edgy sense of limitation and limits.

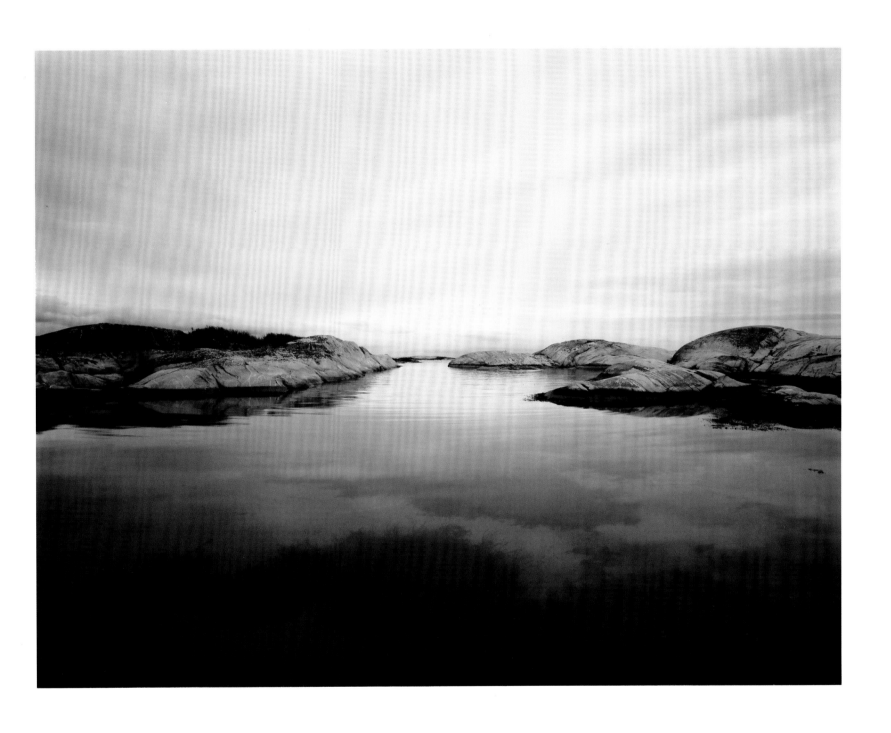

Untitled. From the Series "Empty Landscape, Portør (Norway). October 1992"

We can only go so far. Take only so much time. Time to stop, time to wonder. To think and tell. To see and to show. And then, as always, as we must, to start onward again, ambling into increasingly uncertain terrain, onto holier ground.

"Time present and time past. Are both present in time future,
And time future contained in time past If all time is eternally present..."
 T.S. Eliot, Burnt Norton

No matter the shutter or emulsion speed, the lens or aperture, Jim's images are a twined, entwined complementarity of stop-watched freeze frame and slo-mo time lapse. Dwelling and fleeting. Splashed, frozen; elemental and momentary. Boulders set still in tide-tried sands; snow in the air. Wind-worn rime, crises in ice; sodden salt shores, calm seas. The Real real world is seen as synchronous, simultaneous; historical, circular, and relativistic. This world, then is depicted as it is; as both timeless and time-laden.

As I see them, Jim's objectives are not optical, his focus non-planar. Time is always latent, waiting for our clicked moment of exposure and assurance, composure and aspiration. Time is Jim's breath. Time is Jim's air.

HERE AND/OR THERE

It is March, our two-faced month. I write this in Colorado, on the High Plains. I rewrite this in Colorado, too, in the High Peaks. It's nearing the equinox. Dust and sun, snow and sun; long dusks, high noons. Wind and clouds; clear air and haze—the West. The Real West. The Interior West. The Interior.

I am thinking about Jim. I wander around. I make some photographs. Is what I am looking at what Jim would look for? Some time, some place, elsewhere, I'll bet he does the same, asks the same of me.

Maybe not.

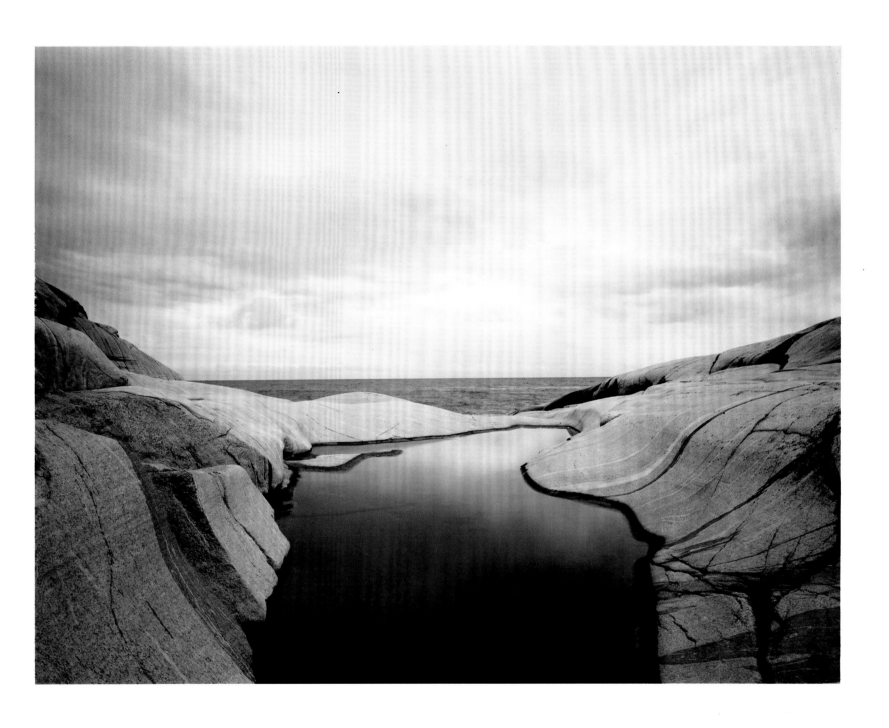

Untitled. From the Series "Empty Landscape, Portør (Norway). October 1992"

Untitled. From the Series "Empty Landscape, Portør (Norway). October 1992"

Untitled. From the Series "Empty Landscape, Portør (Norway). October 1992"

Untitled. From the Series "Empty Landscape, Portør (Norway). October 1992"

Untitled. From the Series "Empty Landscape, Portør (Norway). October 1992"

Untitled. From the Series "Empty Landscape, Portør (Norway). October 1992"

Untitled. From the Series "Empty Landscape, Portør (Norway). October 1992"

Untitled. From the Series "Empty Landscape, Portør (Norway). October 1992"

BIOGRAPHIES: PHOTOGRAPHERS

LEWIS BALTZ
Paris, France
Born in 1945 in Newport Beach, California, USA
Educated at San Francisco Art Institute (1969) - MFA

Selected one-person exhibitions:
1971 Castelli Graphics, New York
1974 Corcoran Gallery, Washington D.C.
1976 Museum of Fine Arts, Houston, Texas
1980 Werkstatt für Fotografie, Berlin
1985 Victoria and Albert Museum, London
1987 Tokyo Institute of Polytechnics, Tokyo
1990 Museum at the PS 1, New York
1991 Centre Culturel, Vitre, France
1992 Stedelijk Museum, Amsterdam, The Netherlands
1992 Centre Pompidou, Paris, Frankrike
1993 Musée d´Art Moderne de la Ville de Paris, France
1993 Fotomuseum Winterthur, Switzerland

Selected group exhibitions (after 1991):
1991 Fundació "la Caixa", Barcelona: "Fotografica Americana del S. XX"
1992 Rotterdam Biennale III: "Wasteland"
1993 Tokyo Metropolitan Museum of Photography: "Critical Landscapes"

Selected publications
1975 "The New Industrial Parks Near Irvine, California"
1978 "Nevada"
1981 "Park City"
1986 "San Quentin Point"
1989 "Candelstick Point"
1992 "Ronde de Nuit"

Works included in
Art Gallery of Ontario (Toronto, Canada), Art Institute of Chicago (USA), Bibliothèque Nationale (Paris, France), Corcoran Gallery of Art (Washington D.C., USA), Moderna Museet (Stockholm, Sweden), Henie-Onstad Kunstsenter (Bærum, Norway), Musée d´Art Moderne de la Ville (Paris, France), Victoria and Albert Museum (London, England), National Museum of Modern Art (Kyoto, Japan)

JIM BENGSTON
Oslo, Norway
Born in 1942, Evanston, Illinois, USA
Educated at Lake Forest College, Illinois in Literature (BA) (1964)

Selected one-person exhibitions
1979 Fotogalleriet, Oslo
1981 Henie-Onstad Kunstsenter, Bærum
1984 – 85 Tour of European and American towns; "Alcatraz" (with the composer Ingram Marshall)
1991 Henie-Onstad Kunstsenter, Bærum: "Empty Landscape"
1993 Jernigan/Wicker Gallery, San Francisco: "Empty Landscape"

Selected group exhibitions
1978 Museum of Modern Art, New York: "Mirrors and Windows"
1981 Venezia Biennale: "Extended Photography"
1982 The Walker Center, Minneapolis: "The Frozen Image"
1988 Burden Gallery (Aperture), New York: "Swimmers"
1992 Berlinische Galerie, Berlin: "Sprung in Die Zeit"

Selected publications
1978 "Afterwords"
1981 "Fiber" (with Bård Breivik)
1986 "Slow Motion"
1991 "Alcatraz"

Works included in
Art Institute of Chicago (USA), Bibliothèque Nationale (Paris, France), Museum Ludwig (Cologne, Germany), Museum of Modern Art (New York, USA), Henie-Onstad Kunstsenter (Bærum, Norway), Museum for fotokunst (Odense, Denmark), National Museum of American Art (Smithsonian, Washington D.C., USA), San Francisco Museum of Modern Art (USA), Trondheims Kunstforening (Norway)

LEE FRIEDLANDER
New York, USA
Born in 1934 in Aberdeen, Washington, USA

Selected one-person exhibitions
1963 International Museum of Photography, George Eastman House, Rochester
1972 Museum of Modern Art, New York
1974 Museum of Modern Art, New York
1976 Corcoran Gallery, Washington D.C.
1979 Musée d´art Contemporain, Montreal
1980 Minneapolis Institute of Fine Arts
1985 Tel Aviv Museum
1986 ICA, London
1987 Seibu Museum, Tokyo
1991 Victoria and Albert Museum, London
1991 Museum of Modern Art, New York: "Nudes"
1993 Canadian Centre for Architecture, Montreal

Selected publications
1969 "Work From the Same House" (with Jim Dine) (London)
1970 "Selfportrait" (NY)
1976 "The American Monument" (NY)
1978 "Lee Friedlander: Photographs" (NY)
1981 "Flowers and Trees" (NY)
1982 "Factory Valleys" (NY)
1985 "Lee Friedlander: Portraits"
1987 "Cray at Chippewa Falls"
1989 "Like a One-Eyed Cat" (NY)
1991 "Nudes" (London)
1992 "The Jazz People of New Orleans" (NY)
1992 "Maria" (Mass.)
1993 "Letters from the People" (NY)

Works included in
Art Institute of Chicago (USA), Museum of Modern Art (New York, USA), Bibliothèque Nationale (Paris, France), National Gallery of Canada (Ottawa, Canada), Victoria and Albert Museum (London, England), Metropolitan Museum of Art (New York, USA), Stedelijk Museum (Amsterdam, The Netherlands), National Gallery of Australia (Canberra, Australia), Minneapolis Institute of Fine Arts (USA)

FLOR GARDUÑO
Mexico City, Mexico
Born in 1957 in Mexico City, Mexico
Educated at School of Fine Arts, National University, Mexico City

Selected one-person exhibitions
1980 National Academy of Fine Arts Gallery, Mexico City
1982 Casa Jose Clemente Orozco, Mexico City
1985 Galeria Tartessos, Barcelona: "A Mexican Photographer"

1987 La Chambre Claire, Paris: "Magica del Juego Eterno"
1988–1991 Mexico City; Rotterdam; Chicago; Montreal; Montpellier: "Bestiarium"
1992–1993 Lausanne; Mannheim; Houston; Chicago; Tuscon; New York; San Diego; Mendrisio: "Witness of Time"

Selected group exhibitions
1982 Mexican Biennale of Photography, Mexico City
1986 Houston Center for Photography: "39 Mexican Photographers"
1987 Schirn Kunsthalle, Frankfurt: "The Image of Mexico"
1990 Art Institute of Chicago: "What´s new, Mexico City?"

Selected publications
1985 "Magica del Juego Eterno" (Oaxaca)
1987 "Bestiarium" (Zurich)
1992 "Witness of Time" (London etc.)

Works included in
Museum of Modern Art (New York, USA), Museum Ludwig (Cologne, Germany), Museum of Fine Arts (Houston, USA), Bibliothèque Nationale (Paris, France), Museo de Arte Moderno (Mexico City, Mexico), Santa Barbara Museum of Art (USA), Stiftung für Photographie (Zürich, Switzerland)

PAUL GRAHAM
London, England
Born in 1956 in Stafford, England
Educated at Bristol University (1975–1979)

Selected one-person exhibitions
1986 National Museum of Photography, Bradford

1987 FNAC, Les Halles, Paris
1988 PPOW Gallery, New York
1989 Galerie Claire Burrus, Paris
1989 Centre Regional de la Photographie, Douchy
1990 National Museum of Film and Photography, Bradford
1991 Aschenbach, Amsterdam
1992 Anthony Reynolds Gallery, London

Selected group exhibitions
1986 Museum of Photography, Chicago: "The New British Document"
1987 Museum of Modern Art, New York: "New Photography 3"
1987 Corcoran Gallery, Washington D.C.: "Future Photography"
1988 Victoria and Albert Museum, London: "Towards a Bigger Picture"
1989 Barbican Gallery, London: "Through the Looking Glass – Independent Photography in Britain 1946–1989"
1991 Museum of Modern Art, New York: "British Photography from the Thatcher Years"

Selected publications
1983 "A1 – The Great North Road" (London)
1986 "Beyond Caring" (London)
1987 "Troubled Land" (London)
1990 "In Umbra Res" (Manchester)

Works included in
Museum of Modern Art (New York, USA), Metropolitan Museum of Art (New York, USA), Museum of Modern Art (Tampere, Finland), Victoria and Albert Museum (London, England), Museum Ludwig (Cologne, Germany), National Museum of Photography (Bradford, England), Musée de la Photographie (Charleroi, Belgium)

JAN GROOVER
Montpon-Menesterol, France
Born in 1943 in Plainfield, New Jersey,
USA
Educated at Pratt Institute, Brooklyn and
Ohio State Universities (1965–1970)

Selected one-person exhibitions
1974 Light Gallery, New York
1976 Corcoran Gallery, Washington D.C.
1978 Sonnabend Gallery, New York, Paris
1983 Neuberger Museum, New York: "Jan
Groover: Photographs" (retrospective)
1985 Robert Miller Gallery, New York
1987 Museum of Modern Art, New York:
"Jan Groover: Photographs" (retrospective)
1989 Demure Bossuet, Metz: "Jan Groover"
(retrospective)
1992 Robert Miller Gallery, New York

Selected group exhibitions
1977 Museum of Fine Arts, Houston:
"Contemporary Photographic Works"
1978 Museum of Modern Art, New York:
"Mirrors and Windows"
1979 Whitney Museum of American Art,
New York: "Auto-Icons"
1980 Rheinisches Landesmuseum, Bonn:
"Lichtbildnisse – Das Portrait in der
Fotografie"
1982 Metropolitan Museum of Art, New
York: "Counterparts: Form and Emotion in
Photographs"
1983 Museum of Modern Art, New York:
"Big Pictures"
1985 Barbican Art Gallery, London:
"American Images: Photograph 1945–1980"
1988 List Visual Arts Center,
Massachusetts Institute of Technology:
"Three on Techonology: Robert Cumming,
Lee Friedlander, Jan Groover"
1991 University of Akron, Ohio: "The

Encompassing Eye – Photography as
Drawing"
1993 Isetan Museum, Tokyo, Japan:
"American Made: The New Still-Life"

Selected publications
1993 "Jan Groover" (with text by John
Szarkowski) (Boston)

PER MANING
Oslo, Norway
Born in 1943 in Oslo, Norway
Educated at Akademiet for fri og merkantil
kunst, Copenhagen (1965–1967)

Selected one-person exhibitions
1989 Galleri Riis, Oslo
1990 Museum Folkwang, Essen
1991 Tarazona Photo Festival, Tarazona
1993 Steven Wirtz Gallery, San Francisco

Selected group exhibitions
1988 Fotobiennale Rotterdam:
"Questioning Europe"
1992 The Biennale of Sydney, Australia
1993 Galleri F-15, Moss: "Legeme"

Works included in
Museum of Modern Art (New York, USA),
Museum Folkwang (Essen, Germany),
Stedelijk Museum (Amsterdam, The
Netherlands), Museet for Samtidskunst
(Oslo, Norway)

MARTIN PARR
Bristol, England
Born in 1952 in London, England
Educated at Manchester Polytechnics, pho-
tography (1970–1973)

Selected one-person exhibitions
1974 Impressions Gallery, York: "Home
Sweet Home"

1982 Photographers Gallery, London og
International Photography Festival,
Malmö: "Bad Weather"
1984 Orchard Gallery, Derry: "A Fair Day"
1986 Serpentine Gallery, London: "The
Last Resort"
1987 Centre National de la Photographie,
Paris: "Spending Time"
1989 Royal Photographic Society, Bath
(with tour in Finland, Portugal, Spain and
Ireland): "The Cost of Living"
1992 Janet Borden Gallery, New York:
"Signs of the Times"
1993 Galerie du Jour, Paris: "Bored
Couples"

Selected group exhibitions
1986 Houston Art Festival: "British
Contemporary Photography"
1989 Barbican Center, London: "Through
the Looking-Glass. British Photography
1945–1989"
1991 Museum of Modern Art, New York:
"British Photography from the Thatcher
Years"

Selected publications
1982 "Bad Weather"
1984 "A Fair Day"
1986 "The Last Resort"
1989 "The Cost of Living"
1992 "Signs of the Times"
1993 "Home and Abroad"

Works included in
Museum for Fotokunst (Odense, Denmark),
Victoria and Albert Museum (London,
England), Museum of Modern Art (New
York, USA), Philadelphia Museum of Art
(USA), Museum of Modern Art (Tokyo,
Japan), Museum Folkwang (Essen,
Germany), Museum of Modern Art
(Tampere, Finland)

GILLES PERESS
New York City, USA
Born in 1946 in Neuilly, France
Educated at Institute d´Études Politiques,
Paris (1966–1968) and Université de
Vincennes (1968–1971).

Selected one-person exhibitions
1977 Massachusetts Institute of
Technology, Cambridge, USA
1980 Adaku Grand Gallery, Tokyo
1981 Palais de Luxembourg, Paris
1984 Musée d´Art Moderne, Paris
1987 Museum of Contemporary
Photography, Chicago
1989 International Museum of Photo-
graphy/ Eastman House, Rochester, NY
1990 Art Institute of Chicago

Selected group exhibitions
1985 Corcoran Gallery, Washington D.C.
1989 International Center of Photography,
New York
1989 Side Gallery, Newcastle-upon-Tyne

Selected publications
1984 "Telex Iran" (NY)
1993 "Power in the Blood: Photographs of
Northern Ireland" (NY)

Works included in
Art Institute of Chicago (USA),
Bibliothèque Nationale (Paris, France),
Musée d´Art Moderne (Paris, France),
Victoria and Albert Museum (London,
Great Britain), Metropolitan Museum of
Art (New York, USA), Museum of Fine Arts
(Houston, USA), Museum of Modern Art
(New York, USA)

JUDITH JOY ROSS
Bethlehem, Pennsylvania, USA
Born in1946 in Hazleton, Pennsylvania, USA

Educated at Illinois Institute of
Technology, Chicago
(Masters of Science in Photography).

Selected one-person exhibitions
1989 Pennsylvania Academy of Fine Arts,
Philadelphia: "Portraits of the U.S.
Congress 1986–1987"
1991 James Danzinger Gallery, New York
1993 San Francisco Museum of Modern Art

Selected group exhibitions
1985 Museum of Modern Art, New York:
"New Photography"
1987 Philadelphia Museum of Art: "Twelve
Photographers Look At Us"
1988 Whitney Museum of American Art at
Philiph Morris, New York: "Real Faces"
1990 Museum of Modern Art, New York:
"Photography Until Now"
1992 Museum of Modern Art, New York:
"More Than One Photograph"

Works included in
Museum of Modern Art (New York, USA),
Metropolitan Museum of Art (New York,
USA), San Francisco Museum of Modern
Art (San Francisco, USA), Museum of Fine
Arts (Houston, USA)

THOMAS RUFF
Düsseldorf, Germany
Born in 1958 in Zell am Harmersbach,
Germany
Educated at Staatliche Kunstakademie
Düsseldorf under Professor Bernd Becher

Selected one-person exhibitions
1981 Galerie Rüdiger Schöttle, Munich
(Germany)
1984 Galerie Konrad Fischer, Düsseldorf
(Germany)

1987 Galerie Sonne, Berlin (Germany)
1988 Mai 36 Galerie, Luzern (Switzerland)
1989 Stedelijk Museum, Amsterdam (The
Netherlands)
1990 Verein Kunsthalle, Zurich
(Switzerland)
1991 Kunstverein Bonn, Arnsberg,
Braunchsweig (Germany)

Selected group exhibitions
1982 Art Galaxy, New York: "Work by
Young German Photographers"
1986 Museum Folkwang, Essen: "Reste des
Authentischen"
1988 Venezia Biennale: "Aperto 88"
1989 Musée d´art Contemporain Montreal:
"Tenir l´image à distance"
1990 San Francisco Museum of Modern
Art: "New Work: A New Generation"
1991 Martin Gropius Bau, Berlin:
"Metropolis"
1992 Kassel: Documenta IX
1992 Museum of Modern Art, New York:
"More than One Photography"
1992–93 Lausanne, Torino, Athens,
Hamburg: "Post Human"

TOM SANDBERG
Oslo, Norway
Born in 1953 in Narvik Norway
Educated at Trent Polytechnics,
Nottingham and Derby College of Art and
Technology, Derby

Selected one-person exhibitions
1984 Galerie de Musée de la Photographie,
Charleroi
1985 Henie-Onstad Kunstsenter, Bærum
1989 Galleri Riis, Oslo
1993 Fotogalleriet, Oslo

Selected group exhibitions
1978 Moderna Museet, Stockholm: "Tusen

och en Bild"(Sweden)
1985 Calouste Gulbenkian Foundation,
Lisbon: "Dialogue on Contemporary Art in
Europe"(Portugal)
1986 Kunstmuseum Dusseldorf:
"Scandinavian Photography"(Germany)

Works included in
Museet for Samtidskunst (Oslo, Norway),
Henie-Onstad Kunstsenter (Bærum, Norway)

MICHAEL SCHMIDT
Berlin, Germany
Born in 1945 in Berlin, Germany

Selected one-person exhibitions
1975 Galerie Springer, Berlin
1981 Museum Folkwang, Essen
1985 Museo di Rimini, Rimini
1987 Sprengel Museum, Hannover
1988 Museum of Modern Art, New York
1989 Goethe Institut, Torino, Roma, Ghent
1991 Kunstverein Gottingen
1993 Galerie Springer, Berlin

Selected group exhibitions
1979 Rheinisches Landesmuseum, Bonn:
"In Deutschland"
1980 Folkwang Museum, Essen: "Absage
an das Einzelbild"
1984 Castelli Graphics, New York:
"Fotografie aus Berlin"
1986 Folkwang Museum, Essen: "Reste des
Authentischen"
1989 Victoria and Albert Museum, London:
"Photography Now"
1990 Museum of Modern Art, New York:
"Photography Until Now"
1990 Museum of Modern Art, Kyoto: "The
Past and Present of Photography"
1991 Museum of Art St Petersburg:
"Inteferenzen, Kunst aus West-Berlin"

1992 Museum of Modern Art, New York:
"More than One Photography"
1993 Akademie der Künste, Berlin: "Uber die
grossen Städte"

Selected publications
1987 "Waffenruhe"

Works included in
Berlinische Galerie (Germany), Folkwang
Museum (Essen, Germany), Bibliothèque
Nationale (Paris, France), Museum of
Modern Art (New York), Museum of
Modern Art (Tokyo, Japan), Museum of
Modern Art (San Francisco, USA), Victoria
and Albert Museum (London, Great
Britain), Neue Nationalgalerie (Berlin,
Germany), Sprengel Museum (Hannover,
Germany)

MICHAEL SPANO
New York City, USA
Born in 1949 in New York City, USA
Educated at Yale University, School of Art
– MFA

Selected one-person exhibitions
Lawrence Miller Gallery, New York
Jane Corkin Gallery, Toronto
Cleveland Museum of Art
Zabriskie, Paris
Robert Miller Gallery, New York

Selected group exhibitions
Museum of Modern Art, New York
Los Angeles County Museum of Art
National Portrait Gallery, Washington
D.C.

Works included in
Art Institute of Chicago (USA), Museum of
Modern Art (New York, USA), Whitney

Museum of American Art (New York,
USA), Museum of Fine Arts (Boston, USA),
Museum of Fine Arts (Houston, USA),
Museum für Kunst und Gewerbe
(Hamburg, Germany)

JOEL STERNFELD
New York City, USA
Born in 1944 in New York City, USA
Educated at Dartmouth College, Hanover,
New Hampshire (BA)

Selected one-person exhibitions
1976 Pennsylvania Academy of Fine Arts,
Philadelphia
1981 The Photography Gallery, La Jolla,
CA
1985 Higashikawa International Festival,
Japan
1987 Museum of Fine Arts, Houston (with
tour): "American Prospects: The
Photographs of Joel Sternfeld"
1989 Pace/MacGill Gallery, New York
1992 Museum of Fine Arts, Boston:
"Campagna Romana"

Selected group exhibitions
1977 Festival d´Arles, France: "The Second
Generation of Color Photographers"
1978 Kunsthalle, Cologne: "New Color
Visions"
1981 San Francisco Museum of Modern
Art: "Larry Fink and Joel Sternfeld"
1984 Museum of Modern Art, New York:
"Three Americans"
1985 Barbican Art Gallery, London:
"American Images 1945–1990"
1989 The National Gallery of Art,
Washington: "On the Art of Fixing a
Shadow"
1992 Museum of Modern Art, New York:
"More than One Photography"

1993 New Society for Fine Art, Berlin:
"About Big Cities"

Selected publications
1987 "American Prospects" (NY)
1992 "Campagna Romana: The
Countryside of Ancient Rome" (NY)

Works included in
Museum of Modern Art (New York, USA),
San Francisco Museum of Modern Art
(USA), Houston Museum of Art (USA),
High Museum of Art (Atlanta, USA), Art
Institute of Chicago (USA), Fotomuseum
Winterthur (Switzerland)

SHOMEI TOMATSU
Chiba, Japan
Born in 1930 in Nagoya, Japan
Educated at Aichi University, Japan, (eco-
nomy)
Selected one-person exhibitions
1962 Fuji Photo Salon, Tokyo: "Nagasaki
at 11:02"
1981 Tour of 30 of Japan's largest cities:
"Now Shomei Tomatsu and his World"
1984 Towns in Austria and Germany:
"Shomei Tomatsu, Japan 1952–1981"
1989 Tokyo, Osaka, Sapporo: "Plastics"
1990 Osaka, Kagoshima: "Sakura - sakura
- sakura"
1992 New York, Metropolitan Museum of
Art: "Sakura-sakura-sakura and Plastics"

Selected group exhibitions
1963 National Museum of Modern Art,
Tokyo: "Photography Today."
1974 Museum of Modern Art, New York:
"New Japanese Photography"
1986 Centre George Pompidou, Paris: "Le
Japon des avant-gardes 1910-1970"
1990 Metropolitan Museum of Art, New

York: "Photographs of the 1940´s and
1950´s"

Selected publications
1966 "Nagasaki at 11:02"
1967 "Japan"
1975 "Chronicle of the Sun"
1990 "Sakura - sakura - sakura"

Works included in
Tokyo Museum of Modern Art (Japan),
Tokyo Museum of Photography (Japan),
Art Museum of Yamaguchi (Japan),
Museum of Modern Art (New York, USA),
Metropolitan Museum of Art (New York,
USA), Philadelphia Museum of Art (USA),
Centre Georges Pompidou (Paris, France)

BIOGRAPHIES: WRITERS

ROBERT ADAMS
Longmont, Colorado, USA
Born in 1937, Orange, New Jersey, USA
Educated at University of Southern
California, Ph. D. in English, 1965

Selected books and articles
1970 "White Churches of the Plains"
(Boulder, Colorado)
1974 "The Architecture and Art of Early
Hispanic Colorado" (Boulder, Colorado)
1980 "From the Missouri West" (NY)
1981 "Beauty in Photographs: Essays in
Defense of Traditional Values" (NY)
1983 "Our Lives & Our Children" (NY)
1985 "Summer Nights" (NY)
1988 "Perfect Times, Perfect Places" (NY)
1989 "To make it Home: Photographs of the
American West" (NY)

Selected activities
Up to 1970: lecturer at Colorado College
Photographer and writer

DAG ALVENG
Oslo, Norway, and New York City, USA
Born in 1953 in Oslo, Norway
Educated in photography at Tent
Polytechnic, Nottingham, England, 1977-
1978

Selected one-person exhibitions
1979 Fotogalleriet, Oslo
1981 Preus Fotomuseum, Horten
1983 Trondheims Kunstforening, Trondheim
1985 Wang Kunsthandel, Oslo
1988 Museum for fotokunst, Odense
1989 OPSIS Foundation, New York
1993 Holly Solomon Gallery, New York

Selected publications
1986 "Asylum" (Oslo)
1990 "Verftet i Solheimsviken" (Oslo)

Works included in
Bibliothèque Nationale (Paris, France),
Museum of Modern Art (New York, USA),
Metropolitan Museum of Art (New York,
USA), Henie-Onstad Kunstsenter (Bærum,
Norway), Museum for fotokunst (Odense,
Denmark), Fotografiska Museet
(Stockholm, Sweden), Stedelijk Museum
(Amsterdam, The Netherlands), Museet for
samtidskunst (Oslo, Norway), Preus
Fotomuseum (Horten, Norway)

BRUCE BOICE
Montpon-Menesterol, France
Born in 1941 in New Jersey, USA
Educated at University of Hartford,
Connecticut

Selected activities
Visual artist and painter
1972-1973 writer for "Artforum"

BORIS VON BRAUCHITSCH
Frankfurt am Main, Germany
Born in 1963 in Aachen, Germany
Educated at the universities of Berlin,
Bonn and Frankfurt in art history

Selected books and articles
1992 "Das Magische im Vorübergehen.
Herbert List und die Photographie"
(Münster)
1992 "Thomas Ruff" (Frankfurt)

PHILIP BROOKMAN
Washington D.C., USA.
Born in 1953 in Salt Lake City, Utah, USA
Educated at University of California, Santa
Cruz. Studies: Art history and visual arts
(1976)

Selected books and articles
1989 "California Assemblages; The Mixed
Message" (in "Forty Years of California
Assemblages", University of California, LA)
1990 "Looking for Alternatives: Notes on
Chicano Art 1960-1990" (in "Chicano Art:
Resistance and Affirmation", University of
California, LA)
1992 "Censorship in the Arts: An
Annotated Chronology of Events"
(in"Culture Wars", NY)
1992 "The Politics of Hope: Sites and
Sounds of Memory" (in "Sites of
Recollections", Williamstown,MA)

Selected activities
1979–1983 Leader of Mary Porter Sesnon
Art Gallery, University of California, Santa
Cruz
1985–86 Curator at Centro Cultural de la
Raza, San Diego, California
1987–91 Curator, later Director of
Programs ved Washington Project for the
Arts, Washington D.C.
from 1991 Visiting curator at National
Gallery of Arts, Washington D.C.
from 1993 Curator for photo and media at
Corcoran Gallery of Art, Washington D.C.

FRANK GOHLKE
Ashland, Maryland, USA
Born in 1942 in Whichita Falls, Texas,USA
Educated at Yale University - 1966. M.A.
in English
Photography studies 1967-68 under Paul
Caponigro

Selected books and articles
1988 "Landscapes from the Middle of the
World" (Chicago)
1992 "Measure of Emptiness: Grain
Elevators in the American Landscape"
(Baltimore)

1993 "The Sudbury River: A Celebration" (Lincoln, MA)

Selected activities
1967 Photographer
Teacher at Massachusetts College of Art, Boston.

CATHERINE GROUT
Paris, France
Born in 1960 in Paris, France
Educated at École des Hautes Études en Science Sociale, Sorbonne, Paris

Selected books and articles
1988 "Métamorphoses du paysage" (in "Ligéria")
1990 "Le paysage en questions" (in "Artefactum")
1991 "A propos de l´art dans la ville" (Besancon)
1991 "Les ravisseurs de la beauté moderne: les décollagistes" (in "Artstudio")
1992 "Sites et Paysages" (ed.) (Reims)
1993 "Lewis Baltz: Rule without execption" (in "Art Press")
1993 "Gary Hill: La condition humaine de la pensée" (in "Artefactum")

Selected activities
Art historian, teaches at the University of Picardie
Art critic for the journals: Art Press, Artefactum, Katalog, Artstudio

MARVIN HEIFERMAN
New York, USA
Born in 1948 in Brooklyn, New York, USA

Selected books and articles
1980 "Park City. Photograhs by Lewis Baltz" (ed.) (NY)

1986 "The Ballad of Sexual Dependency. Photographs and text by Nan Goldin" (ed.) (NY)
1990 "The Indomitable Spirit. United Against Aids" (ed. catalogue) (NY)
1992 "Frida Kahlo: The Camera Seduced" (with Carole Kismaric) (San Francisco)
1992 "Dennis Oppenheim: And The Mind Grew Fingers" (with Carole Kismaric) (NY)

Selected activities
Curator:
1984 PS 1, New York: "The Family of Man 1955–1984"
1986 Queens Museum, New York: "The Real Big Picture"
1989 Whitney Museum of American Art, New York: "Image World: Art and Media Culture"
1989 to present: co-owner Lookout with Carole Kismaric

HANNE HOLM-JOHNSEN
Oslo, Norway
Born in 1950 in Porsgrunn, Norway.
Educated at universities in Munich (Germany) and Oslo (Norway), in art history, classical archaeology and history

Selected books and articles
1982-87 Articles in Norwegian Art Encyclopedia

Selected activities
1984–86 Assistant at Oslo Kommunes Kunstsamlinger
1988–1992 Director of Oslo Kunstforening
1992 Director of Fotogalleriet, Oslo

TOSHIHARU ITO
Tokyo, Japan
Born in 1953 in Tokyo, Japan

Educated at Tokyo Universitety in art history

Selected books and articles
1986 "Magical Hair" (Tokyo)
1987 "City Obscura 1830-1985" (Tokyo)
1988 "Diorama Transfixion" (Tokyo)
1993 "Holy Body" (Tokyo)

Selected activities
Art critic
Art historian
From 1987 professor of the history of art and design at Tama Art University, Tokyo

CAROLE KISMARIC
New York, USA
Born in 1942 in Orange, New Jersey
Educated at Pennsylvania State University in psychology and philosophy

Selected books and articles
1977 "The Photographs Catalog"
1989 "Forced Out: The Agony of the Refugee in Our Time"
1990 "I´m So Happy" (with Marvin Heiferman) (NY)
1992 "Frida Kahlo: The Camera Seduced" (with Marvin Heiferman) (San Francisco)
1992 "Dennis Oppenheim: And The Mind Grew Fingers" (with Marvin Heiferman) (NY)

Selected activities
1976–1985 Editorial Director of "Aperture", New York
1985–1990 Director of publications at Institute of Contemporary Art, PS 1 Museum, New York

STUART D. KLIPPER
Minneapolis, USA
Born in 1941 in New York, USA
Educated at University of Michigan

Selected books and articles
1993 "America in a Few States"
1993 "High Latitudes"

Activities: Photographer

MAX KOZLOFF
New York, USA
Born in 1933 in Chicago, USA
Educated at University of Chicago

Selected books and articles
1969 "Renderings"
1969 "Jasper Johns"
1972 "Cubism/Futurism"
1979 "Photography and Fascination"
1987 "The Privileged Eye"
1991 "Duane Michaels: Now Becoming Then"

Selected activities
1961–1968 Art critic in "The Nation", New York
1974-1976 Chief Editor of "Artforum"

ROBERT MEYER
Bergen, Norway
Born in 1945 in Oslo, Norway

Selected books and articles
1985 "Slow Motion (Jim Bengston)" (Oslo)
1987 "Simulo" (Oslo)
1988 "Norsk landskapsfotografi" (Oslo)

Selected activities
1963–1977 Photographer, first 1970
1977 Curator of exhibitions
1982–1989 Art critic in "Aftenposten" (Oslo)
1990 Professor of photography, Bergen College of Art and Design

GERTRUD SANDQVIST
Moss, Norway
Born in 1955 in Uddevalla, Sweden

Educated at University of Lund in art history (1983)

Selected books and articles
1983 "Charlotte Mannheimer: konstnär och mecenat"
1985 "Marika Mäkelä" (catalog text)
1991 "Episodes: Olaf Christopher Jensen"
1991 "Jennifer Bolande" (catalog text)
1992 "Ulf Rollof" and"Jussi Niva" (in "siksi" 2.1992)
1993 "Tony Oursler" (catalog text)

Selected activities
1981–1984 Editor of "Paletten"
1986–1988 Chief editor of"siksi"
1988–1990 Art critic "Hufudstadsbladet", Helsinki, Finland
1990–1992 Art critic "Svenska Dagbladet", Stockholm, Sweden
1992 Director Galleri F-15, Moss, Norway

WIELAND SCHMIED
Munich, Germany
Born in 1929 in Frankfurt am Main, Germany
Educated at University of Vienna, in law and art history.

Selected books and articles
1967 "Alfred Kubin" (Saltzburg)
1969 "Neue Sachlichkeit und magischer Realismus in Deutschland 1918-1933" (Hannover)
1975 "Caspar David Friedrich" (Cologne)
1985 "Francis Bacon" (Berlin)
1985 "Kritische Graphik der Weimarer Zeit" (with E. Roters) (Stuttgart)
1991 "Matta" (Tübingen)

Selected activities
1952–1960 Art critic in Vienna

1963–1973 Director at Kestner-Gesellschaft, Hannover
1973–1975 Chief conservator (division for free-hand drawing) at National Gallery, Berlin
1975–1977 Documenta, Kassel
1978-1986 Director of Berliner Künstlerprogram des Deutschen Akademischen Austauschdienstes
1988–1993 Head Master at Akademie der Bildende Künste, Munich
In addition curator for several exhibitions, including: "Retrospective Giorgio de Chirico"
(1982–83, Haus der Kunst, Munich; Centre Pompidou, Paris), "Gegenwart-Ewigkeit. Spuren des Tranzendenten in der Kunst unserer Zeit" (1990, Martin Gropius Bau, Berlin)

ROBERT SIMON
Paris, France
Born in 1952 in New York City, USA
Educated at Harvard University, Cambridge, Massachusetts, USA

Selected activities
Author of articles on the problem areas art/society in among others:. "Art History," "Art in America," "Texte zur Kunst"
Ph. D.-candidate at Harvard University, in the study of romanticism and history-painting in early 1800´s french paintings